Thrilling Quilling

THE ULTIMATE QUILLER'S SOURCEBOOK

Elizabeth Moad

David and Charles

www.mycraftivity.com

A DAVID & CHARLES BOOK
Copyright © David & Charles Limited 2008

David & Charles is an F+W Publications Inc.
company
4700 East Galbraith Road
Cincinnati, OH 45236

First published in the UK in 2008

Text and designs copyright © Elizabeth Moad 2008
Photography and illustrations copyright © David
and Charles 2008

A catalogue record for this book is available from
the British Library.

ISBN-13: 978-0-7153-2854-5 hardback
ISBN-10: 0-7153-2854-9 hardback

ISBN-13: 978-0-7153-2851-4 paperback
ISBN-10: 0-7153-2851-4 paperback

Printed in China by SNP Leefung
for David & Charles
Brunel House, Newton Abbot, Devon

Commissioning Editor: Jane Trollope
Assistant Editor: Emily Rae
Project Editor: Jo Richardson
Designer: Eleanor Stafford
Production Controller: Ros Napper
Photographers: Karl Adamson and Kim Sayer

Visit our website at www.davidandcharles.co.uk

David & Charles books are available from all
good bookshops; alternatively you can contact
our Orderline on 0870 9908222 or write to us
at FREEPOST EX2 110, D&C Direct, Newton
Abbot, TQ12 4ZZ (no stamp required UK only);
US customers call 800-289-0963 and Canadian
customers call 800-840-5220.

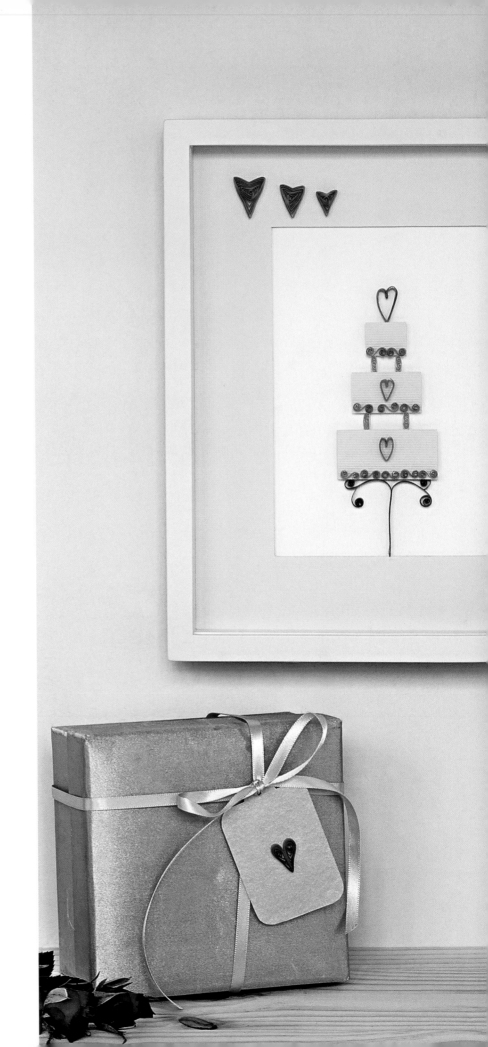

Contents

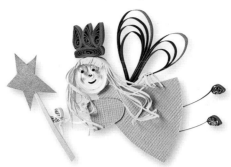

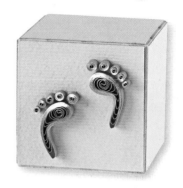

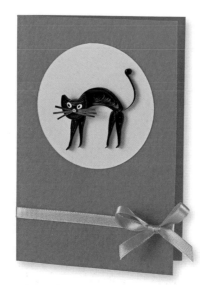

Introduction

Quilling is the papercraft that started me off on my creative career ten years ago, and is the craft that I have since been drawn back to over and over again. The technique of quilling is a particular skill and yet it is easy to do. By simply turning a basic tool and thereby manipulating strips of paper, wonderful shapes and forms can be created that have numerous decorative applications. This explains why it has always appealed to me and is increasingly growing in popularity. In addition, quilling requires very little equipment and materials, so it can be carried out anywhere using just the manual quilling tool, glue and paper. This makes it a very economical craft too, with packets of ready-cut paper strips purpose designed for quilling being inexpensive and allowing plenty of scope for trial and error without undue expense. The only investment is your time and this is often what daunts the beginner. But time is a relative concept and also doesn't mean complication, so in this book I have set out to dispel the myth that quilling is necessarily a long and involved process. Here, I have presented a wide variety of quilled elements and motifs that are individually quick to make, which can then be used in combination to construct larger projects.

Quilling is also a craft that can bring much satisfaction and joy to the creator. The act of twirling, curling and coiling the strips of paper is very relaxing and therapeutic in times of stress. What's more, it is an authentic craft in a world of quick-fix consumerism and ready-to-assemble kit crafts. Most importantly, it brings a lot of happiness to those who receive a quilled card or gift – and money just can't buy that!

History

Paper quilling, or 'paper filigree' as it is sometimes called, has a history that can be traced back over 500 years. The exact origins are not known, as paper degrades over time, but it is thought that the first quillers were members of religious institutions creating paper art for devotional purposes. However, examples of quilling do exist that date from Georgian and Victorian times, when ladies of leisure decorated tea caddies and boxes with rolled paper shapes – a craft thought appropriate for gentlewomen of the time. These ladies rolled papers around the quills of bird feathers, which is how the craft gained its name.

Having caught on in England in the late 18th and early 19th centuries, quilling spread to the American colonies. It subsequently experienced a decline, only to resurface in the 21st century with a flourish to become a popular modern craft that is now practised throughout the world.

Elizabeth

How to use this book

If you are a beginner in this craft, it is a good idea to start by familiarizing yourself with the papers (see pages 6–7) and basic equipment (see pages 8–9) needed for quilling. The coils and pinched-coil shapes displayed on pages 12–15 are the most frequently used forms in quilling, and although this is not an exhaustive guide, it is best to practise with these to begin with. For the novice quiller, it is worthwhile spending some time initially just experimenting with paper strips – coiling, curling and pinching them – to become acquainted with how the techniques work in practice.

This book is specially structured so that you can dip into any themed chapter that suits your mood or purpose, from Flower Power to Party Time, and choose any project that appeals, rather than having to follow it from start to finish. And each project includes a comprehensive 'you will need' list and clear step-by-step instructions, accompanied by a gallery of inspirational ideas on how to use and apply your quilled decorations and designs in a variety of creative ways.

Papers

Quilling is all about the paper, given that it is entirely formed from strips of paper. Traditionally, quillers would cut their own strips from paper sheets, but today most quillers purchase pre-cut strips to the width they require in the colours they want. The quiet satisfaction of opening a new packet of papers that has arrived through the mail is one that is treasured and shared throughout the quilling fraternity!

Weights

The weight of paper used for quilling is crucial, as it determines the end result. Paper about 100gsm in weight is best. This weight is strong enough to coil easily and holds its shape. Paper that is too thin will be flimsy and crease, but if it is too thick, it won't coil or make flowing coils.

Widths

Pre-cut paper strips come in several standard widths, but many suppliers will trim paper to the width you require. The following widths are used in this book:

- 1.5 or 2mm ($^1/_{16}$in) – the minimum width that is available
- 3mm ($^1/_8$in) – the most common width and ideal for beginners
- 5mm ($^3/_{16}$in) – good for freestanding 3-D quilling work
- 10mm ($^3/_8$in) – the most common width for use with a fringing tool
- 15mm ($^5/_8$in) – some suppliers offer this width for making frilly flowers (see page 115), with the adjustable 90 degree-angled fringing tool (see page 9)

Colours

The papers come in every shade imaginable, so the beginner may find selection a daunting process, or an expensive one if they fail to make the right choice. It is therefore advisable at first to buy a packet of pink, yellow or green shades or a 'rainbow' pack with a basic range of colours, to give you just enough to choose from. As you find colours that you like, you can then buy a whole pack of just one colour to extend your stock.

Single colour

Packs of ready-cut strips of paper are available in a single colour and the colour extends all the way through the paper.

Single colour with metallic edge

Gilded with a metallic edge, this paper looks fantastic when it catches the light. It is available in copper, gold and silver. You can also buy papers edged with metallic red, green, blue or purple. These are ideal for Christmas motifs and themes (see pages 106–113), and for creating light-catching butterflies (see Fluttering Butterfly, page 37), as well as for adding alluring sparkle to your quilling work in general.

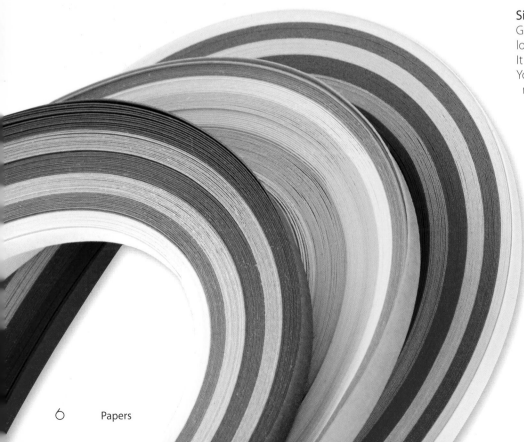

Different colour on either side

These papers are generally used for the Spreuer technique (see page 17).

Graduated colours

Paper strips can be graduated in colour along their length, for example ranging from pale at one end to darker in the centre and pale again at the other end. Other papers graduate in colour across their width. These can be used to create highly attractive frilly flowers (see Frilled to Thrill, page 115) and hat trimmings (see Tendril-trimmed Hat, page 76).

Cutting your own

It is possible to cut your own strips of paper by hand, but this can be time-consuming and also demands a high degree of precision, since the strips must be cut to exactly the same width. Some people use a paper shredder (not the cross-shredder type) to cut strips of paper for quilling. The advantage of professionally cut strips is that you can be sure of their uniformity and therefore will give an even finish every time.

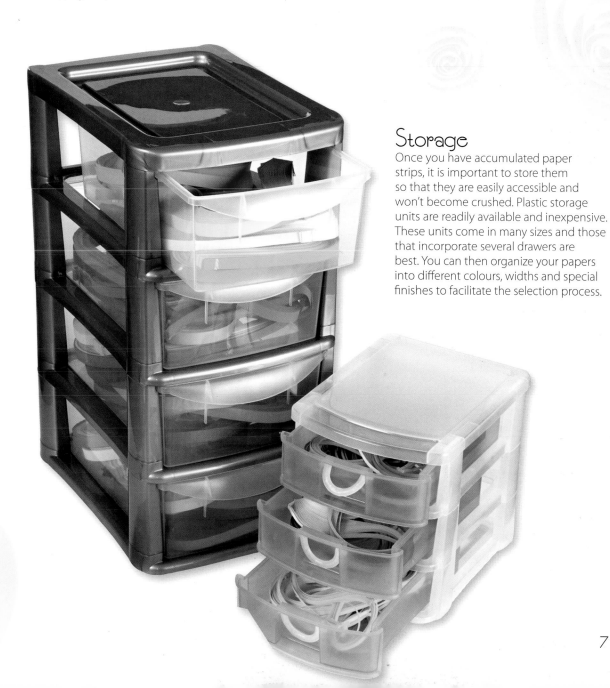

Storage

Once you have accumulated paper strips, it is important to store them so that they are easily accessible and won't become crushed. Plastic storage units are readily available and inexpensive. These units come in many sizes and those that incorporate several drawers are best. You can then organize your papers into different colours, widths and special finishes to facilitate the selection process.

Equipment

The good news is that quilling doesn't require a huge array of tools. In fact, only one specialist item – a simple quilling tool – is needed. The following is a guide to the basic essentials and how to choose a quilling tool that's right for you.

Basic tool kit

Many of these items are general papercrafting tools and equipment, but some need specially selecting for quilling purposes or are specific to quilling.

Cutting mat, craft knife and metal ruler

A self-healing cutting mat is essential for cutting with a craft knife, and also protects your work surface. A craft knife should always be used with a metal ruler; those with a cork base prevent slippage.

HB pencil and eraser

Required for marking lines on graph paper and for tracing templates.

PVA (white) glue

Regular PVA (white) glue is fine, but it should not be too runny. Too much water in glue makes the papers overly wet. A tacky PVA is best, but you can use a water-based non-toxic glue as long as it dries clear.

Small, fine-pointed scissors

Vital for snipping and trimming the narrow strips of paper.

Small, fine-pointed scissors

Fine-tipped tweezers

These are invaluable for picking up and positioning coils, wiggly eyes, gem stones and other embellishments. The pair shown is self-locking, which avoids having to keep them squeezed.

Self-locking, fine-tipped tweezers

Quilling tools

These come in all shapes and sizes, but all consist of a two-pronged slot through which a paper strip is threaded. They can be very cheap, but even the most expensive is not much to pay for a lifetime's service. It is important to find the tool that suits you. Some people prefer long handles, while others favour shorter ones that fit into the palm of the hand. When choosing, check the size of the gap at the curling end. A large gap means a large hole in the centre of the coil, which is most noticeable when making tight closed coils. Two of the quilling tools shown below comprise a sewing needle with one end snipped off embedded into a wooden handle. These have a gap just wide enough to slot the paper through to create a very small central hole in a tight coil.

Fine-tip applicator or cocktail sticks (toothpicks)

Many quillers find a fine-tip applicator attached to a pot of glue the most precise way to apply glue direct to paper, as shown above. The pot is stored upside down in a jar on a damp sponge so that the glue doesn't dry in the nozzle. Alternatively, you can use a cocktail stick (toothpick) or needle tool (see right) to apply small dots of glue.

Other quilling methods

Some quillers prefer to make coils by rolling the paper around a needle tool (see below) or just using their fingers. The advantage of a quilling tool is that the slot catches the end of the paper so that you can make coils just by turning the tool, otherwise you need to actively wrap the narrow paper strip with your fingers. As I have always used a tool and find that it is much easier for beginners to use, this is the method featured throughout the book.

Needle tool

This metal point on a handle is useful for rolling paper around to leave a hole in the centre.

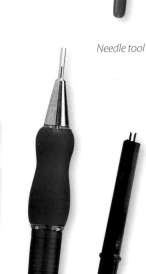

Needle tool

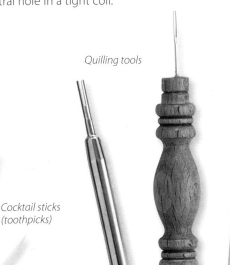

Cocktail sticks (toothpicks)

Quilling tools

Fringing tools

These enable you to fringe narrow paper strips with speed and precision for use in quilling (see page 16). By manually moving the handle of the fringing tool up and down, the paper strip is pulled through and sliced either 90 degrees across or at a 45 degree angle, leaving an uncut margin so that the paper remains in one piece.

Adjustable 90 degree-angled fringing tool – for varying widths of paper up to 15mm (⁵⁄₈in) wide

90 degree-angled fringing tool – for papers 10mm (³⁄₈in) wide

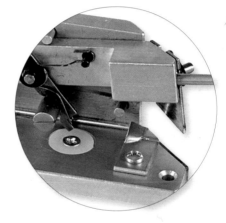

45 degree-angled fringing tool – for 10mm (³⁄₈in) wide paper folded in half

Snips

Used in needlework, snips can be useful as an alternative to fringing tools for snipping or fringing paper, in preference to scissors, since they automatically release.

Bulldog clips

When manually fringing paper, you need a wide or very wide bulldog clip to hold the edge of the paper securely while you cut.

Snips

Bulldog clip

Further tools and materials

These tools have been used in the book for different effects and you may decide to purchase them once you have mastered the basics. Also included here is a representative selection of materials and embellishments used in the projects.

Board and pins
A thick piece of foam, polystyrene or Styrofoam board, used for the husking technique (see page 16), allows pins to be inserted to position and hold papers in place. A cork board can be used instead.

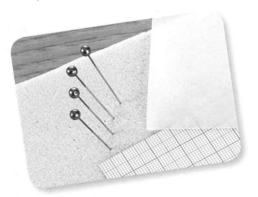

Wooden spoons or dowel
Many quillers keep lengths of wooden dowel around which to make large rings of paper (see Precious Rings, page 53). However, I lose mine, so I tend to use wooden spoon handles, as I know where these are! But any smooth, round object can be used for this purpose.

Quilling board
This cork- or foam-based template board has a plastic top with cutout circles of various sizes, into which you can insert coils and let them unwind to achieve the exact size of coil.

Wooden spoon

Magnifier
Very intricate work can be tiring on the eyes, so a magnifier should be used to avoid eyestrain.

Onion holder
This consists of a series of metal prongs on a plastic handle around and through which paper is looped to create intricate designs, known as the Spreuer technique (see page 17). Originally designed to slice onions, internationally renowned quiller Jane Jenkins found a better use for the holder and the quilling world forgot about the onions!

Ribbler (crimper)
By turning the handle of this tool, two cogs are turned and the paper is fed through and ribbled or crimped.

Onion holder

Magnifier

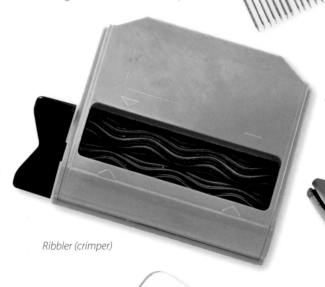

Ribbler (crimper)

Quilling board

Felt-tip pens and brush pens

Felt-tip pens are used to colour the ends of fringed paper strips, as in the Dainty Daisy, page 45, and finer brush pens to add features to quilled items, as in the Fairy Queen, page 60.

Chalks and applicator

Coloured chalks can be applied to coils, such as in the Fairy Queen, page 60, or to the edges of fringed papers.

Coloured chalks and applicator

Perfect Pearls™

This metallic powder is mixed with water and brushed onto coiled shapes to create a gilded finish – see the Fairy Queen Crown, page 59.

3-D paint

As its name implies, this paint has more volume than ordinary paint, so is ideal for adding three-dimensional details to quilled items, such as flower stamens – see Beautiful Bloom, page 72. Bear in mind that it does take a relatively long time (at least two hours) to dry.

Fancy-edged scissors

These scissors have blades with a decorative edge. They can be used to cut 10mm (³⁄₈in) wide paper for quilling, as in Dazzling Daffodil, page 43.

Wiggly eyes

These eyes that move around are great for bringing quilled animals and other crazy creatures to life, such as the Staring Starfish, page 85, and Dotty Bug, page 34, adding an extra fun element to your designs. They are available in a variety of different sizes.

Punches

Small punched shapes can be attached to strips for coiling and forming flowers – see Beautiful Bloom, page 72.

Gem stones

Small gem stones can be added to coils for rings – see Precious Rings, page 53 – or for eyes – see Hovering Dragonfly, page 36. These are also perfect for highlighting flower centres.

Ribbon and bow-maker

A bow-maker comprises lengths of wooden dowel of different heights and diameters set in a block, and is very handy for making very tiny ribbon bows for quilling – see Polka-dot Bikini, page 86 – as well as perfectly symmetrical bows.

Adhesive foam pads

Available in a wide range of shapes and sizes, these can be used for mounting quilled motifs and embellishments onto card and other surfaces. The mini variety (2mm (¹⁄₁₆in) high) is ideal for mounting paper to the same height as the quilling (see Wedding Cake, page 52, and Spotty Buggy, page 56).

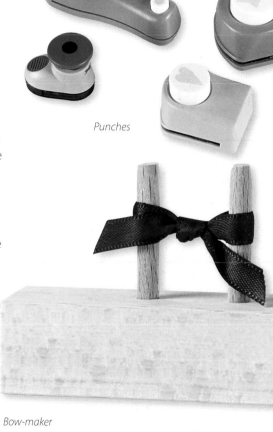

Fancy-edged scissors

Wiggly eyes

Punches

Bow-maker

Gem stones

Adhesive foam pads

3-D paint

Basic techniques

The fundamental factors involved in quilling are: the length of paper used for coiling, how much the coil is allowed to unwind and whether or not the end of the coiled paper is glued in place. So here you can see how these factors are used in practice to produce different types of coil, and how the resulting coils can be manipulated to create various shapes.

How to make a coil

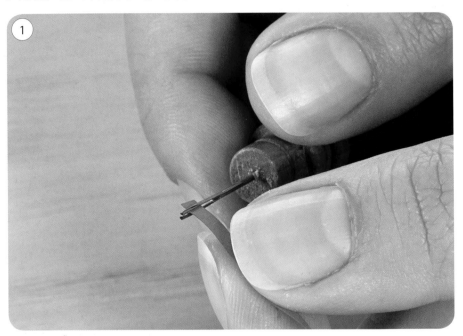

Insert a strip of paper into the slot of the quilling tool 2mm (¹⁄₁₆in) from the end of the paper strip. Here, a 3mm (¹⁄₈in) wide paper strip is used.

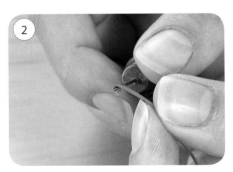

Continue to turn the tool. I always turn the tool away from me, but in workshops I have found that many people prefer to turn towards them; there is no hard and fast rule. Guide the coil with your fingers and keep a light tension on the paper with your spare hand.

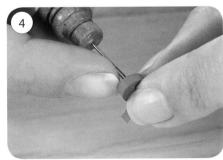

Turn the quilling tool to catch the end of the paper strip.

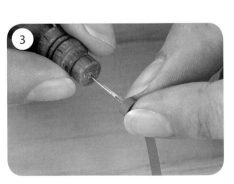

Continue turning to the end of the strip of paper, then carefully remove the tool by sliding the paper off the prongs, holding the coil in place.

TIP
If you make a mistake, just discard the coil and try again – the cost is minimal.

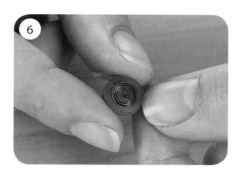

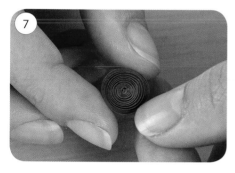

Add a dot of glue to the end of the paper strip with a cocktail stick (toothpick) or fine-tip applicator (see page 8) and adhere to the coil to create a tight closed coil.

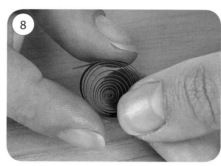

Alternatively, release the coil a little and then glue the end of the strip to the coil to create a shape with thick edges – a loose closed coil.

If you release the coil further, it becomes larger in size.

Release the coil even further or let go altogether to create an open coil.

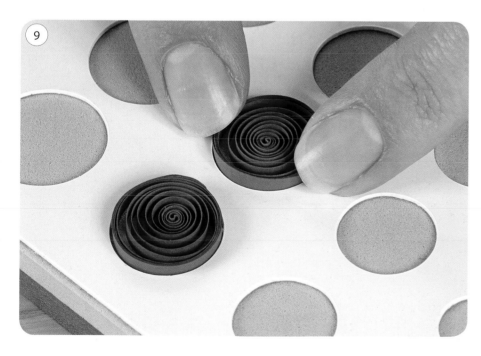

Alternatively, insert the coil into a template in a quilling board (see page 10) to achieve a specific size of coil.

TYPES OF COIL

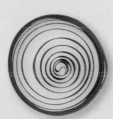

Tight closed coil

Loose closed coil

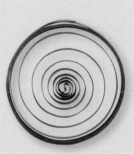

Loose closed coil released further

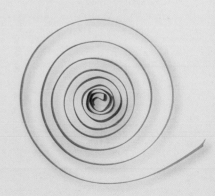

Open coil

Pinching loose closed coils

Loose closed coils are where the end of the paper has been glued to the coil, but the coil has been allowed to unwind a little so that it becomes loose while remaining closed. The basic coil can then be pinched between the thumb and index finger at one or more points to form a variety of different shapes, as follows.

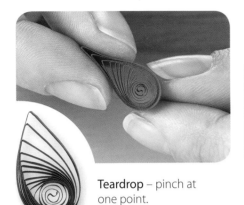

Teardrop – pinch at one point.

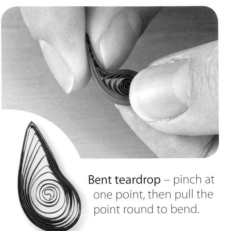

Bent teardrop – pinch at one point, then pull the point round to bend.

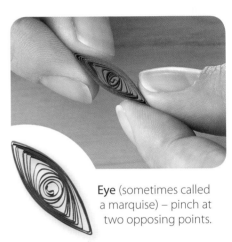

Eye (sometimes called a marquise) – pinch at two opposing points.

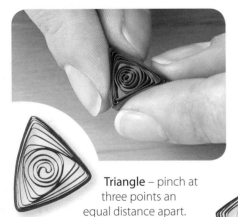

Triangle – pinch at three points an equal distance apart.

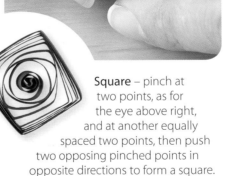

Square – pinch at two points, as for the eye above right, and at another equally spaced two points, then push two opposing pinched points in opposite directions to form a square.

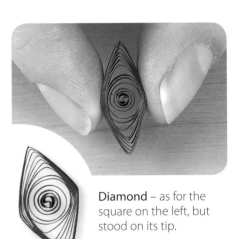

Diamond – as for the square on the left, but stood on its tip.

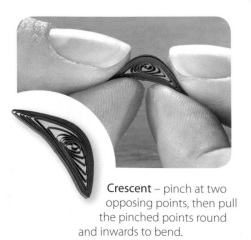

Crescent – pinch at two opposing points, then pull the pinched points round and inwards to bend.

TIP
You may find that some coils are too small to manipulate, in which case simply allow them to unwind a little more before gluing the end in place and pinching.

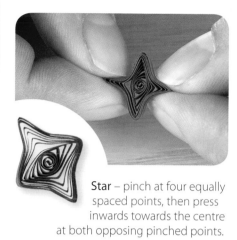

Bug-head crescent or half-circle – pinch at two points relatively close together, leaving the curve of the coil intact on the opposite side.

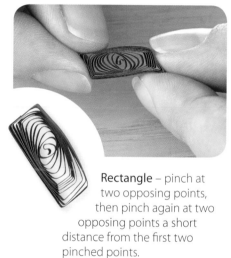

Star – pinch at four equally spaced points, then press inwards towards the centre at both opposing pinched points.

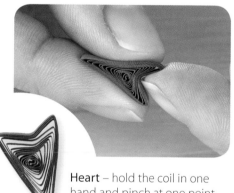

Heart – hold the coil in one hand and pinch at one point while simultaneously pushing inwards with a fingernail at the opposing point.

Rectangle – pinch at two opposing points, then pinch again at two opposing points a short distance from the first two pinched points.

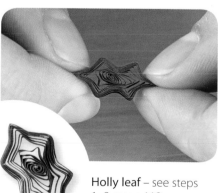

Holly leaf – see steps 1–3, page 112.

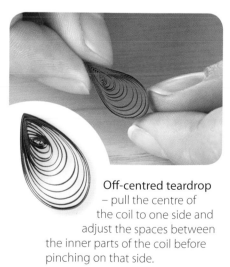

Off-centred teardrop – pull the centre of the coil to one side and adjust the spaces between the inner parts of the coil before pinching on that side.

OPEN COIL SCROLLS

For open coils, the quilling tool is removed and the coil is left to assume its shape without being glued at all. All kinds of scrolled decorations can be created using open coils, as shown. To increase the variety, the length of paper can be folded at differing points and then open coils made in the ends.

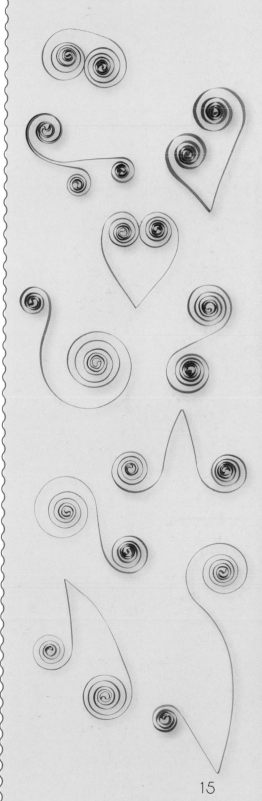

Further techniques

Like any craft, quilling has evolved over time and pioneering practitioners have pushed the boundaries forward to incorporate new tools and techniques. While these may not be considered to fall within the realms of 'pure' quilling, they do add variety and spice to quilled pieces. For more experienced quillers, it is always advantageous to have a range of techniques at your disposal when creating a new item or developing a design, since you can then select the most appropriate method to realize your ideas.

Fringing

I regard the fringing tool (see page 9) simply as a godsend. It allows you to fringe narrow strips of paper quickly and precisely, as opposed to fringing by hand, which is much more time-consuming and hard on the hands. Some fringing tools are adjustable so that you can fringe different widths of paper. The fringed strips can then be coiled or otherwise used to create flowers (see Dainty Daisy, page 45), hairy caterpillars (see page 35), feathers (see Feathered Hat, page 77), frondy leaves (see Carrot Bunch, page 24) and a frilly decoration for a wand (see page 61).

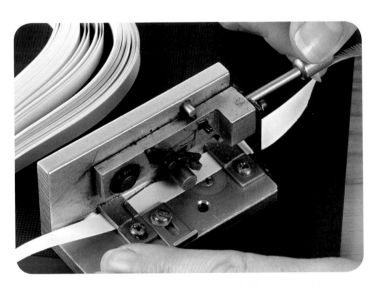

A 90 degree-angled fringing tool is being used here to fringe 10mm (⅜in) wide paper

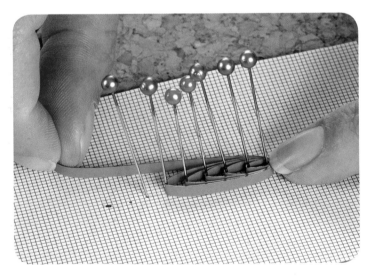

In husking, paper strips are looped around carefully positioned pins inserted into a board

Husking

This technique involves looping paper around pins inserted into a cork, foam, polystyrene or Styrofoam board, to create any shape you want in any size. Although it is simple to do, the results are wonderfully delicate, as in the Hovering Dragonfly, page 36. You can make a template showing the position of the pins, so that it can then be used to create identical items in whatever quantity you require.

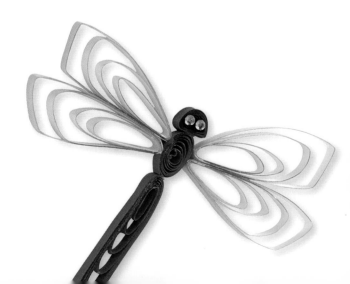

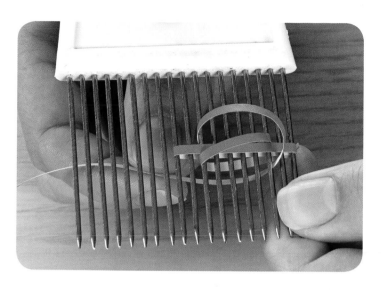

Spreuer

The Spreuer technique uses an onion holder (see page 10), which has a series of metal prongs around and through which paper is looped to create elaborate decorations, such as in Chic Shoe, page 78. The paper can be looped in numerous ways to produce a wide variety of designs.

This shows the use of the onion holder for the Spreuer technique to make a shoe bow

Weaving

Strips of paper of equal or differing widths can be woven together to make background papers or add textured elements to a quilled design, as in Delicious Ice Cream, page 87, where it is used to create the cone. Using precise, commercially cut quilling papers ensures that the woven effect is perfectly even. The colours used can also be selected to match the coils or shapes you are making with other techniques. Weaving shows how you can think laterally and use quilling papers in unexpected and creative ways.

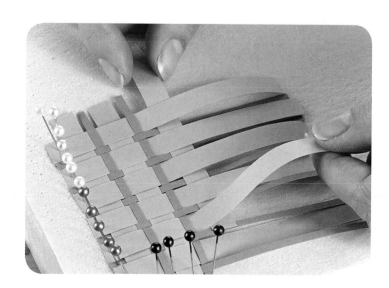

A foam block and pins are used to secure the strips of paper in place in the weaving technique

Protecting and preserving your quilling

Being made of paper and three-dimensional, quilled items are susceptible to damage over time. But taking a few simple precautionary measures will ensure that their condition is preserved. After all, if examples of quilled pieces have survived from Victorian times, then yours can surely last into the next century!

Fading

Paper will fade if it is placed in direct sunlight, and it is surprising how quickly it will do so. Here is an example of a quilled carrot that has faded from bright to pale orange after being placed on a windowsill. So keep your paper and quilled items away from sunlight to avoid such undesirable damaging effects.

Framing

A box frame that has a recess is ideal for displaying a quilled picture, as the coils are kept away from the glass. Otherwise, you can purchase a picture frame and discard the glass, but it will collect dust over time. Quilled pictures in box frames with or without glass will fade if they are placed where the direct sunlight will reach them, so position them with care.

Sprays

Some quillers use an acrylic spray sealant to protect their papers from fading and dust. These sprays have to be used carefully and it is always best to test them out on a spare piece of quilling first and leave it to dry to check that it doesn't have an adverse effect.

Recording designs

If you have worked hard on a quilled card or gift for somebody, you might find yourself feeling reluctant to give it to them! But one way of holding onto your best creations is to take a photograph of them for your records. Using a digital camera is an ideal method of compiling a catalogue of images of your quilled designs that you can store safely and compactly on disk, then easily access and view on a computer whenever you want.

You need to decide how precious your quilled work is and which are your favourite items that you want to record or try and preserve. I personally regard my quilling work as a continual process of evolution, and I don't always like to see my pieces from years ago. However, it can be interesting and valuable to chart your progress in quilling by preserving your work for the future.

Sending your quilled cards

Presentation of your quilled designs is important and extends to the way they are delivered. A special box or envelope provides the perfect finishing touch and ensures optimum condition. Make the box or envelope large enough to accommodate bubblewrap for extra protection.

Making a box

Tailor-making a box for your card will take only a few extra minutes and is sure to impress the recipient, especially if tied up with some pretty ribbon. Use strong card, around 300gsm in weight.

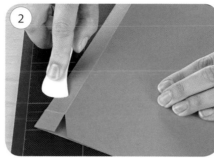

Fold and crease along the score lines.

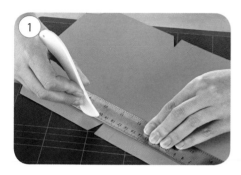

Enlarge the template on page 116 on a photocopier to the size you require. Cut along the outside solid lines, then draw around the template onto scrap card and cut out with a craft knife and metal ruler. Draw around the template onto your chosen card and cut out in the same way. Use the metal ruler and a scoring or embossing tool to score the lines indicated on the template.

Apply PVA (white) glue with a cocktail stick (toothpick) to each of the four tabs on the box base. Press these tabs to the inside of the box side to complete the box base. The lid will then fit neatly into the base.

Making an envelope

Alternatively, if you are hand-delivering the card, make an envelope to fit in a coordinating coloured strong paper or lightweight card. A quick way to do this is to use a plastic envelope maker, which allows you to make several sizes and shapes of envelope.

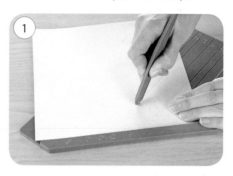

Follow the measurements given with the envelope maker and select the scoring lines needed on the plastic templates. Score a line along the groove by pressing the scoring tool through the paper into the groove. Turn the paper 180 degrees and score in the same groove, then turn 90 degrees and score in a different groove, as instructed, and finally turn 180 degrees to score a fourth line.

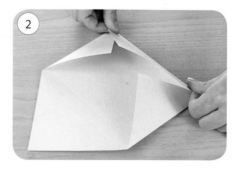

Remove the scored paper from the template and fold along the scored lines. Glue the bottom flap in place.

19

Projects

Cooking capers, page 96

Baby talk, page 54

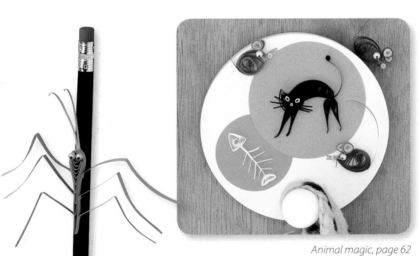
Animal magic, page 62

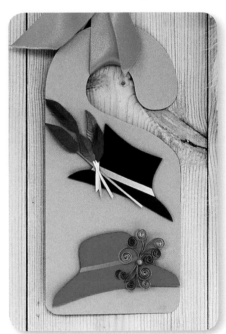
Fab fashion, page 74

Beautiful bugs, page 30

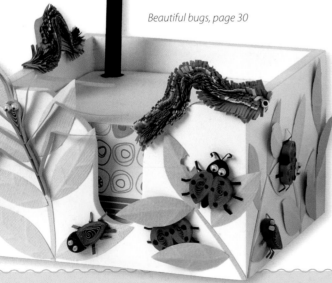

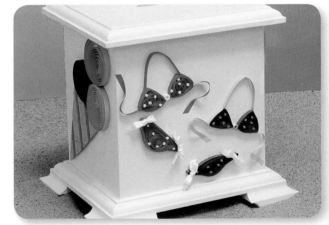
Beach life, page 82

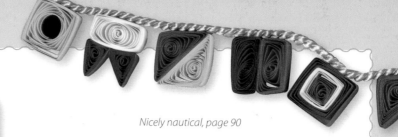

Nicely nautical, page 90

Gardening gems, page 22

Flower power, page 38

Christmas crackers, page 106

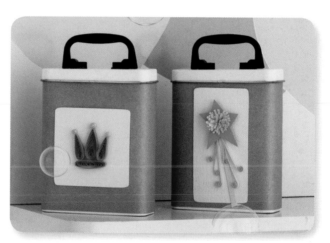

Fairy fantasy, page 58

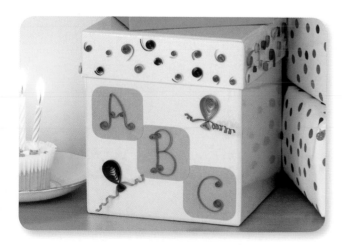

Party time, page 102

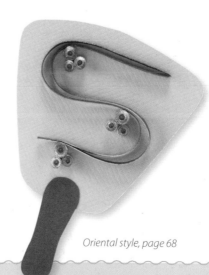

Oriental style, page 68

Wonderful
weddings, page 48

Gardening gems

Cultivate the perennial interests of your green-fingered friends and family yet further with some prize-winning papercrafted produce. These delightful quilled items can be used to transform everyday utilitarian items, such as a seed box or a plant pot or vase, into unique gifts with equal appeal to both sexes.

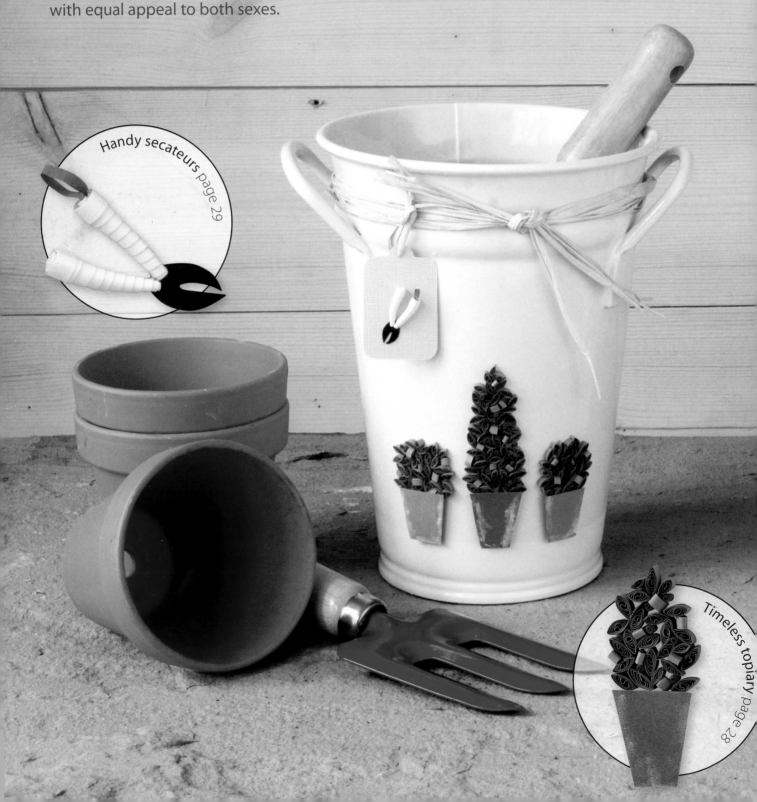

Handy secateurs page 29

Timeless topiary page 28

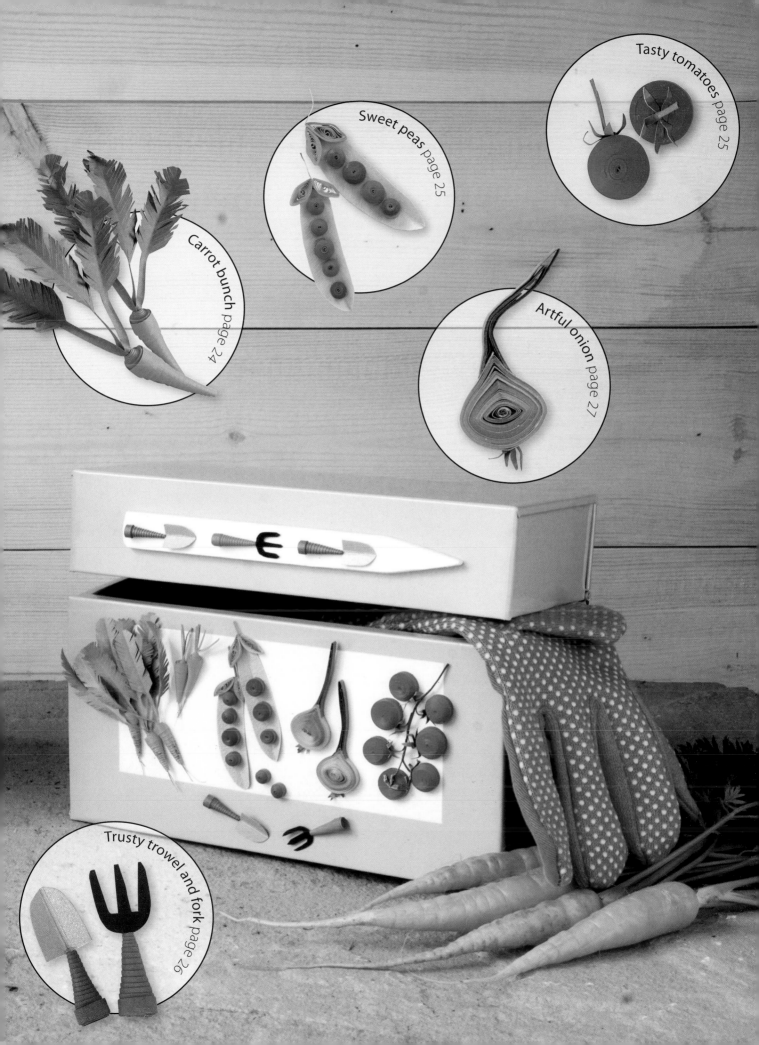

Tasty tomatoes page 25

Sweet peas page 25

Carrot bunch page 24

Artful onion page 27

Trusty trowel and fork page 26

Carrot bunch

Each of these crunchy-looking carrots, complete with lush green leafy tops, is formed from a paper strip coiled into a cone. All are made with 20cm (8in) lengths of paper, which demonstrates how the way in which you coil can alter the size and shape of the resulting cone. For extra touches of realism, the cones are made slightly unevenly and soil is used to colour them.

You will need

- 3mm (⅛in) wide orange paper
- 10mm (⅜in) wide green paper
- soil
- 45 degree-angled fringing tool
- snips (optional)
- Basic Tool Kit (see page 8)

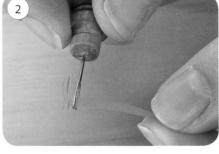

1 For the carrot roots, cut a 1.3cm (½in) length of the orange paper into four very narrow strands, but leave them joined at the end. Glue to the end of a 20cm (8in) length of orange paper for the carrot itself.

2 Position the quilling tool to the left of the strands, with the strands hanging downwards, and begin to turn the tool to coil the paper tightly for a few turns.

3 Continue turning the quilling tool, but as you do so, angle the paper away from the tool so that as you coil it creates a cone shape. When coiling, make sure that the paper overlaps, but vary the overlaps to make the cone uneven. Secure the end of the paper with glue. Apply a generous coating of glue inside the cone with a cocktail stick (toothpick) and leave to dry.

TIP

Customs regulations prohibit the transport of soil internationally so if you are sending your quilled carrots abroad, use felt-tip pen to colour them instead.

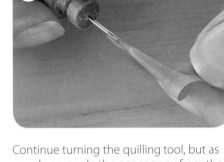

4 For the leaves, fold a length of the green paper in half along its length and use the fringing tool to fringe. Cut the fringed paper into 5cm (2in) lengths. Keeping the paper folded in half, trim the fringes for a length of 1.5cm (⅝in) from one end, leaving the uncut margin as a stalk.

5 Using small scissors or snips, make random cuts into the fringing before unfolding and opening the paper strip. Round the tip of the leaf. You will need three or four leaves per carrot.

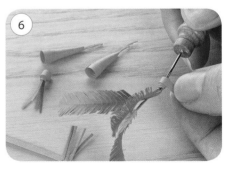

6 Glue the leaf stalks to the end of a 10cm (4in) length of orange paper and start coiling from the end with the leaves. Make a tight coil. Apply a generous amount of glue inside the top of the carrot cone, then insert the tight coil. Add real soil to the carrots and trim the ends of the roots to make them look as realistic as possible.

Sweet peas and tasty tomatoes

These luscious vegetables are quick and easy to make, and it is highly satisfying to see a pile of them growing on your work surface. Both are created using tight coils, the tomatoes using a longer length of the paper for a larger result. The coils are pushed up slightly to achieve a domed effect.

You will need

- 3mm (⅛in) wide paper – red, dark green, green
- 2mm (¹⁄₁₆in) wide pale green paper
- green card
- Basic Tool Kit (see page 8)

To make a tomato, glue two 40cm (15¾in) lengths of red paper together end to end. Make a tight coil and glue the end in place. Push the inner edge of the coil out with your fingernail. Be careful not to push the centre of the coil out, as this makes the shape too high.

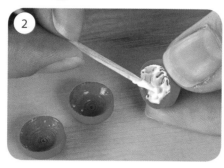

Apply a generous amount of glue inside the tomato, taking great care not to change the shape. Leave to dry.

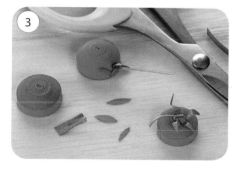

Cut tiny leaves from the dark green paper. To make stalks, glue two lengths of the dark green paper together lengthways and leave to dry. Cut in half lengthways and trim to 1cm (⅜in) lengths. Glue a stalk and three or four leaves to the top of each tomato – they will crumple to realistic effect in the process.

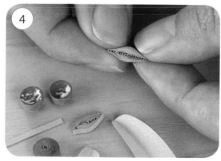

For the peas, make tight closed coils with 20cm (8in) and 30cm (12in) lengths of the green paper, then push out the inner edge of each coil and glue inside, as in Step 1. For the leaves, make loose closed coils from 20cm (8in) lengths of the pale green paper, then pinch into eye shapes (see page 14). Glue a short strand of the paper in the centre. Using the template on page 116, cut a pea pod from green card, then score and gently fold down the centre. Glue the peas to the centre of the pod and the leaves at one end.

TIP
If you find it difficult to use your fingernail to push out the inner edges of the coils, use the rounded end of a pen or a similar object.

INSPIRATIONS

Carrot cupcake
Celebrate a veggie-lover's birthday with this novel card design, featuring a carrot cake with a difference, decorated with a pile of simple open coils and topped with a colourful carrot. See page 116 for the cupcake template.

Pod pairing
Here, two pea pods adorn a wooden plant label, which would make a lovely gift for a vegetable grower combined with a seed tray and a selection of suitable seed packets. Alternatively, they could be used to decorate the cover of a gardening journal, diary or calendar.

Tomato trio
Three quilled tomatoes mounted onto squares of contrasting pale-coloured card are positioned in a row for a stylish, contemporary-style tag to make a gardening gift extra special. Note that the central tomato's stalk and leaves are glued to the edge of the coil for added interest.

Trusty trowel and fork

These matching mini gardening tools are irresistibly intriguing, with their realistic 3-D handles formed from brown paper strips coiled into cone shapes, to which simple card shapes for the trowel or fork blades are attached. All you need is a little practice to sharpen up your hand-eye coordination and apply the correct degree of tension to create short, stubby cone shapes.

You will need

- 3mm (⅛in) wide paper in two shades of brown
- card – silver, black
- Basic Tool Kit (see page 8)

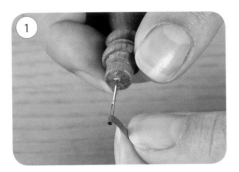

Insert one end of a 20cm (8in) length of one of the brown papers into your quilling tool. Coil tightly for three turns.

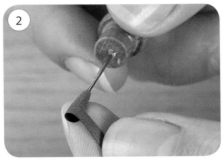

Continue turning the quilling tool, but as you do so, angle the paper away from the tool so that as you coil it creates a cone shape. You need to make sure that the paper overlaps as you coil.

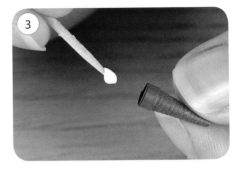

Continue coiling away from the tool until you reach near to the end of the paper. For the final 2cm (¾in), coil without angling the paper away from the tool to create a flat top. Carefully remove the quilling tool and secure the end of the paper with glue. Use a cocktail stick (toothpick) to apply a generous coating of glue inside the cone shape, right down to the bottom, to give it some rigidity when dry.

Using a medium-sized pair of scissors, cut a 15cm (6in) length of the same brown paper in half along its length, thereby creating two 1.5mm (1/16in) wide pieces.

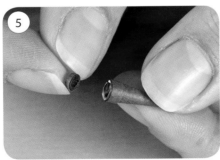

Use one of the 1.5mm (1/16in) wide pieces of brown paper to make a tight closed coil, which will form a 'plug' for the end of the cone. Apply a generous amount of glue inside the top of the cone and insert the tight closed coil.

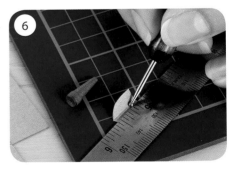

Using the template on page 116, cut a trowel blade from silver card. Using a scoring tool against a metal ruler, score a line down the centre. Fold along the score line, then open out to leave a slight fold. Glue to the handle. Make the fork in same way, using the other brown paper for the handle and cutting the fork blade from black card (template on page 116).

TIP
The exact size of the cones will vary depending on how much you overlap the paper as you coil, so it's a good idea to make a batch of cones and closed coil 'plugs', then see which fit together the best.

Artful onion

Different quilling techniques are combined here to great effect. The main part of the onion uses lengths of paper joined together to make a large coil with the quilling tool, which is only slightly released and then pinched into shape, while the leaves are formed into loops by hand.

You will need

- 3mm (⅛in) wide paper – pale brown, green, dark brown
- Basic Tool Kit (see page 8)

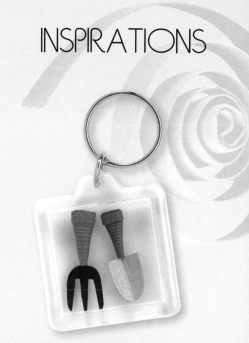

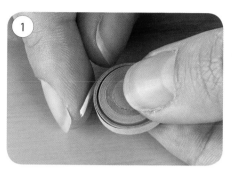

Glue four 40cm (15¾in) lengths of the pale brown paper together end to end. Make a tight coil, but release it a fraction before gluing the end in place. Keep holding the coil.

TIP
The onion may look as though it has two shades of brown, but this is because each side of the paper is a very slightly different colour due to the way it has been cut. This only adds to the realistic effect.

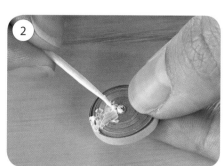

Continue holding the coil while spreading glue onto one side; if you release the coil before gluing, the centre will spring outwards and it will lose its evenness. Pinch the top of the coil when the glue has dried.

Key tools
This clear plastic key ring has a 2mm (1/16in) wide recess, in which the trowel and fork set has been placed. The cones for the handles are squashed slightly, but this serves to hold them in place and prevent them from moving around inside the key ring.

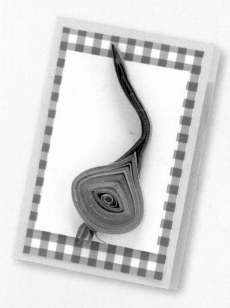

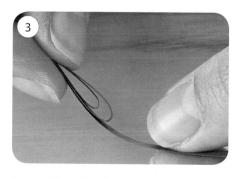

Form a 20cm (8in) length of the green paper into a loop 1.5cm (⅝in) high. Then make another loop around the first loop and repeat twice more.

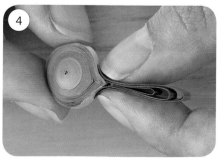

While still holding the loops, cut through the bottom of the loops. Place glue on all the ends and attach to the top of the onion. Cut tiny leaves from the dark brown paper and glue to the bottom of the onion to resemble roots.

Notable bulb
Make a gift something to remember – literally – by creating this smart holder for mini stick-on notes for all those cultivation or cooking reminders. The quilled onion is simply mounted onto layered cream, checked and orange card – a scheme that will fit in well with any kitchen or garden shed setting. The same design could be used for a thank you or birthday card.

Timeless topiary

Topiary has many attractive stylized shapes and forms that can be successfully imitated in quilling to produce some wonderfully textural, sophisticated designs with wide appeal. Although the bushes need a lot of pinched coils, they are easy to make and won't take long to create once you get into the coiling rhythm.

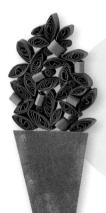

You will need

- 3mm (⅛in) wide paper – green, red
- brown card
- white inkpad
- cotton bud
- adhesive foam pads
- Basic Tool Kit (see page 8)

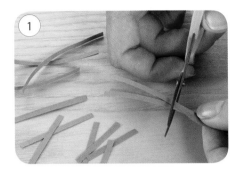

Snip lengths of the green paper between 3cm (1⅛in) and 7cm (2¾in) in order to create a variety of different-sized leaves.

TIP
These topiary pots are ideal for decorating doll's houses.

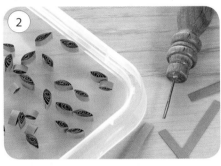

Use the lengths of green paper to make loose closed coils and then pinch at two opposing points to create leaf shapes. Place in a container or a shallow lid to prevent them from getting lost on your work desk.

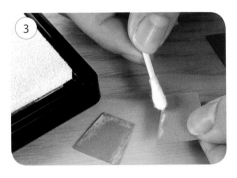

Using the templates on page 117, cut plant pots from brown card. Press a cotton bud into the white inkpad, then lightly run it down the edges of the plant pots. Repeat several times to achieve the desired effect of aged terracotta.

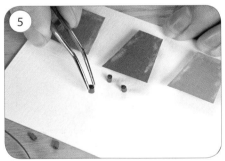

Make tight closed coils with 2–3cm (¾–1⅛in) lengths of the red paper. Pick up a coil with tweezers and add glue to one side or dip into glue, then position on the card or other surface above the pot. Use about seven coils for the small pot and 13 for the larger pot, but you can make some bushes without the red coils.

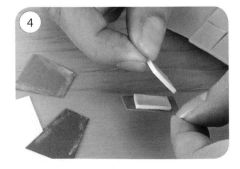

Place an adhesive foam pad on the back of each plant pot, remove the backing paper and then place another adhesive foam pad on top, to create a double thickness. Position on the card or other surface you are decorating.

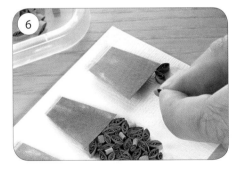

Glue the leaves around the red coils, working upwards and filling the bush shape as you go. Some leaves can be placed on their side in order to vary the effect slightly.

Handy secateurs

The handles of this cute cutting tool are made using the same technique as for the carrots and the trowel and fork (see pages 24 and 26), but here the overlap is smaller to create a narrow cone shape. The cone is quite fragile and so requires a very delicate touch when handling until the glue applied to the inside is dry.

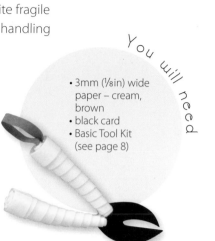

You will need

- 3mm (⅛in) wide paper – cream, brown
- black card
- Basic Tool Kit (see page 8)

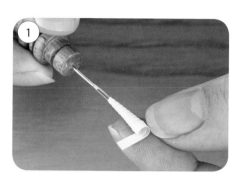

Insert a 9cm (3½in) length of the cream paper into your quilling tool. Turn the tool, and as you do so, angle the paper away from the tool, as in Step 1, page 26, but with very small overlaps. Glue the end in place and then place glue inside the cone, as in Step 3, page 26. Repeat to make a second cone.

When the glue has dried, bend the cones slightly with your fingers.

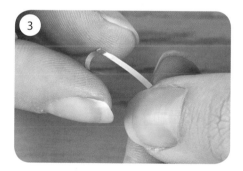

Cut a 4.5cm (1¾in) length of cream paper in half lengthways and glue a 1cm (⅜in) piece of brown paper in a loop to one end. Start coiling from the end with the loop and make a tight closed coil.

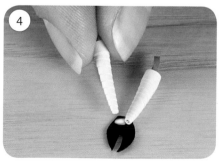

Insert the coil into the end of one cone shape. Make another tight closed coil but without the loop and insert this into the other cone. Using the template on page 117, cut two secateurs blades from black card. Apply glue to the blades and then the ends of the cones and stick in position.

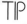

TIP
These cones are a little challenging to make, but once mastered, you can use the technique to make shears (see Shear Delight right), a skipping rope, decorator's paintbrush or a saucepan.

INSPIRATIONS

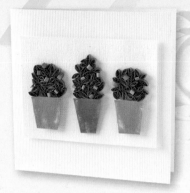

Pots of style
Two smaller topiary bushes flank a larger one to make an attractive arrangement for this versatile card design. You could dress it up by using metallic-edged papers for the coils (see page 6) and adding gem stones for Christmas.

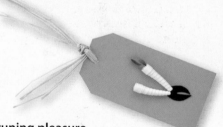

Pruning pleasure
The secateurs are mounted onto a lime green gift tag tied with raffia for a rustic finishing touch. Team with the topiary to inspire some creative cutting!

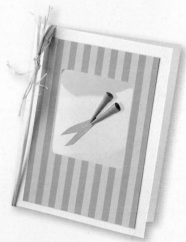

Shear delight
Here, an aperture was cut in a small green card and correspondingly in green striped paper, then glued together with a sheet of acetate in between. The shears, made in the same way as the secateurs (template on page 117), are glued onto the acetate and raffia tied around the card spine.

Beautiful bugs

The insect world offers a fascinating variety of colourful, delicate and intricate forms on a miniature scale – qualities also inherent in quilling, making it the ideal medium for re-creating these characterful creatures. Adults and children alike are guaranteed to be intrigued and amused by these quilled curiosities.

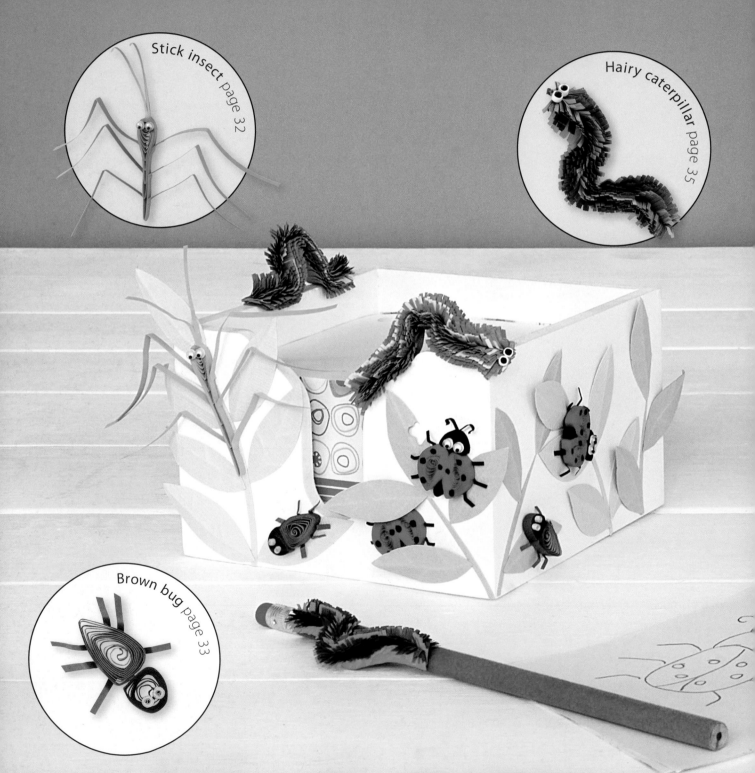

Stick insect page 32

Hairy caterpillar page 35

Brown bug page 33

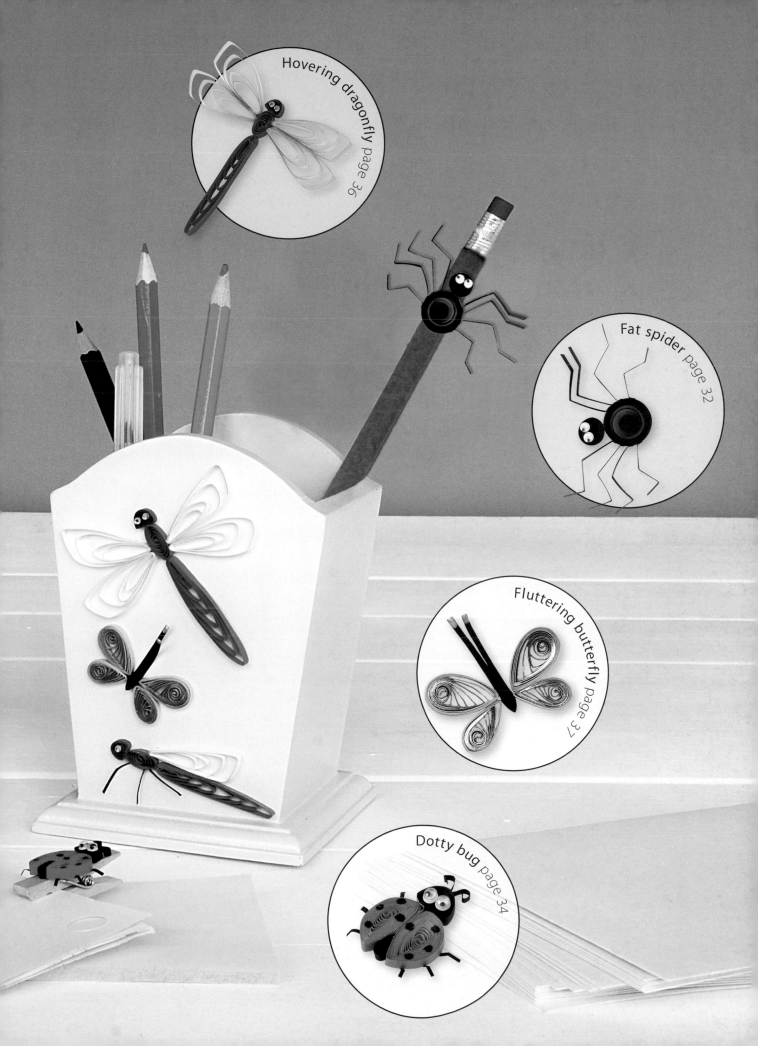

Hovering dragonfly page 36

Fat spider page 32

Fluttering butterfly page 37

Dotty bug page 34

Fat spider and stick insect

These insects may be contrasting in their proportions, but their bodies are made in the same way, from loose closed coils – very loose in the case of the stick insect and then squeezed and glued to hold. Both have long, thin legs, and these are easily created by making appropriate folds in paper strips and curling with your fingernail into just the right shape.

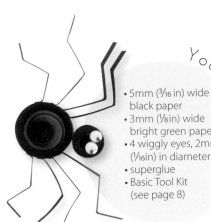

You will need

- 5mm (3/16 in) wide black paper
- 3mm (1/8 in) wide bright green paper
- 4 wiggly eyes, 2mm (1/16 in) in diameter
- superglue
- Basic Tool Kit (see page 8)

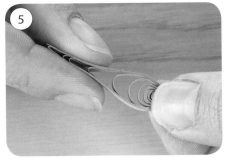

To make the spider, for the body, glue two 40cm (15¾in) lengths of the black paper end to end and make a loose closed coil. For the head, make a smaller loose closed coil with a 40cm (15¾in) length of the same paper and then glue to the body.

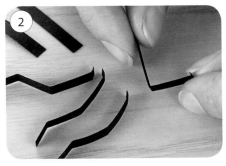

For the legs, cut six 4cm (1½in) and two 3cm (1⅛in) lengths of the black paper. Make a fold 3mm (1/8in) from one end and then two more folds in each length, alternating the direction of the folds.

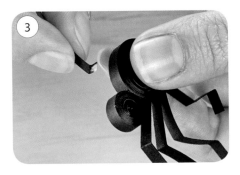

Place a small dot of glue on the 3mm (1/8in) folded piece and glue to the body. Glue four legs on each side, with the slightly smaller ones at the back.

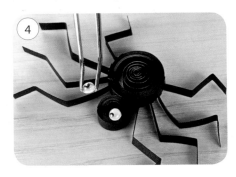

Pick up a wiggly eye with tweezers and apply superglue to the underside, then position on one side of the head. Add the other eye in the same way.

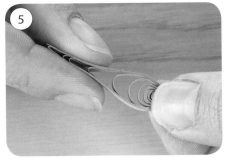

For the stick insect, make a very loose closed coil with a 40cm (15¾in) length of the bright green paper. With your fingertips, pull the centre of the coil to one side and pinch the opposing side. When you let go, this will make a teardrop shape, so when you glue it to your chosen surface, you will need to squeeze it into a thin shape, apply glue all the way along and hold in place for a few seconds while the glue dries.

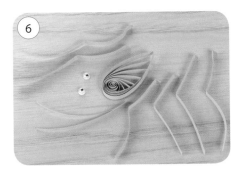

For the legs, cut four 6cm (2½in) and two 5cm (2in) lengths of the green paper. Make a fold 2mm (1/16in) from one end and another fold halfway along. Glue to the body using the 2mm (1/16in) fold. For antennae, cut a 4.5cm (1¾in) length of the paper in half lengthways and glue to the body. Attach two wiggly eyes, as in Step 4.

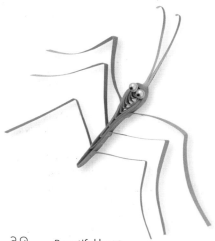

Brown bug

Even bugs become cute when quilled!
The body of this tiny brown beast
is created by coiling two shades of
paper together at once to produce a
loose coil with an interesting two-tone
effect. The same technique can be
applied to flowers.

You will need

- 3mm (⅛in)
 wide paper – pale
 brown, dark brown,
 mid brown, pale
 cream
- Basic Tool Kit
 (see page 8)

For the body, glue a 20cm (8in) length
of the pale brown paper to a 20cm (8in)
length of the dark brown at one end.

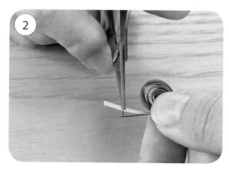

Start coiling both pieces together, making
sure that the dark brown paper is on the
outside. Continue coiling until the other
ends are reached. The paler brown paper
will now be longer than the dark brown,
so trim the excess and then make a loose
closed coil by gluing the ends in place.

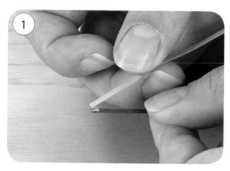

Pinch the body coil at one end and flatten
the other end to make a flat teardrop
shape. For the head, make a loose closed
coil with a 15cm (6in) length of the mid
brown paper and then pinch into an
elongated crescent shape (see page 14).
Glue to the body.

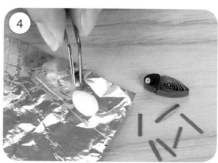

For the eyes, make tight closed coils with
two 2cm (¾in) lengths of the pale cream
paper. Use tweezers to dip into glue, then
position on the head. For the legs, cut two
1.5cm (⅝in) lengths of mid brown paper,
then cut each lengthways into three
very thin strands and follow Steps 5–6 of
Dotty Bug, page 34, to attach and trim.

TIP
These bugs don't
have to be brown – they
could be green, black or
dark red.

INSPIRATIONS

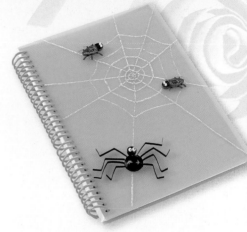

Web wonder
This vibrant orange-coloured notebook is
decorated with a silver glitter glue spider's
web. Two quilled brown bugs are caught
up in the web, while the big fat spider sits
watchfully in the corner!

Insect jar
Encourage children in their curiosity
about the wonderful world of insects with
this jam jar containing a stick insect that
looks as though it's equally curious in
return, topped by a piece of red gingham
fabric secured with a
rubber band. For
an extra realistic
touch, cut some
leaves from
pale green
card (template
on page 117),
score and
fold down the
centre, then
attach either
side of a green
card stem.

Bugged tag
Give someone an enjoyably
scary surprise with this insect-
infested tag. A trio of
quilled bugs are simply
mounted onto a wooden
tag with a decorative
faux stitched edging
and tied with
paper string.

Dotty bug

A quickly assembled combination of pinched loose coils creates this charming little ladybird (ladybug) to cheer up any card, tag or stationery item. The insect's characteristic dots are speedily added too, just by drawing them on with felt-tip pen.

You will need

- 3mm (⅛in) wide paper – red, black
- 2 wiggly eyes, 2mm (1/16in) in diameter
- superglue
- black felt-tip pen
- Basic Tool Kit (see page 8)

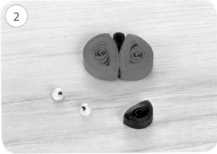

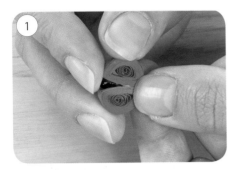

For the body, make two slightly loose tight coils with 60cm (23¾in) lengths of the red paper. Pinch into crescent shapes (see page 14). Make a loose closed coil with a 5cm (2in) length of the black paper and pinch into a teardrop shape (see page 14). Glue all three shapes together as shown, holding in place while the glue dries.

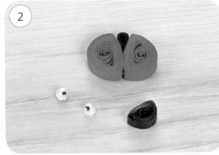

For the head, make a loose closed coil with a 20cm (8in) length of the black paper and pinch into a crescent shape. Glue to the body and attach two small wiggly eyes with superglue.

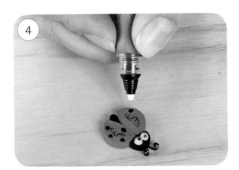

For the antennae, cut a 1.5cm (1/16in) length of the black paper in half lengthways. Fold one piece in half, then coil both ends outwards to the fold. Glue to the head.

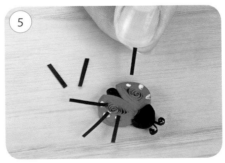

Draw spots on the red paper with the black pen. The ink is likely to spread or 'bleed', so either test on a spare shape or proceed slowly. Add as many spots as you wish, but make sure that the wings are symmetrical.

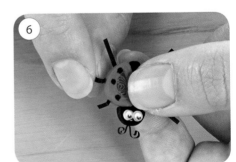

For the legs, cut three 1cm (⅜in) lengths of the black paper, then cut each length lengthways into three. Glue to the underside of the ladybird, three legs on each side.

TIP
You don't have to add the legs, as it could be a resting ladybird.

Turn the ladybird over and fold the legs upwards. Trim the ends of the legs so that they are in proportion and at an angle.

Hairy caterpillar

The fringing technique is usually associated with making frilly flowers, but here it is inventively applied to create a realistic hairy effect for this creeping caterpillar, using multiple fringed lengths in two different colours glued together and then spread out.

You will need

- 10mm (³⁄₈in) wide paper – green and yellow or brown and orange
- 2mm (¹⁄₁₆in) wide paper – black, white
- 90 degree-angled fringing tool
- Basic Tool Kit (see page 8)

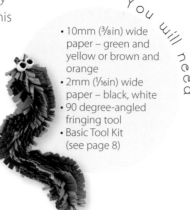

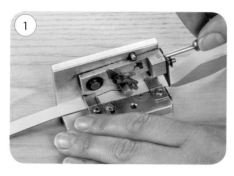

1

Fringe two 45cm (18in) lengths of the 10mm (³⁄₈in) wide papers in two different colours, green and yellow or brown and orange. In some fringing tools, you can fringe two pieces at once to save time.

TIP
All pieces of the caterpillar must be glued thoroughly, otherwise when you bend it, gaps will show in the unglued sections.

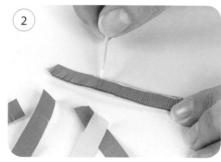

2

Cut the fringed pieces into 7cm (2³⁄₄in) lengths. Glue these together at the uncut margin, alternating the colours as follows: five of green or brown, one of yellow or orange, five of green or brown, one of yellow or orange, five of green or brown. Make sure that they are glued all the way along the margin.

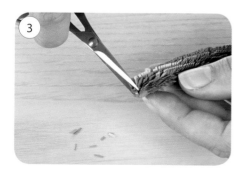

3

Push the fringe out all the way along to make the caterpillar fluffy. Trim a few pieces from one end to make space for the eyes.

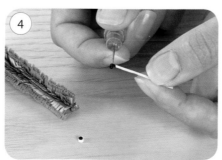

4

For the eyes, glue a 2cm (³⁄₄in) length of the black paper to 3cm (1¹⁄₈in) of the white. Start coiling from the black end and make a tight closed coil. Repeat for the other eye. Glue to the trimmed head.

INSPIRATIONS

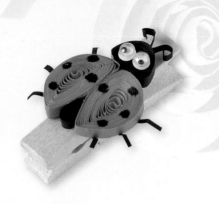

Well pegged
The lovable quilled ladybird has been attached to a mini wooden peg to make an endearing gift for a nature lover. It would be useful for sealing half-used seed packets, so present it with a couple, or clip it onto a notepad.

Creepy crawly pencil
Make a child squirm with delight with this caterpillar-enhanced pencil. Alternatively, he could be seen creeping over a pencil box or the cover of a notebook. This tactile insect would also, being quilled rather than real, make a welcome gift for a grown-up gardener.

Hovering dragonfly

The intricate, airy quality of this glamorous insect's wings and the fineness of its body are achieved by using the husking technique (see page 16), whereby the quilling paper is wrapped around pins inserted into a board.

You will need

- 3mm (⅛in) wide paper – white, blue edged with metallic blue
- tiny yellow gem stones or beads
- cork or foam board and pins
- masking tape (optional)
- Basic Tool Kit (see page 8)

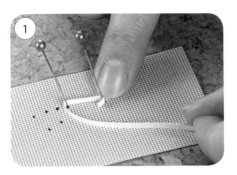

For the wing, photocopy or trace the template on page 117. Place on a cork or foam board. Hold in position with masking tape or pins at the corners. Insert a pin at points 1 and 2. Fold over 3mm (⅛in) at one end of a length of the white paper. Loop around pin 1 and take the other end to pin 2 and wrap around. Add a dot of glue at this end and secure the paper to it.

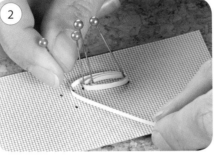

Insert a pin at point 3. Take the end of the paper around this pin and back to pin 1. Add a dot of glue at the base. Insert a pin at points 4 and 5.

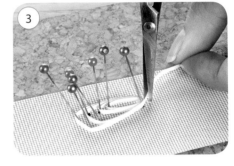

Take the paper around pins 4 and 5, then glue at the base. Insert a pin at points 6 and 7, wrap the paper around and glue at the base. Trim the excess paper. Make three more wings in this way, plus one for the resting dragonfly, if required (see Winged Delight opposite).

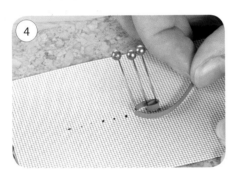

For the body, photocopy or trace the template on page 117 and place on the cork or foam board, as in Step 1. Insert a pin at points 1 and 2. Fold over 3mm (⅛in) at one end of a length of the metallic-edged blue paper. Loop around pin 1, take the other end to pin 2 and wrap around, then glue at the base. Insert a pin at point 3 and wrap around.

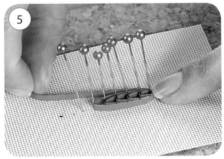

Insert the remaining pins, following the template for positioning, and wrap the paper around, as for the wings.

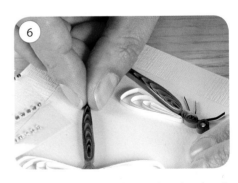

For the head, make a loose closed coil with a 10cm (4in) length of the metallic-edged blue paper and pinch into a crescent shape (see page 14). For the upper body, make a loose closed coil from a 15cm (6in) length of the blue paper and gently pinch in the centre. Glue the head and body parts to your chosen surface, then glue on the wings either side. Add gem stones for eyes or use beads.

Fluttering butterfly

Everyone's favourite insect, both the body and wing parts of this beautiful butterfly are simply formed from loose closed coils pinched into shape, the latter using metallic-edged paper for a shimmering effect. Silver 3-D paint adds dimension and sheen to the antennae.

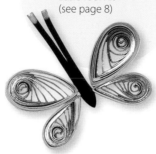

For the body, make a loose closed coil with an 8cm (3in) length of the black paper and pinch at two opposing points. Cut a 2cm (¾in) length of the black paper in half lengthways for 1.5cm (⅝in). Glue the uncut part to the body.

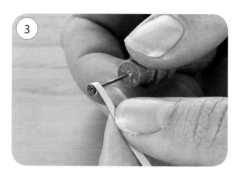

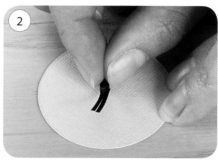

Glue the body and antennae to your chosen surface.

For the wings, make two loose closed coils from 15cm (6in) lengths of the metallic-edged purple paper glued to 20cm (8in) lengths of plain purple and another two with 15cm (6in) lengths of metallic-edged purple paper glued to 10cm (4in) lengths of plain purple. Pinch each into a teardrop shape (see page 14) and glue to either side of the body, with the smaller shapes at the bottom.

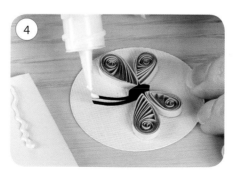

Add dots of silver 3-D paint to the ends of the antennae and leave to dry; squirt some of the paint out onto scrap paper first to get it flowing and to gauge how hard to press the tube.

TIP
While 3-D paint adds desirable dimension here, it takes a relatively long time to dry, so use silver pen if you have to fly!

INSPIRATIONS

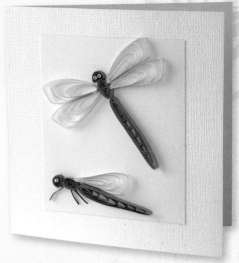

Winged delight
A gossamer-winged blue dragonfly appears to hover over a green specimen resting below – for this variation, just make one wing, and attach three legs, as for the ladybird (see page 35, Steps 5–6). This card is sure to enchant any nature lover or budding entomologist.

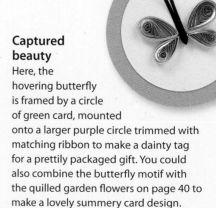

Captured beauty
Here, the hovering butterfly is framed by a circle of green card, mounted onto a larger purple circle trimmed with matching ribbon to make a dainty tag for a prettily packaged gift. You could also combine the butterfly motif with the quilled garden flowers on page 40 to make a lovely summery card design.

Flower power

Flowers and foliage have a universal appeal and make suitable subjects for so many occasions. What's more, flowers and quilling go hand in hand, since the delicate quality of quilled paper naturally forms floral shapes. The colours and varieties of real flowers can offer endless inspiration for quilled designs.

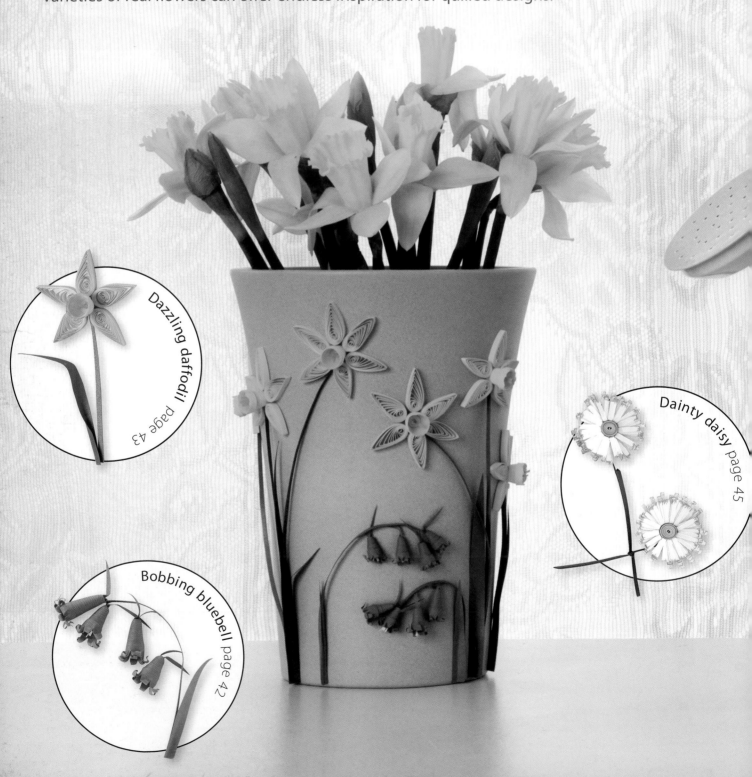

Dazzling daffodil page 43

Dainty daisy page 45

Bobbing bluebell page 42

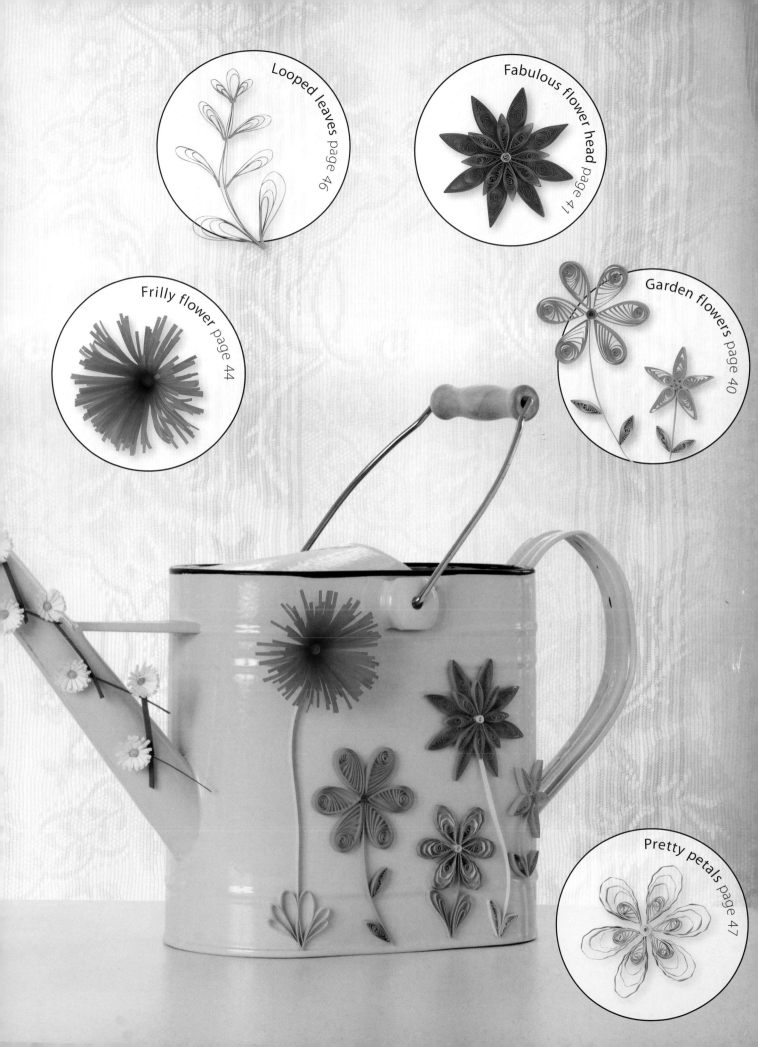

Looped leaves page 46

Fabulous flower head page 41

Frilly flower page 44

Garden flowers page 40

Pretty petals page 47

Garden flowers

These flowers are an ideal introduction to the coiling and pinching techniques of quilling, but they also involve an extra refinement, where the inner parts of the coil are manipulated before being pinched. In this way, you can ensure that each petal is prettily formed.

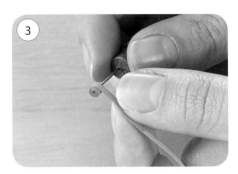

You will need

- 3mm (1/8in) wide paper – orange, pink or red, green
- quilling board (optional)
- Basic Tool Kit (see page 8)

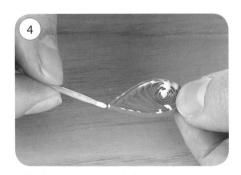

Make loose closed coils with 40cm (15¾in) lengths of the orange paper. Here, a quilling board (see page 10) has been used to ensure that the coils are the same size, using the 2cm (¾in) diameter template.

Before pinching the coils into regular teardrop shapes to create petals (see page 14), pull the centre of each coil to one side and flex the coil to make the spaces between the inner parts even, then pinch so that the join is at the pointed end.

Glue a 10cm (4in) length of the pink or red paper to an equal length of the green paper end to end. Make a tight coil, starting at the pink or red and stopping at the green. Glue in position on the card or other surface you are decorating to form a flower centre and an adjoining stem.

Apply glue all over the underside of one petal and at the point, but take care not to smother it with glue.

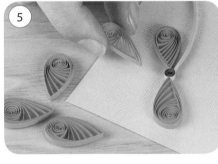

Adhere the petal to one side of the flower centre, with the pointed end butting up to the coil. Glue another petal opposite the first one, if making a six-petalled flower. Then glue on another two petals at a time opposite each other.

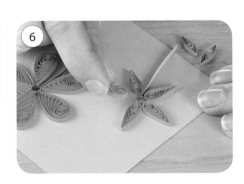

The smaller flower is made with five 20cm (8in) lengths of orange paper for petals but with the same size flower centre as in Step 3. The coils are then pinched with the join at the rounded end and glued pointed-end outwards around the flower centre. Pinch two loose closed coils made with 20cm (8in) lengths of green paper for each flower into leaf shapes and glue either side of the stems.

TIP

If you don't have a quilling board, draw a circle on a piece of card and use as a guide to size.

Fabulous flower head

Although quilling is in its nature three-dimensional, there is no reason not to create additional depth by making two layers of coiled shapes. For this showy-looking flower head, an upper layer of smaller petal shapes has been glued on top of the base layer of larger petals, allowing the light to pass through.

You will need

- 2mm (¹⁄₁₆in) wide paper in two shades of deep pink
- 5mm (³⁄₁₆in) wide yellow paper
- quilling board
- Basic Tool Kit (see page 8)

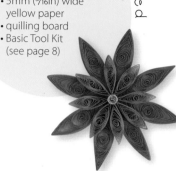

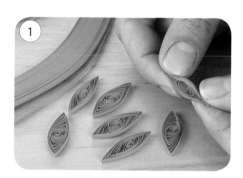

1

Make loose closed coils from eight 40cm (15¾in) lengths of one shade of pink paper. Pinch each coil to make eye shapes (see page 14). Use the 2cm (¾in) diameter template of a quilling board to ensure that all the coils are the same size.

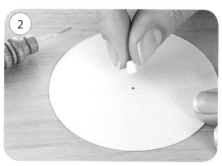

2

Make a loose closed coil from a 5cm (2in) length of the yellow paper for the flower centre. Make a mark with a pencil on your chosen surface where you want to position the flower centre and glue the coil over this.

TIP

You can use 3mm (¹⁄₈in) wide papers for both layers for an alternative, chunkier result.

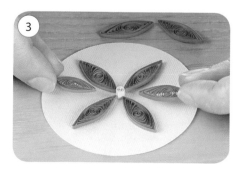

3

Arrange the petals around the flower centre first, to make sure that they fit and are positioned evenly, then glue in place.

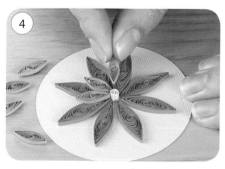

4

Make smaller loose closed coils from 20cm (8in) lengths of the other shade of pink paper, using the 1.3cm (½in) diameter template of the quilling board to ensure that they are all the same size. Pinch as in Step 1. Glue to the top of the first set of petals to create a second layer.

INSPIRATIONS

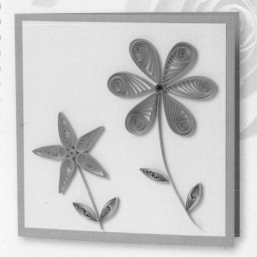

Sun flowers

These simple yet striking orange quilled flowers, glued onto pale orange card and then mounted onto a deeper orange single-fold card, are guaranteed to bring warmth and cheer to their recipient. The smaller flower could be used to create a coordinating gift tag.

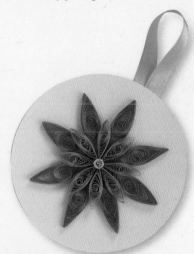

In full bloom

This luxurious double-layered bloom, glued to a circle of pale pink card, makes a great tag for a Mother's Day gift. The satin ribbon loop is attached by backing the tag with a second circle of card and sandwiching it in between. The design could be adapted to make an intriguing brooch or colourful fridge magnet, or used to decorate a gift box.

Bobbing bluebell

The technique of coiling paper into a cone shape used for the carrots and trowel and fork set on pages 24 and 26 is adapted here to form a bell shape and to realistically re-create this delightfully delicate wild flower in paper. The end of a 10mm (³/₈in) wide strip is snipped into points and then the remainder trimmed lengthways before coiling to create the decorative lip of the bluebell.

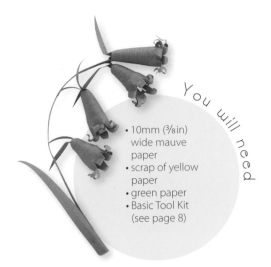

You will need

- 10mm (³/₈in) wide mauve paper
- scrap of yellow paper
- green paper
- Basic Tool Kit (see page 8)

Cut eight points in one end of a 30cm (12in) length of the mauve paper.

TIP

You can vary the size of the overlaps to create bluebells of slightly differing sizes for a naturalistic look.

Trim the remaining length of the paper strip to leave it 3mm (¹/₈in) wide.

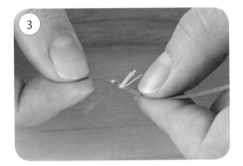

Glue about four narrow strands of yellow paper to the other end of the mauve strip from the points but on the same side as the points. Cut a stem and leaf from the mauve paper, then glue opposite the yellow strands.

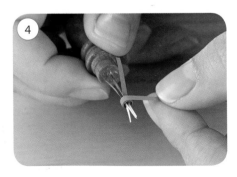

Starting from the yellow strands end, make a tight coil, allowing the stem and leaf to hang downwards, keeping the coil flat to begin with but for more turns than for the carrots (see step 2, page 24) to create a wider base.

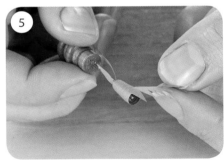

Continue coiling to the points, but angle the paper away from the tool, making sure that the paper overlaps. Glue the end of the paper in place.

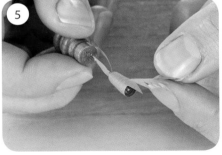

Using the quilling tool, coil each of the eight points outwards without gluing. Apply glue to the inside of the bell shape with a cocktail stick (toothpick), then leave to dry. Glue the flower stem to a 3mm (¹/₈in) wide length of green paper and allow the flower leaf to hang free. Cut a tapered leaf from green paper. Trim the green stem to the length you require and attach the leaf before gluing in place on the card or other surface.

Dazzling daffodil

The trumpet of this gloriously bold flower, which traditionally heralds the coming of spring, is again formed by using the coiled cone technique but in a chunkier guise. The wider base provides the foundation for building the cone upwards and outwards, with the decorative edge, snipped with fancy-edged scissors, supplying the finishing touch.

You will need

- 10mm (³⁄₈in) wide paper – yellow, orange, green
- 3mm (¹⁄₈in) wide yellow paper
- green paper
- fancy-edged scissors
- Basic Tool Kit (see page 8)

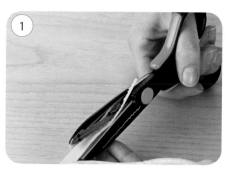

1

Cut along the edge of a strip of the 10mm (³⁄₈in) wide yellow paper using fancy-edged scissors.

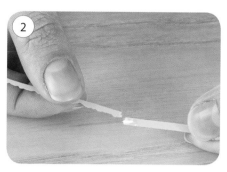

2

Glue a 20cm (8in) length of the same yellow paper to a 40cm (15¾in) length end to end, then glue a 10cm (4in) length of the fancy-edged strip to the end of this. For stamens, cut four strips of the orange paper about 1mm x 1.5cm (¹⁄₁₆ x ⁵⁄₈in) and glue to the plain end.

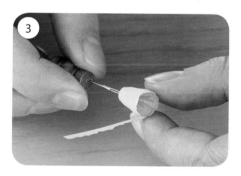

3

Starting at the plain end, make a tight coil for a length of about 20cm (8in), then angle the paper away from the tool, making sure that it overlaps, to form a cone shape. This becomes quite a challenge towards the end, so coil slowly and carefully. Glue the end in place.

TIP
Make a narcissus instead by gluing white petals around a yellow trumpet.

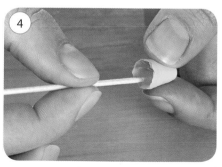

4

Move the orange stamens to one side and use a cocktail stick (toothpick) to apply glue inside the trumpet around the side. Leave to dry. For the petals, make five loose closed coils from 30cm (12in) lengths of the 3mm (¹⁄₈in) wide yellow paper pinched into teardrop shapes (see page 14), then pull the points of the inner parts in line with the pinched point when glued to the card or other surface. For the stem, glue two lengths of the 10mm (³⁄₈in) wide green paper together lengthways, and then cut a long narrow leaf with one pointed end from green paper.

INSPIRATIONS

Planter's plaque
A spray of four bluebells is mounted onto a square of cream card layered onto a slightly larger square of mauve card and in turn attached to the top of a blue wooden plant label to make a lovely gift for a flower lover – especially in conjunction with a potted indoor plant or a pretty plant plot and bulbs for planting. You could add an appropriate message to the cream card.

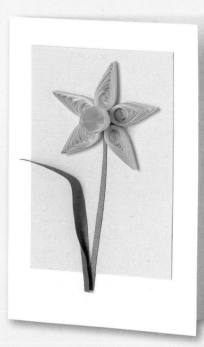

Springtime special
In this elegant design, a single quilled daffodil makes a strong impact in its very simplicity, set against a pale green background and mounted onto a paler green, slightly textured single-fold card. Besides being ideal for celebrating Easter, it would bring an ailing friend or relative great comfort as a get well card.

Frilly flower

Create a big impact with this flamboyant flower, which is deceptively quick and easy to make using fringed paper. And the moment when you push the fringe out to reveal the flower is guaranteed to deliver just as much wow factor to you as to the recipient. In this case, the fringing is cut by hand, but pre-fringed papers are available for an even speedier result.

You will need

• red parchment (translucent) paper
• 3mm (1/8in) wide pink paper
• bulldog clip, 6cm (2³⁄₈in) wide
• Basic Tool Kit (see page 8)

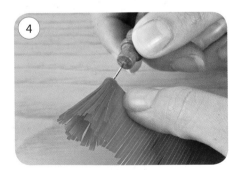

Cut a strip of the red paper 3 x 20cm (1⅛ x 8in). Fold the length into three and secure with the bulldog clip along one long edge.

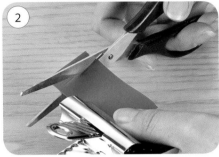

Using a pair of scissors, make cuts all along the paper 1.5mm (1/16in) apart, finishing 3mm (1/8in) from the secured edge to leave a narrow uncut margin.

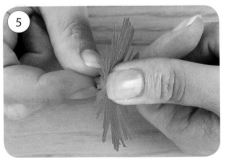

Remove the bulldog clip and unfold the fringed strip. Using scissors, make cuts where the folds were as in Step 2 so that the entire strip is evenly fringed.

TIP
The width of the paper used for fringing can be varied to achieve larger (up to 15cm/6in in diameter) or smaller flowers, as desired, and any papers – not just purpose-designed quilling papers – can be used.

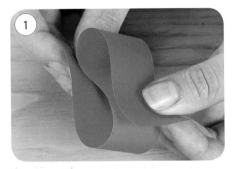

Cut a 15cm (6in) length of the pink paper. Glue to the uncut margin at one end of the red fringed strip. Insert the end of the pink paper into your quilling tool and coil tightly until you reach the end of the red fringed strip, to form the flower centre. Glue the end in place.

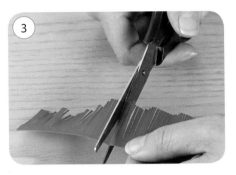

Use your fingers to spread the fringe out to form the flower, then use your little finger to push the pink centre up slightly.

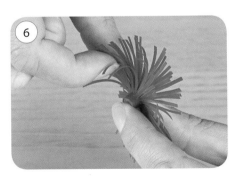

Gently drag your fingernail along the underside of each fringed 'petal' so that the paper curls under slightly.

Dainty daisy

These delightfully delicate daisies are made using a specially designed fringing tool (see page 9). This wonderful invention allows you to fringe lengths of paper quickly and easily, thus avoiding hand- and eye-strain, and produces perfect, evenly spaced cuts, ensuring that each flower is identical every time.

You will need

- 10mm (³⁄₈in) wide white paper
- 3mm (¹⁄₈in) wide papers – yellow, dark green
- 90 degree-angled fringing tool
- pink felt-tip pen
- Basic Tool Kit (see page 8)

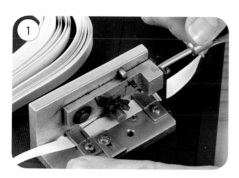

1 Insert a 45cm (17¾in) length of the white paper into the fringing tool. Fringe the paper by moving the handle up and down. Continue until the whole length of the paper is fringed.

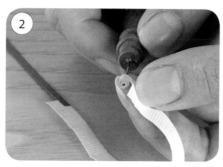

2 Remove the paper from the tool and check that there are no uncut areas. Cut a piece 12cm (4¾in) long. Glue a 12cm (4¾in) length of the yellow paper to the uncut margin at one end of the fringed strip and a 5cm (2in) length of the green paper to the other end in the same way. Insert the yellow paper into your quilling tool and coil tightly until you reach the green paper. Glue in place.

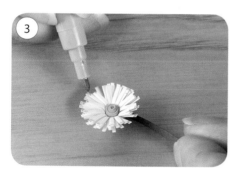

3 Use your fingers to spread out the fringe to form a flower shape. Gently brush the fringed ends of the flower with a pink felt-tip pen. Do this before the flowers are glued to your chosen surface, and make sure that you wash any pen off your hands.

TIP

To make the stems of the daisies stronger, glue two lengths of dark green 3mm (¹⁄₈in) wide paper together lengthways.

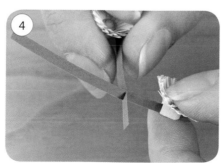

4 To link the daisies together to make a daisy chain, using a craft knife or scissors, cut a 1.5mm (¹⁄₁₆in) slit in the stem of one daisy partway down from the flower. Make a slit in the stem of another daisy in the same way. Insert the second stem through the slot in the first stem.

INSPIRATIONS

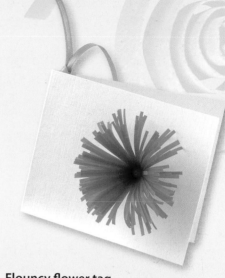

Flouncy flower tag

A single red frilly flower mounted onto a simple white tag makes a bold yet refined statement – perfect for a special birthday gift. A hole punched in the back panel is threaded with sheer pink ribbon to finish. The design could be adapted to make place cards for an anniversary dinner, or a similar bloom could be added to a hat shape (see pages 76–77) for a sophisticated card.

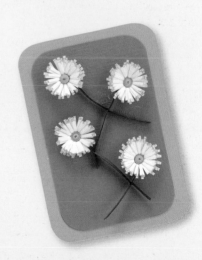

Daisy chain charmer

Here, four daisies with stems are made and linked together, as in the steps on the left, to create an attractive lattice-type arrangement. They are glued to pink card and mounted onto a paler pink folded card, the corners of both rounded to match. This card was designed as an artist trading card, which needs to measure 9 x 6.5cm (3½ x 2½in).

Looped leaves

Instead of making leaves from loose closed coils pinched into eye shapes, you can create more sinuously shaped leaves from looping paper strips by hand for an ornamental effect. The following instructions give you two alternative leaf designs, which can be used on their own (see Evergreen tag opposite) or in conjunction with any of the quilled flowers in this chapter.

You will need

• 3mm (⅛in) wide green paper
• Basic Tool Kit (see page 8)

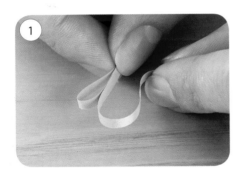

1 Form a loop in a 40cm (15¾in) length of the green paper about 3cm (1⅛in) high. Glue the end of the paper strip in place at the base of the loop.

2 Loop the free end of the paper strip over the first loop, making a slightly larger loop. Glue the loop in place at the base.

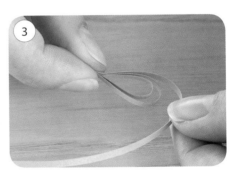

3 Repeat Step 2 to make a slightly larger loop than before and glue at the base. Either leave at three loops and trim the end of the paper or continue to create more loops.

1 To make a side-looped leaf, again form a loop in a 40cm (15¾in) length of the green paper about 3cm (1⅛in) high and glue the end in place at the base. Make another, slightly larger loop to the side of the first loop and glue at the base.

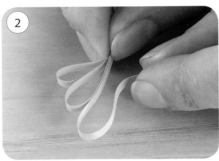

2 Make a third loop to the side of the second loop, again slightly larger, and glue at the base. You can trim the end of the paper at this point and leave the leaf as is, without an outer wrapping, or continue on to the next step if you wish.

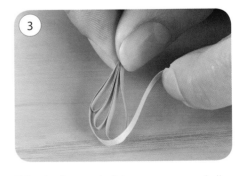

3 Take the free end of the paper around all three loops to encircle them, pulling the end of the paper quite tightly to hold the loops in place. Glue at the base and trim the excess paper.

TIP
These looped leaves could be used to create seaweed to accompany the beach items on pages 82–89.

Pretty petals

These highly attractive petals combine the standard coiling and pinching technique with hand looping, as featured in the leaves opposite, but in this case using ribbled or crimped paper (see page 10) in a graduated colour for an additional, easily achieved decorative effect.

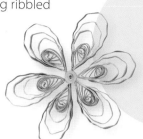

You will need

- 3mm (⅛in) wide paper – graduated pink with dark centre, mauve
- ribbler (crimper)
- Basic Tool Kit (see page 8)

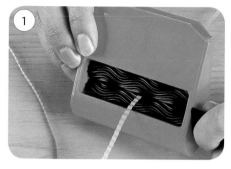

1

Insert a 30cm (12in) length of the graduated paper into the ribbler (crimper) and turn the handle so that the paper is pulled through and ribbled or crimped.

TIP

If you don't have any suitable graduated paper, select a darker shade of mauve than that used for the teardrop coil for an alternative effective result.

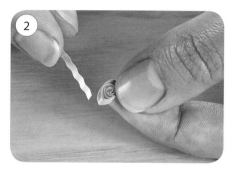

2

Make a loose closed coil with a 10cm (4in) length of the mauve paper, then pinch at one point to create a teardrop shape (see page 14). Cut the length of ribbled paper in half, then glue the pale end to the base of the teardrop.

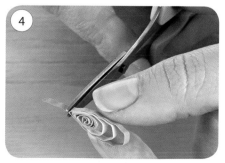

4

Loop the ribbled paper around the teardrop twice more, making each loop slightly larger and gluing to secure each loop. Trim the end of the paper.

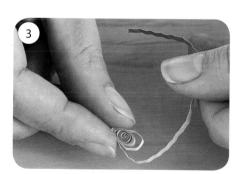

3

Loop the ribbled paper around the teardrop and glue the end to the other side of the base of the teardrop.

INSPIRATIONS

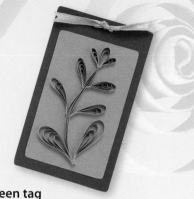

Evergreen tag
Underline the eco-friendly credentials of your gifts with this all-green foliage design, mounted onto complementary coloured purple paper and a darker purple rectangular card tag. The same design could be used to make invitations for an environmental fund-raising event or function with recycled paper and card.

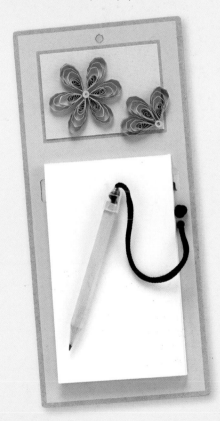

Natural notepad
The looped and ribbled petals have been used here to create one whole flower and part of a flower for a corner motif as a decoration for this fridge notepad. The colour scheme can be adapted to coordinate with the recipient's kitchen décor. Alternatively, use the flowers to decorate greetings cards and gift tags.

Wonderful weddings

Quilling really comes into its own to mark such a big occasion, and a special hand-quilled wedding card and gift tag are sure to stand out and be noticed. You could also make the happy couple a unique framed design for a keepsake. And if you are feeling adventurous, why not create bespoke stationery for the day using the decorative motifs on offer here.

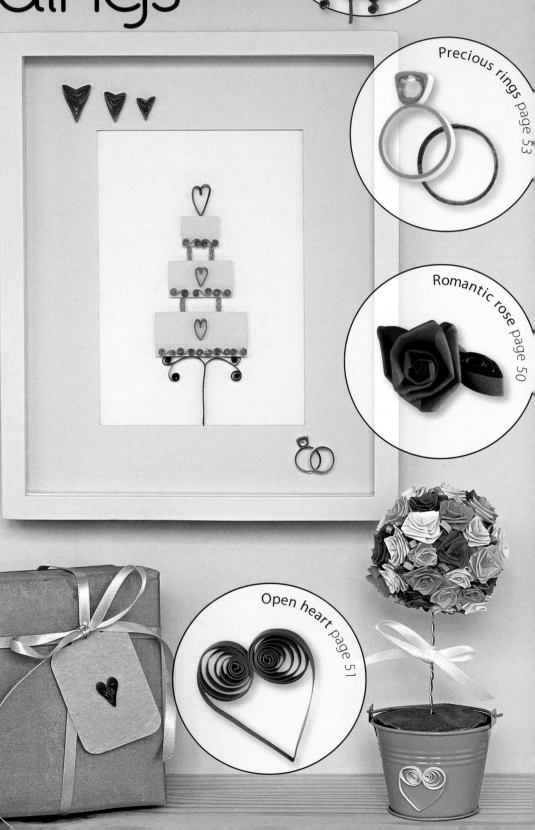

Wedding cake page 52

Precious rings page 53

Romantic rose page 50

Open heart page 51

Happy hearts

You can make quilled heart shapes in two ways, as demonstrated below, the first being the quickest and easiest method using a single loose closed coil and the second using two loose closed coils.

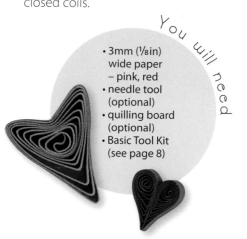

You will need

- 3mm (⅛in) wide paper – pink, red
- needle tool (optional)
- quilling board (optional)
- Basic Tool Kit (see page 8)

Make a loose closed coil from a 40cm (15¾in) length of the pink paper. Hold the coil in one hand and pinch at one point while simultaneously pushing inwards with a fingernail at the opposing point (see page 15). If you don't have good fingernails, use the tip of a needle tool. A quilling board can be used to ensure that the hearts are uniform in size, especially if you are making a batch.

Make two loose closed coils from 20cm (8in) lengths of the red paper. A quilling board can be used to ensure that the coils are all the same size, but this is optional – a heart with one side bigger than the other can look just as appealing.

Remove the coils from the quilling board, if using, and pinch into teardrops (see page 14). At this stage, note which side the inner parts of the coil spring to, then try to place the teardrops together so that the inner parts are facing inwards.

Glue the two teardrop shapes together by placing a small amount of glue along the two inner edges. Then apply glue on the underside of the heart and position on the card or other surface, holding and pinching in place while the glue dries.

TIP
Smaller hearts can be made in this way with shorter lengths of paper, but don't go too small, otherwise they will look less like hearts.

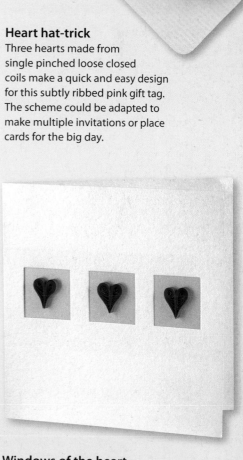

Heart hat-trick
Three hearts made from single pinched loose closed coils make a quick and easy design for this subtly ribbed pink gift tag. The scheme could be adapted to make multiple invitations or place cards for the big day.

Windows of the heart
For a simple yet elegant wedding card design, a row of three square apertures is cut in the front of a white single-fold card, then gold card glued to the inside of the card back, to which double-teardrop red hearts are mounted.

Romantic rose

This exquisite rose is possibly the hardest shape to make in quilling, as it requires a high degree of dexterity in folding the paper as well as concentration. But do persevere if you don't succeed after a couple of attempts, since the results – as you can see – are well worth the extra effort. It is best to use a long length of paper and then trim the end when the rose is the size you want; you can make tight rosebuds or full-sized blooms.

You will need

- 10mm (³⁄₈in) wide red paper
- 3mm (¹⁄₈in) wide green paper
- Basic Tool Kit (see page 8)

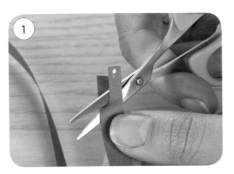

Take a 45cm (18in) length of the red paper and trim one end so that it is 2cm (³⁄₄in) long by 5mm (³⁄₁₆in) deep.

TIP

For larger rose blooms, you may find it easier, after several turns, to remove the tool and continue folding just using your fingers.

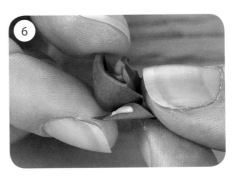

Insert the narrower end into the quilling tool and turn until the wider 10mm (³⁄₈in) width is reached.

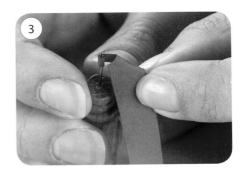

Fold the paper away from you, that is towards the tool, so that the paper is now at right angles to the tool.

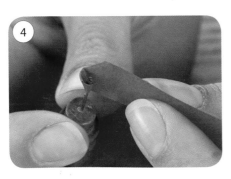

Turn the quilling tool, lifting up the paper strip as you turn, so that it becomes horizontal again.

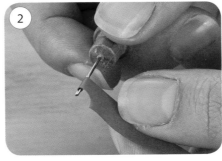

Make another fold, again at right angles in towards the tool, so that the paper hangs down, close to the previous fold. As you continue to fold and turn, space the folds out to make the gap between the previous fold and the next fold very slightly larger each time.

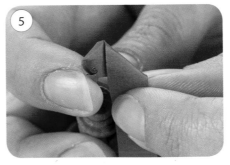

Once the rose is the size you want, trim the excess paper, fold the end inwards and glue in place. Before gluing, you can release the rose slightly to make it fuller. Turn the rose over and apply a generous amount of glue to the base. For the leaves, make teardrop shapes (see page 14) using different lengths of the green paper for a variation in size.

Open heart

This delicate heart uses the open coil technique to great effect, with the two coils made at either end of a centrally folded paper strip facing one another. Although it is quick to make, to ensure the best results, take time to adjust the coils before gluing so that they match.

You will need

• 3mm (⅛in) wide red paper
• Basic Tool Kit (see page 8)

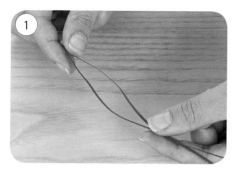

Fold a 40cm (15¾in) length of the red paper exactly in half.

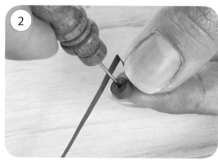

Using the quilling tool, coil one end into the centre fold. Remove the tool and don't glue the coil at this stage.

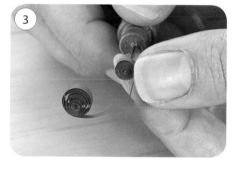

Now use the tool to coil down to the centre fold from the other end and remove the tool. The coils may not be exactly the same size, but don't worry at this stage.

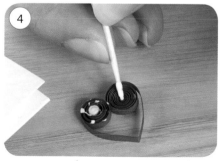

Place a dot of glue on the centre of each coil and very small dots around the edge of the coil and at the folded point. Position on your card or other surface, and before the glue dries, adjust the coils so that they are the same size.

TIP
Simply vary the length of the paper used to create open hearts of different sizes.

INSPIRATIONS

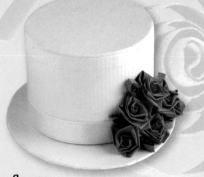

Favour flowers
This high-class favour box fashioned in the shape of a top hat is trimmed with a ribbon band and a posy of sumptuous quilled red roses interspersed with leaves.

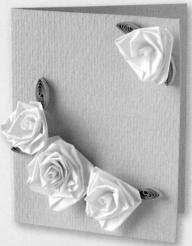

Gorgeous in green
Roses need not be traditional pink and red, as these luscious green examples demonstrate. Use them to adorn a tag for a special wedding gift, as here, or for a place card; the colour can be changed to match any chosen scheme, such as apricot or yellow.

Positioned with perfection
A simple, single open heart makes a highly effective place card for the wedding breakfast, and is easy enough to make in quantity. Alternatively, use to decorate invitations or menu cards, or mount onto pink card for a tag.

Wedding cake

A three-tier wedding cake is a classic motif to mark the big occasion, and with quilling you can decorate it as elaborately as the real thing. Here, dusty pink paper edged with copper is used to catch the light and add sparkle and distinction to the design. The tiers are simply cut from card and mounted with adhesive foam pads to raise them to the same height as the quilled decorations.

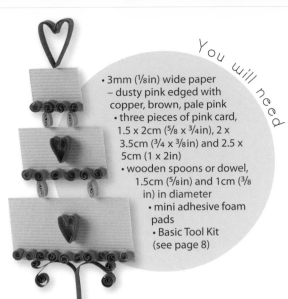

You will need

- 3mm (⅛in) wide paper – dusty pink edged with copper, brown, pale pink
- three pieces of pink card, 1.5 x 2cm (⅝ x ¾in), 2 x 3.5cm (¾ x ⅜in) and 2.5 x 5cm (1 x 2in)
- wooden spoons or dowel, 1.5cm (⅝in) and 1cm (⅜in) in diameter
- mini adhesive foam pads
- Basic Tool Kit (see page 8)

1 For the top heart, wrap a 20cm (8in) length of the copper-edged pink paper around the larger wooden spoon handle or dowel, glue the end in place and remove (see Steps 1–2 opposite). Pinch at one point while pushing the opposing point inwards with your fingernail. Make two smaller hearts from 10cm (4in) lengths wrapped around the smaller wooden spoon handle or dowel.

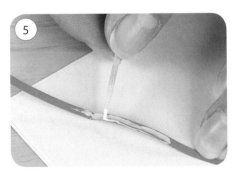

2 Place a small dot of glue in the top centre crease of each heart and a little on the underside of the crease (not the copper-edged side). Using tweezers, pinch the inner point and hold for a few seconds while the glue dries.

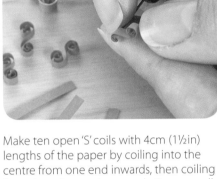

3 Make ten open 'S' coils with 4cm (1½in) lengths of the paper by coiling into the centre from one end inwards, then coiling from the other end outwards. Some scrolls are made with the copper edge in the tool up and some copper-edge down.

4 Using adhesive foam pads, mount the three pieces of pink card onto your chosen surface, ascending in size. Glue the scrolls along the bottom edges of each of the card pieces, inserting the quilling tool back into the centre of each scroll to help position it and recoil if necessary. Glue the large heart above the top tier and the two smaller hearts to the centre and bottom tiers.

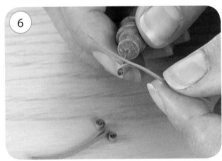

5 For the cake stand, fold a 10cm (4in) length of the brown paper in half, then open out and place on scrap paper. Apply glue for 3cm (1⅛in) to one side of the fold. Fold the paper over and press down so that the paper is glued double for 3cm (1⅛in) and the ends are free.

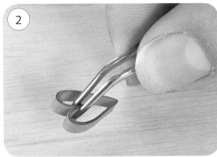

6 Using the quilling tool, coil each end outwards down to the glued section. Repeat to make a second coiled length, then glue together at the base. The tier posts are four 7cm (2¾in) lengths of pale pink paper formed into loose closed coils and pinched into rectangles (see page 15).

TIP
The wedding cake can be made entirely from white card and papers for a subtle, stylish effect.

Precious rings

These opulent, realistic-looking rings are quickly made by wrapping gold-edged paper around a wooden spoon handle or dowel, with a loose closed coil simply pinched into a square providing the decorative setting for a glued-on gem stone.

You will need

- 3mm (⅛in) wide gold-edged ivory paper
- clear gem stone
- wooden dowel or spoon
- superglue
- Basic Tool Kit (see page 8)

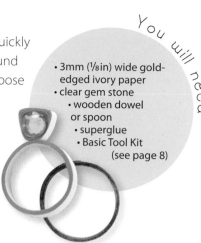

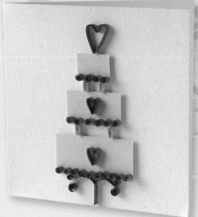

Wrap a 30cm (12in) length of the paper around the handle of a wooden spoon or dowel. Put a dot of glue on the end of the paper, wrap the paper around the handle, not too tightly, and press to the glue so that the rings of paper are exactly in line.

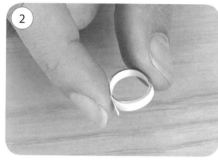

Continue to wind the paper around the handle until the end is reached. Remove and glue the end in place. If you have wrapped too tightly, you may not be able to remove it.

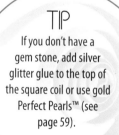

TIP
If you don't have a gem stone, add silver glitter glue to the top of the square coil or use gold Perfect Pearls™ (see page 59).

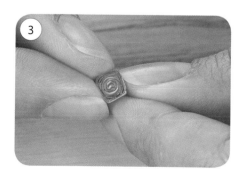

Make a loose closed coil with a 10cm (4in) length of the paper. Pinch into a square shape (see page 14) and glue to the ring at the join.

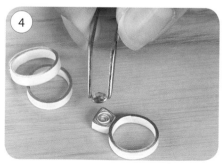

Pick up the gem stone with tweezers and place superglue on the underside, then position on the square coil.

INSPIRATIONS

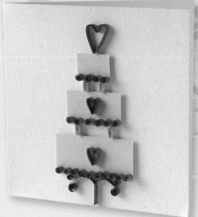

Confection centrepiece
The fabulous quilled wedding cake takes centre stage in this memorable wedding card design, mounted onto a simple white single-fold card. The motif could also be used for a wedding album cover.

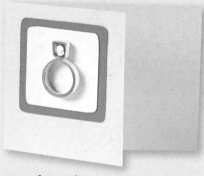

A gem of a card
This sparkling quilled ring set with a gem stone is presented to dramatic effect against a white panel framed with red mounted onto a pink card – a unique handmade design that the happy couple are sure to treasure. It could also be used to celebrate an engagement.

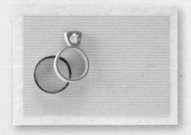

Forever together
Here, two rings, one with a gem stone, are symbolically combined and mounted onto a slightly ribbed pink card for a strong statement in every way. This could be used as a wedding gift tag as well as a place card.

Baby talk

The birth of a baby is such a special event that it demands to be marked in a memorable way, and quilling provides the perfect solution. In addition to the joyful parents' response, the effort involved in making unique christening or new baby cards, or even a captivating mobile, will be doubly rewarded in time when they are preserved as keepsakes.

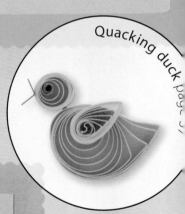

Quacking duck page 57

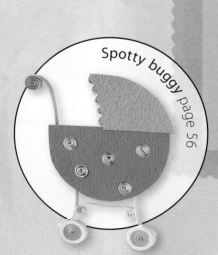

Spotty buggy page 56

Tiny feet

Baby feet are an enduring, endearing symbol of a newborn and are ideal for decorating all kinds of mementos of the happy event. Here, tiny quilled coils represent the toes and a bent teardrop-shaped loose closed coil forms the sole.

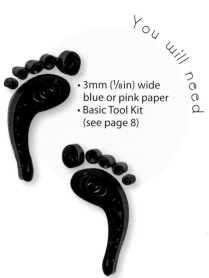

You will need

- 3mm (⅛in) wide blue or pink paper
- Basic Tool Kit (see page 8)

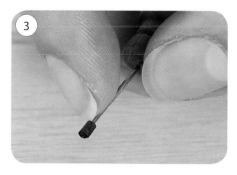

1 Make a loose closed coil from a 30cm (12in) length of the paper. Squeeze into an oval, then pinch halfway along one side and bend the end round. Apply glue to the underside and hold in place on the card or other surface you are decorating for a few seconds while the glue dries so that it holds its shape.

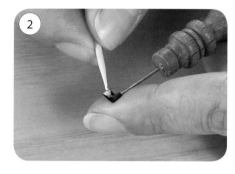

2 For the little toe, make a very tight coil with a 2cm (¾in) length of the paper. While it is still on the quilling tool, add a tiny dot of glue on the end and press to the coil.

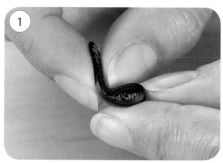

3 Use your fingernail to push the coil up and off the quilling tool.

4 Make the next two toes in the same way with 3cm (1⅛in) lengths of the paper and the next toe with a 4cm (1½in) length. Make the big toe with a 5cm (2in) length, but release it very slightly to make a looser coil. Assemble and glue in place. Repeat for the second foot.

TIP
The toes will fall off if not glued down properly, so rub your finger gently over them to check that they are properly secure.

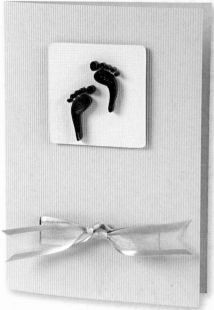

Foot fest
For a cute christening or new baby card design, mount a pair of tiny feet on a pale blue-coloured panel, raised from a folded card with adhesive foam pads for extra impact. For a finishing flourish, cut two slits in the card front, thread with ribbon and tie in a dainty bow.

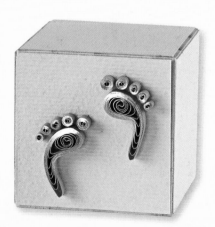

First footsteps
Here, pink baby feet made with metallic-pink edged paper were mounted onto pink card on a wooden block for a novel decoration – just the thing for a party in celebration of the new arrival. More blocks could be made with letters spelling out the baby's name (see page 104), or ducks (see page 57) or hearts in pastel colours (see page 49).

Spotty buggy

A pram or buggy is another timeless symbol for celebrating a newcomer to the family. The smart spots on this example are created by inserting quilled coils into holes punched in the card pram shape, which has been raised on adhesive foam pads so that the holes are recessed. The open coils simply unwind to fit the holes.

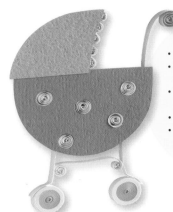

You will need

- pink card in two shades
- 3mm (⅛in) wide paper – white, pink
- 'anywhere' holepunch, 7mm (¼in) in diameter
- mini adhesive foam pads
- Basic Tool Kit (see page 8)

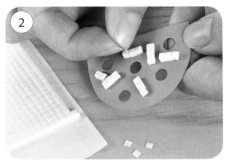

1 Using the templates on page 117, cut the pram body from one shade of pink card and the hood from the other. On the pram body, mark five equally spaced points with a pencil, then punch a hole at each pencil mark, holding the punch upside down to aid positioning.

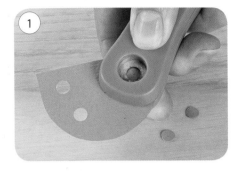

2 Place mini adhesive foam pads on one side of the pram body around the holes, but not too close to the edge. Remove the backing papers and press in position on your chosen surface.

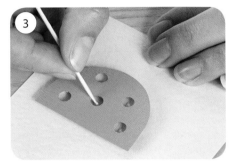

3 Using a cocktail stick (toothpick), apply a dot of glue inside the punched holes on the surface below.

TIP
You can easily change the colour scheme to blue for a baby boy, or make two prams to celebrate a twin birth.

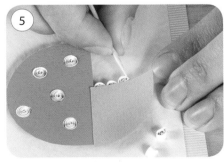

4 Make a loose coil from a 7cm (2¾in) length of the white paper and insert into a hole. Let the coil unravel in the hole.

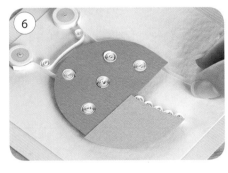

5 Place adhesive foam pads on the underside of the pram hood and above the pram body as shown. Make five loose closed coils from 5cm (2in) lengths of white paper and pinch into crescent shapes (see page 14). Place glue on one side of each crescent and tuck under the side edge of the pram hood. Use a clean cocktail stick (toothpick) or tweezers to position the shapes accurately.

6 Glue a 40cm (15¾in) length of the white paper to 40cm (15¾in) of the pink and make a tight coil, starting with the pink. Repeat and position as wheels. Make pram legs from 2.5cm (1in) lengths of the white paper, curving the bottom ends for wheel arches and tucking the tops under the pram. Make an open coil in each end of a 7cm (2¾in) length of the white paper and glue between the legs. Make an open coil from a 10cm (4in) length of the pink paper and attach for the pram handle, tucking the end under the pram.

Quacking duck

This jolly little duck friend is quickly constructed from three coils, the two for the body and wing loosely coiled and pinched to shape. The head is formed from a strip of brown paper glued to a strip of yellow end to end and coiled so that the inner brown part forms the eye when pulled into position. The 'V'-shaped folded beak adds extra animation to the motif.

You will need

- 3mm (⅛in) wide paper – yellow, brown
- 2mm (¹⁄₁₆in) wide blue paper
- needle tool
- Basic Tool Kit (see page 8)

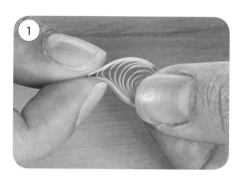

For the body, make a loose closed coil with a 40cm (15¾in) length of the yellow paper. Pull the centre to one side of the coil with your fingers, then pinch the other end and bend upwards to create a duck body shape. Glue to your chosen card or other surface.

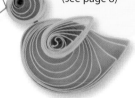

For the head, glue a 2cm (¾in) length of the brown paper to 15cm (6in) of the yellow end to end. Coil tightly, starting with the brown paper. When the yellow is reached, add a dot of glue, then continue coiling to make a loose closed coil.

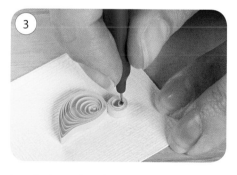

Attach this coil to the card or other surface above the body, using the needle tool to pull the brown centre to one side of the head for the eye.

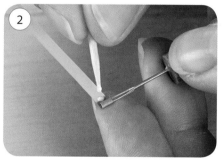

For the beak, fold a 6mm (¼in) length of the brown paper in half and glue to the head at the fold. For the wing, make a loose closed coil with a 20cm (8in) length of yellow paper and pinch into a teardrop shape (see page 14). For water (see Ducks in a Row right), make an open coil in one end of a 10cm (4in) and a 5cm (2in) length of blue paper (see Step 4, page 95).

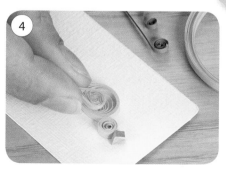

TIP
If you don't have a needle tool, insert a fine sewing needle into a dense wine cork.

INSPIRATIONS

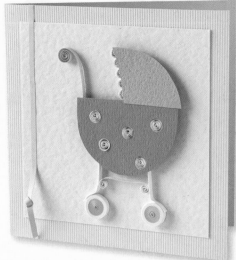

New baby onboard!
The posh-looking quilled buggy has been mounted onto pale pink card and then a darker pink folded card, with a strip of paper tied in a knot and attached to the spine side, for a fetching new baby or christening design.

Ducks in a row
For this cute duck family, add two ducklings to the duck made left by adjusting the paper measurements – 20cm (8in) for the body, 1cm (⅜in) brown and 7cm (2¾in) yellow for the head and 10cm (4in) for the wing. Mount onto pale yellow and then bright yellow card for a tag, with the addition of some yellow ribbon. This would also make an appropriate design for an Easter card.

Fairy fantasy

The fairy theme has an especially strong appeal for children and youngsters. But as well as providing them with enthralling designs for gifts and cards, it also offers them the ideal opportunity to try their hand at quilling, particularly as it involves using lots of colourful and glitzy paper and other fun materials.

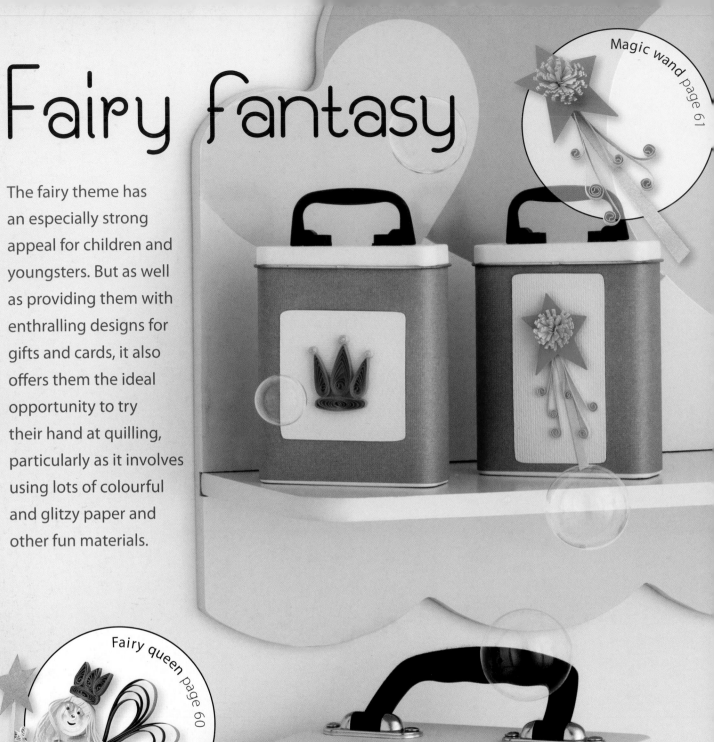

Magic wand page 61

Fairy queen page 60

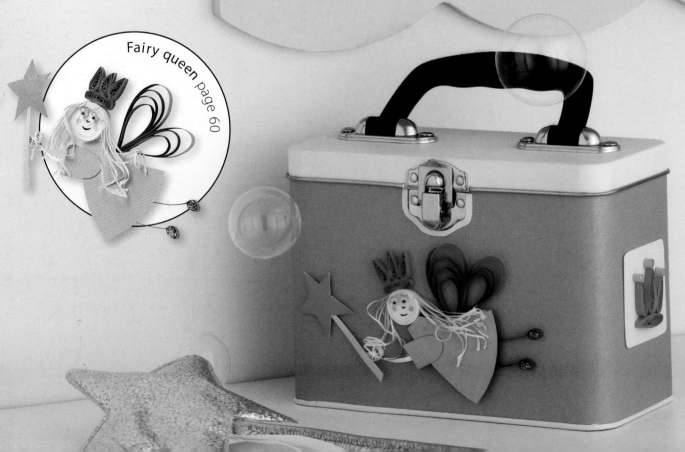

Fairy queen crown

This fairytale crown is easily made from pinched loose closed coils, topped with tight coil 'jewels' gilded with Perfect Pearls™ gold paint for light-catching lustre. Applying this paint is an effective alternative to using metallic-edged papers for the coils.

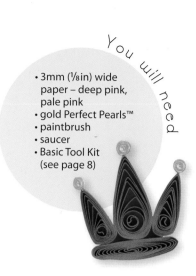

You will need
- 3mm (⅛in) wide paper – deep pink, pale pink
- gold Perfect Pearls™
- paintbrush
- saucer
- Basic Tool Kit (see page 8)

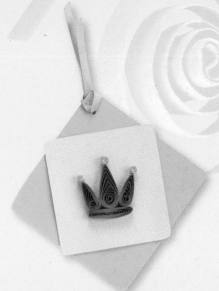

1

Make two loose closed coils with 20cm (8in) lengths of the deep pink paper and pinch into teardrop shapes (see page 14). Make another teardrop with a 30cm (12in) length and a rectangular shape with a 30cm (12in) length (see page 15).

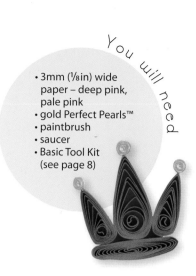

2

Glue the small teardrop shapes either side of the larger one onto card or another surface and the rectangular shape across the bottom. Make two tight coils with 5cm (2in) lengths of the pale pink paper and one tight coil from a 7cm (2¾in) length. Glue these above the points of the teardrops, the largest coil in the centre.

Tiara tag

Make a tag fit for a fairy princess's gift by mounting the pink crown onto a pale pink square of card and in turn onto a larger darker pink square, positioned diamond-style, punched and tied with pretty pink ribbon. The design could be used as name tags for personalizing party bags for a fairy-themed birthday party.

TIP

You can use a gold pen instead of Perfect Pearls™, but it won't produce the same degree of sheen.

4

Paint the top edges of the round tight coils with the gold mixture. Alternatively, you can paint the whole of the coils.

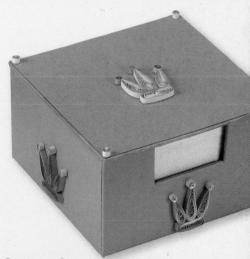

3

Place some of the gold Perfect Pearls™ on a clean saucer. Pick up a little water with a clean paintbrush and mix into the gold powder to make a thick liquid. If it is too runny, add more powder.

Crown casket

This purple notepad holder has been magically transformed into a precious fairy casket with the addition of five sparkling crowns – two made with pink metallic-edged pink paper for the front and back and two with purple metallic-edged purple paper on the sides, all decorated with tight gold coils, plus a final variation in gold-edged ivory paper with pink and purple 'jewels' for the top. Ivory or gold tight coils on each corner add just the right finishing touch.

59

Fairy queen

Always a favourite with little girls, this unique quilled example uses different techniques for making and decorating the various components. The fairy's face is a tight closed coil coloured with pen and chalks, and the strands of hair are wound around a cocktail stick (toothpick) to curl, while looped strips give the wings a special airiness and glitter glue adds sparkle to her feet.

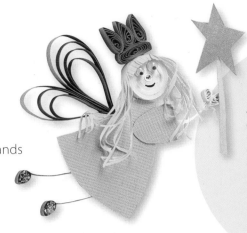

You will need

- 3mm (⅛in) wide paper – dark purple, ivory, very pale pink, yellow, pink, gold
- card – mauve, gold
- 10mm (⅜in) wide gold paper
- mini adhesive foam pads
- silver glitter glue
- pink chalk and applicator
- brown brush pen
- 2 wiggly eyes, 3mm (⅛in) in diameter
- superglue
- Basic Tool Kit (see page 8)

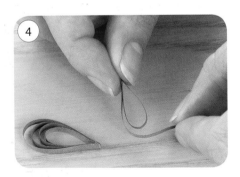

For the legs and feet, make two slightly loose closed coils by coiling 8cm (3⅛in) of 10cm (4in) lengths of the dark purple paper and gently pinch to make oval-type shapes. Glue to your chosen surface. Using the template on page 117, cut out the fairy body from mauve card. Attach mini adhesive foam pads to the underside. Mount overlapping the legs.

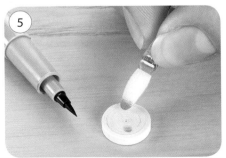

Apply dots of the glitter glue to the feet. Leave to dry.

TIP
You can turn the fairy queen into a Christmas fairy by using a red and green or silver and gold colour scheme.

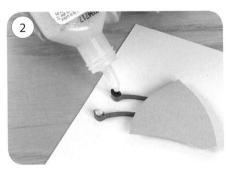

Using the template on page 117, cut out the arm from mauve card. Glue a strip of ivory paper 1.5mm x 1.5cm (¹⁄₁₆ x ⅝in) to the underside. Glue the arm to the body. For a hand, make loose closed coils with a 4cm (1½in) and a 3cm (1⅛in) length of ivory paper pinched into teardrops (see page 14). Glue either side of the end of the arm, the smaller shape uppermost.

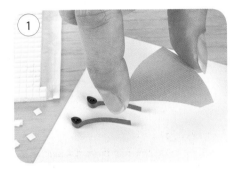

Make the wings by forming four loops in a 25cm (10in) length of dark purple paper and three loops in a 20cm (8in) length, gluing at the base and trimming the ends (see page 46). Glue in position.

For the head, glue three 40cm (15¾in) lengths of the very pale pink paper end to end and make a very tight coil. Using an applicator, rub pink chalk onto the coil for cheeks, then add the wiggly eyes with superglue. Draw on a nose and mouth with a brown brush pen.

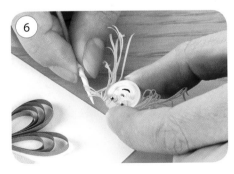

Cut lengths of the yellow paper into strands for hair and glue to the head. Use a clean cocktail stick (toothpick) to curl them. Attach the head to the body. Make a crown following the instructions on page 59 but without the 'jewels' and glue in place. Make a wand from gold card and paper following the instructions opposite but without the frilled centre and attach in position with mini adhesive foam pads.

Magic wand

Go to town with this fabulous star-shaped fairy wand, complete with gold coiled streamers. Its wonderfully tactile central decoration is made using the fringing technique, as in the Frilly Flower, page 44, but without the central coil, for a pompom-type effect.

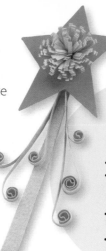

You will need

- 10mm (³⁄₈in) wide gold paper
- deep pink card
- 90 degree-angled fringing tool
- small star punch
- 'anywhere' holepunch, 7mm (¹⁄₄in) in diameter
- mini adhesive foam pads
- Basic Tool Kit (see page 8)

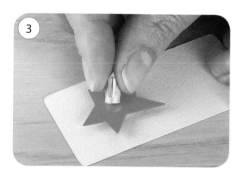

1 Insert a 15cm (6in) length of the gold paper into the fringing tool, then move the handle up and down to fringe the paper. Make a tight closed coil from the fringed paper and glue the end in place.

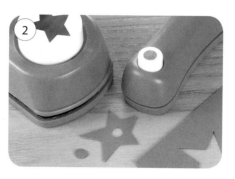

2 Punch a star shape from the pink card. Mark the centre of the star with a pencil, then punch a hole at the mark with the 'anywhere' holepunch.

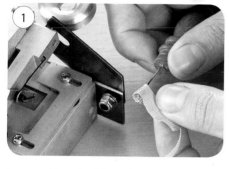

3 Mount the star onto your card or other surface with mini adhesive foam pads. Place glue all over the base of the fringed coil and insert into the hole in the star. Press down, then spread the fringe out.

4 Glue two 7cm (2³⁄₄in) lengths of the gold paper together lengthways and trim to taper at one end. Cut thin strands of the gold paper 2mm (¹⁄₁₆in) wide, then cut into two sets consisting of a 3cm (1¹⁄₈in), 4cm (1¹⁄₂in) and 5cm (2in) length. Glue each set of lengths together at one end, then coil the other ends in different directions without gluing. Tuck each set under the pink star either side of the stick and glue in place.

TIP

The paper used here is gold on both sides, but you can use paper that is gold on one side only if wish.

INSPIRATIONS

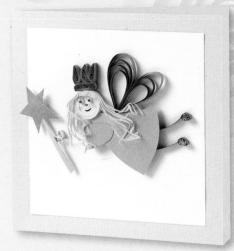

In-flight fairy

The quilled fairy queen has been given due prominence in this enchanting design, mounted 'mid-air' on a cream background attached to a pink square card. This would make a delightful card for a young girl's birthday.

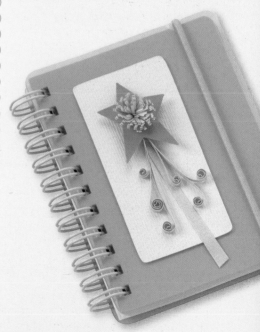

Spell bound

Bring more than a touch of magic and mystery to a shocking pink spiral-bound notebook by mounting the fairy wand on the cover, positioned breaking out of a pale pink panel for an added sense of drama – an ideal place for storing away all those special secrets and spells.

Animal magic

Animals make ever-popular subjects for cards and gifts, and are surprisingly easy to capture in quilling form. Here you will see how loose closed coils can be pinched, bent and otherwise manipulated into various characteristic body and head shapes, both in profile and face on, then brought to life with added details, such as wiggly eyes, curled tails and spiky whiskers.

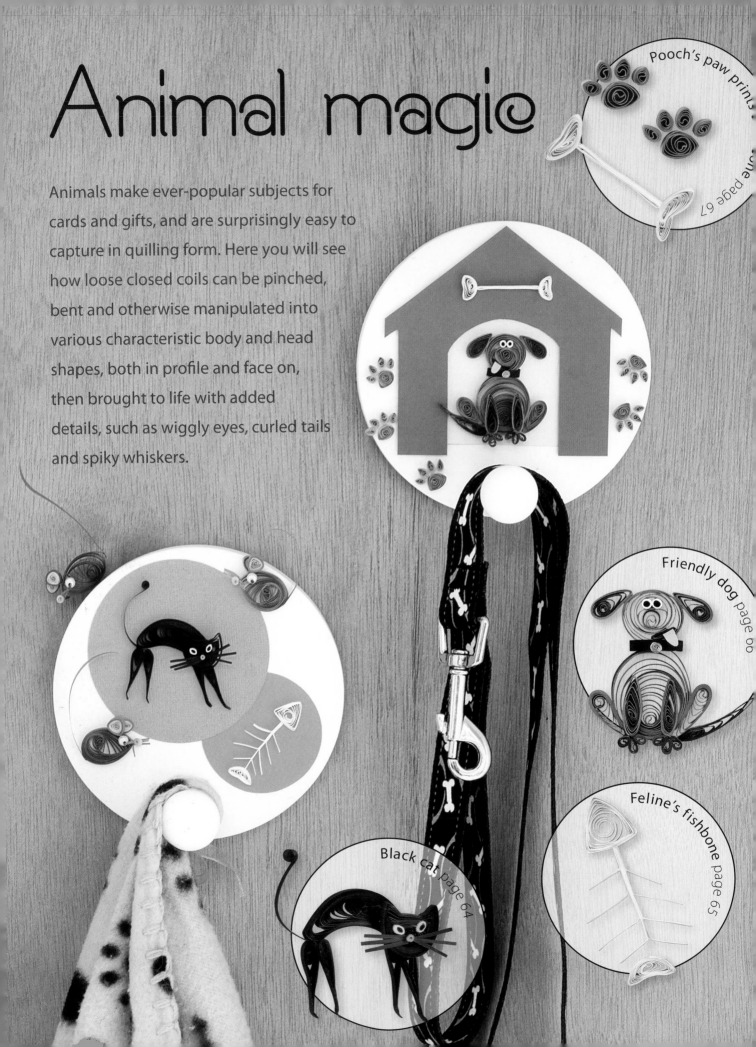

Pooch's paw prints page 67

Friendly dog page 66

Black cat page 64

Feline's fishbone page 65

Mini mouse

Scampering mice make very cute quilled decorations whether in brown or white and are easily constructed from triangular pinched coils for the large pink-centred ears resting on a pinched teardrop for the body. The strip for the tail can be curled with your fingernail in different endearing ways. The pink tight coil nose and whiskers make the mice look as though they are nibbling away.

You will need

- 3mm (⅛in) wide paper – brown, pink
- 2mm (¹⁄₁₆in) wide brown paper
- wiggly eye, 3mm (⅛in) in diameter
- superglue
- Basic Tool Kit (see page 8)

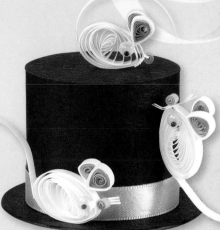

For the whiskers, cut a 1.5cm (⅝in) length of the 2mm (¹⁄₁₆in) wide brown paper into three fine strands at either end, with the centre left uncut. Attach to the pointed end of the mouse body. Make a tight coil from a 5cm (2in) length of the pink paper and glue over the centre of the whisker strip for a nose.

TIP

A sturdier mouse could be made using 5mm (³⁄₁₆in) wide papers.

Taper a 5cm (2in) length of the 3mm (⅛in) wide brown paper to a point for the tail and curl with your fingernail. Attach to the body. Add a wiggly eye to the head with superglue. For a white mouse, substitute the same widths of white paper for the brown papers used in the instructions above.

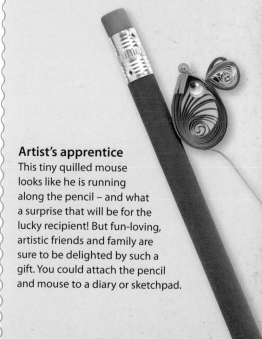

Magician's assistants

A magician's key prop – a top hat – is decorated with his essential accomplices – three white mice – to make a fabulous favour box for a children's birthday party or for a Harry Potter-style magic show. The hat could also house some special sweets or little party playthings to add to the fun.

Artist's apprentice

This tiny quilled mouse looks like he is running along the pencil – and what a surprise that will be for the lucky recipient! But fun-loving, artistic friends and family are sure to be delighted by such a gift. You could attach the pencil and mouse to a diary or sketchpad.

Black cat

Any shape can be created with quilling and can be used as a way of animating a motif, as with this cat, where a loose closed coil for its body has been curled into an arched shape so that it looks poised to jump, pounce or stretch. The tight coil yellow eyes with a black centre have a characteristically feline stare.

You will need

• 3mm (⅛in) wide black paper
• 2mm (¹⁄₁₆in) wide paper – black, yellow, pink
• Basic Tool Kit (see page 8)

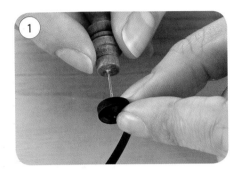

1

For the body, glue three 40cm (15¾in) lengths of the 3mm (⅛in) wide black paper together end to end. Use to make a loose closed coil and glue to your chosen surface in an arched shape.

TIP

You can easily alter the body shape and legs of the cat so that it is jumping or stretching. Or adapt the dog project (see page 66) to make a sitting cat.

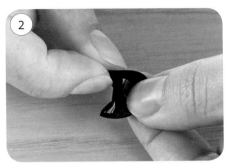

2

For the head, glue two 40cm (15¾in) lengths of the 3mm (⅛in) wide black paper together end to end. Use to make a loose closed coil. Pinch at one point, then at the same point on the other side of the coil to make ears.

3

For the legs, make four very loose closed coils from 20cm (8in) lengths of the 3mm (⅛in) wide black paper, then pinch almost flat at one end to a point.

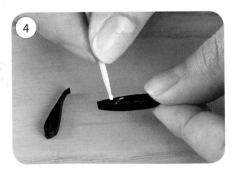

4

In order to maintain the shape of the leg, use a cocktail stick (toothpick) to place glue inside the flat end of the coil, then press together, leaving the rounded end unglued. Bend the pointed end of the shape slightly for a paw effect.

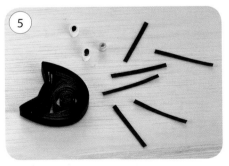

5

For the eyes, glue 1cm (⅜in) of 2mm (¹⁄₁₆in) wide black paper to 1cm (⅜in) of the yellow paper end to end. Make a tight coil, starting from the black paper. Glue the end in place and pinch flat. For the nose, make a tight coil with a 1.5cm (⅝in) length of the pink paper. Cut fine strands of black paper for whiskers.

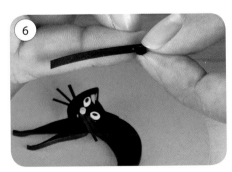

6

Glue the four legs to the body. Glue the features to the head, then glue over the body and front two legs. For the tail, coil a 10cm (4in) length of the 3mm (⅛in) wide black paper for about 6cm (2⅜in), then release the coil slightly and glue in place. Glue to the cat.

Feline's fishbone

This bleached white fishbone is best set off by a dark background. The thin paper is ideal for re-creating the fineness of the bones, and cutting out the centre of the coiled head enhances the stark skeletal effect.

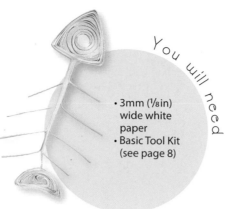

You will need

- 3mm (⅛in) wide white paper
- Basic Tool Kit (see page 8)

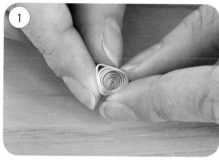

1 For the head, make a loose closed coil with a 20cm (8in) length of the white paper. Pinch into a triangular shape (see page 14).

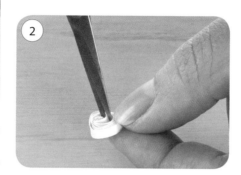

2 Using scissors, cut out the centre of the coil. For the tailbone, make a loose closed coil with a 15cm (6in) length of the white paper and pinch into a crescent shape (see page 14). Glue to the card or other surface at a distance from the head.

3 Cut nine 3.5cm (1⅜in) lengths of white paper. Glue pieces either side of one piece for the backbone, applying glue to 3cm (1⅛in) of the lengths nearest the tail, then 2.5cm (1in) for the middle lengths and 2cm (¾in) for those closest to the head. Bend at an angle to the backbone.

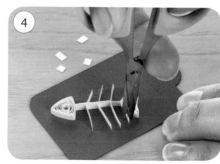

4 Glue the bones to the card or other surface between the head and the tailbone, placing glue only along the underside of the backbone. Trim the ends of the side bones so that they are even on each side and form a skeleton shape.

TIP
A row of these fishbones under or around a quilled cat would make an eye-catching border.

INSPIRATIONS

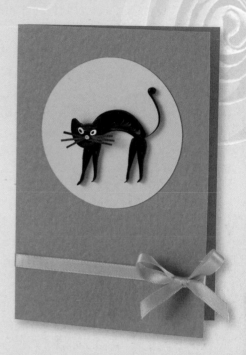

Spooked cat card
The haunted-looking black cat makes the perfect image for an invitation to a Halloween party, spotlighted in a vibrant orange circle mounted onto a red folded card. A length of ribbon tied in a bow around the base of the card adds a softening touch.

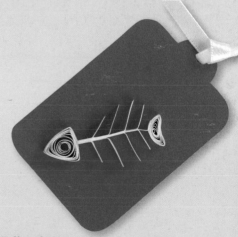

Tell-tail tag
Set against dark blue card for maximum impact, the fishbone makes a fun feature for a gift tag, which is sure to amuse any cat lover. You could use it to present a special treat for their feline friend.

Friendly dog

As opposed to the cat that is pictured in profile, this equally lively dog is sitting face on as if expecting a walk. He is simply constructed from a series of loose closed coils, with the forelegs forming a second layer for extra dimension. The curled pink tongue and flattened coil wagging tail add further to his personality.

You will need

- 3mm (⅛in) wide paper – pale brown, dark brown, black, white, pink
- 1.5mm (¹/₁₆in) wide gold-edged ivory paper
- Basic Tool Kit (see page 8)

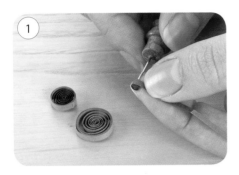

1 For the dog's head, make a loose closed coil with a 40cm (15¾in) length of the pale brown paper. Glue to card or another surface. For the ears, glue a 10cm (4in) length of the pale brown paper to a 10cm (4in) length of the dark brown end to end and make a loose closed coil, starting with the dark brown. Repeat and pinch into teardrop shapes (see page 14). Glue either side of the head.

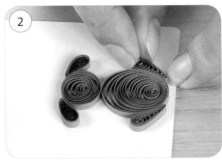

2 For the body, glue two 40cm (15¾in) lengths of the pale brown paper together end to end and make a loose closed coil. For the legs, make loose coils with a 20cm (8in) length of the same paper and pinch into teardrop shapes. Glue in place.

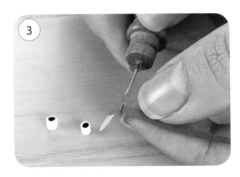

3 For the eyes, glue a 1cm (⅜in) length of the black paper to 3.5cm (1⅜in) of the white end to end and make a tight coil, starting with the black. Repeat. Glue inside the head. For the mouth and tongue, glue a tiny piece of pink paper to one end of a 5cm (2in) length of the dark brown paper. Make a loose closed coil, leaving the tongue hanging down, and pinch flat.

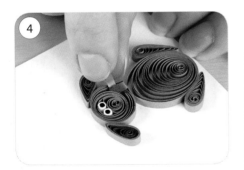

4 Insert the mouth and tongue into the head – you may need to use tweezers to move the coil about to make room.

TIP
You could add wiggly eyes for an extra dimension of animation.

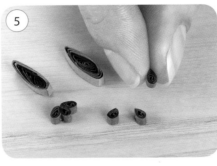

5 For the paws, make six loose closed coils from 4cm (1½in) lengths of the dark brown paper, then pinch into teardrops and glue into two groups of three. For the forelegs, glue a 10cm (4in) length of the pale brown to a 10cm (4in) length of the dark brown paper and make a loose closed coil, starting with the dark brown. Repeat. Glue in place.

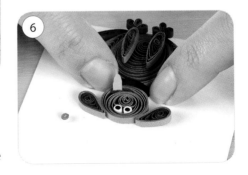

6 For the tail, make a very loose closed coil with a 20cm (8in) length of the dark brown paper and pinch almost flat. For the collar, make a small fold at either end of a 2cm (¾in) length of the black paper. Glue one end around the neck, then the other end, holding in place while the glue dries. For a tag, make a tight coil with a 1.5cm (⅝in) length of the gold-edged ivory paper.

Pooch's paw prints and bone

Quilled shapes don't always need to be joined together to make an effective motif, such as these paw prints, made from just four separate coils, which are really quick to make. The bone consists of two pinched coils linked by a central strip of paper folded over several times.

You will need
• 3mm (⅛in) wide paper – brown, white
• Basic Tool Kit (see page 8)

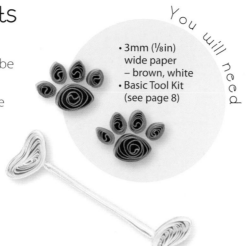

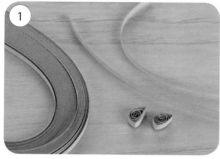

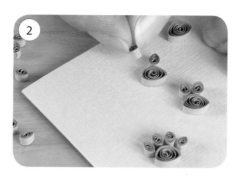

1
For the paw prints, for each one, make a loose closed coil with a 10cm (4in) length of the brown paper and pinch into a crescent shape (see page 14).

2
Make four loose closed coils per paw print with 5cm (2in) lengths of the brown paper; vary the size by allowing some coils to release slightly more before gluing. Pinch into teardrop shapes (see page 14). Glue the crescents onto the card or other surface. Glue the larger teardrops at the centres of the crescents, with two smaller ones either side.

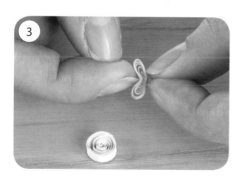

3
For the bone, make a loose closed coil from a 20cm (8in) length of the white paper and pinch into a crescent shape.

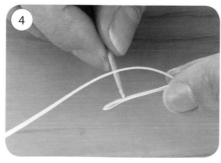

4
Take a 20cm (8in) length of the white paper, fold over 2.5cm (1in) at one end and glue in place. Continue folding over in the same way and gluing each time. Glue one crescent shape to the card or other surface, then the central bone and finally the other crescent shape.

TIP
Instead of dog paw prints, you can change the size, colour and number of toes to make other animal footprints.

INSPIRATIONS

Top dog bookmark
The waggy dog is mounted onto a white card doorway attached to a kennel-shaped piece of brown card, which is glued to a rectangular piece of brown card for a bookmark. Two slits cut in the base enable him to sit obediently on top of the page to encourage young readers.

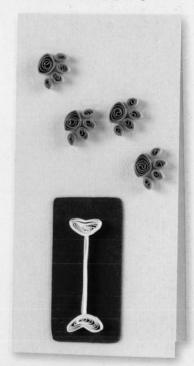

Canine call signs
Here, the doggy paw prints and bone have been combined to make a novelty gift tag to bring a smile to the face of any dog lover. These quirky motifs could also be used to decorate a photo frame for a portrait of a beloved canine companion or a memo pad or notebook.

67

Oriental style

Oriental-inspired designs have a delicate, decorative quality that brings a sophistication and distinction to papercrafted items. Quilling, with its flowing lines and fine, intricate forms, lends itself particularly well to this style, especially when produced in soft, harmonious hues of orange, pink and red.

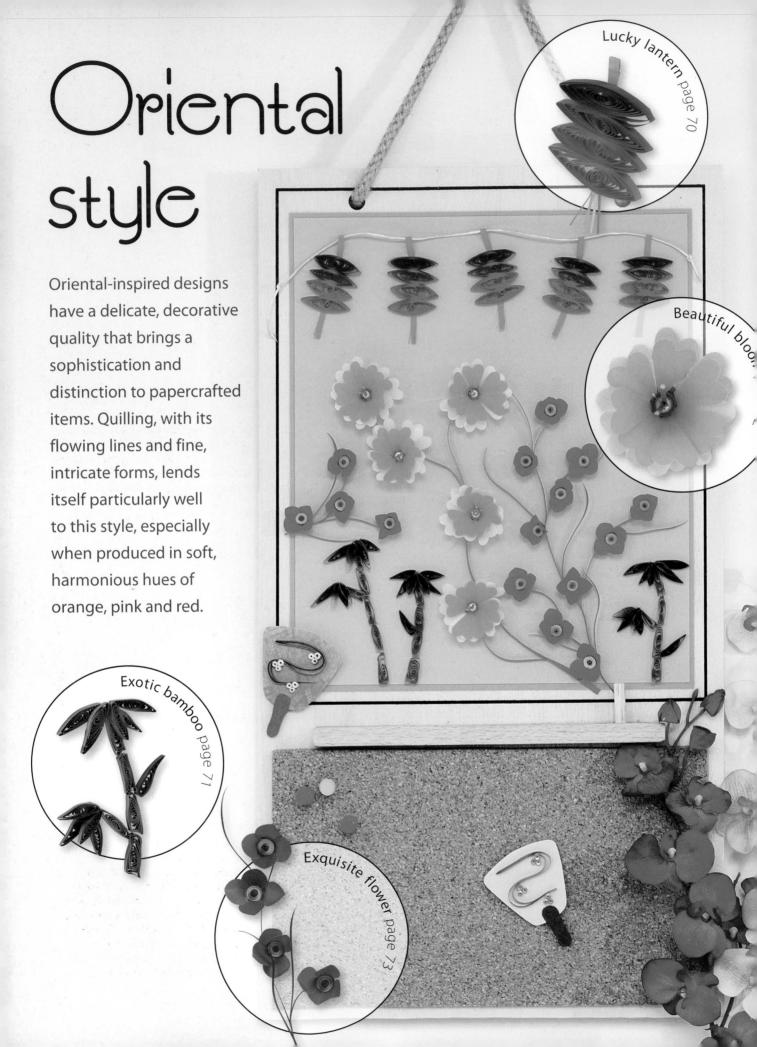

Lucky lantern page 70

Beautiful bloom

Exotic bamboo page 71

Exquisite flower page 73

Ornamental fan

To embellish this elegant Far Eastern-inspired fan, tight coils have been made with a needle tool so that they have open centres, then flowing movement introduced by winding a double length of darker paper around the coils. Using metallic-edged papers adds overall richness to the design.

You will need

• 3mm (⅛in) wide paper – copper-edged ivory, gold-edged brown
• card – orange, brown
• needle tool
• Basic Tool Kit (see page 8)

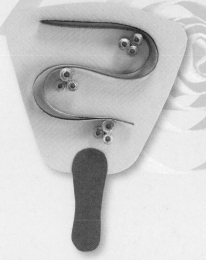

1 Place a 5cm (2in) length of the copper-edged ivory paper around a needle tool.

2 Hold the needle tool still in one hand and wrap the paper around the tool with the other hand, making a tight coil. Glue the end in place and remove the tool. Make three coils each with 5cm (2in), 4cm (1½in) and 3cm (1⅛in) lengths of the paper.

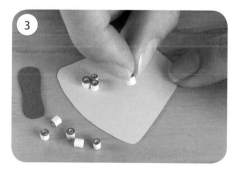

3 Using the templates on page 117, cut out the fan shape from orange card and the handle from brown card. Glue the coils to the fan in groups of three at evenly spaced intervals. Glue the handle to the bottom of the fan.

4 Apply glue to the upper side of the top coils in each group. Fold a 20cm (8in) length of the gold-edged brown paper in half and glue the ends together. Bend around the coils and press to the glued sides to secure.

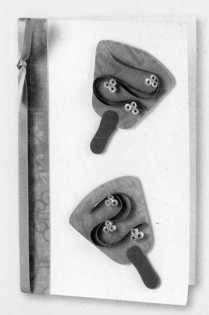

Fridge fan
Make a single ornamental fan into a distinctive fridge magnet by gluing a magnet to the reverse side. You could also turn it into a fabulous gift tag for an oriental-style present by mounting it onto a piece of complementary coloured card, punching a hole through the card and threading with cord or ribbon.

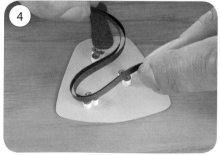

Fan fantasy
Two fans are used here to create an elegant card design to celebrate a birthday or an anniversary. The main fan shapes were cut from oriental-style printed paper, with the same paper used for a decorative border for the card spine, further embellished with coordinating ribbon tied in a knot. The fans were attached to the pale orange card with adhesive foam pads for added depth.

Lucky lantern

This traditional oriental-style lantern is ingeniously made by pinching four loose closed coils, then gluing them together in graduating shades. The shapes hang free to allow daylight to illuminate the quilling effect. A quilling board is used here to ensure that the coils are uniform in size before being pinched so that they exactly match.

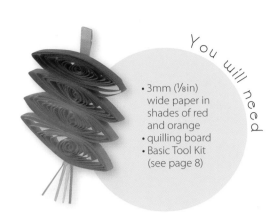

You will need

- 3mm (⅛in) wide paper in shades of red and orange
- quilling board
- Basic Tool Kit (see page 8)

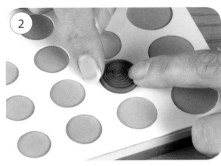

1. Make a loose closed coil with a 40cm (15¾in) length of red paper. Add a dot of glue to the end of the paper with a cocktail stick (toothpick).

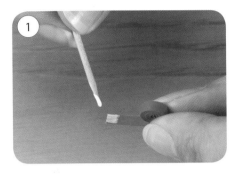

TIP
Take care when handling these coils, otherwise the centres will pop out. You can apply glue to the reverse side of the lantern to help keep the centres in position.

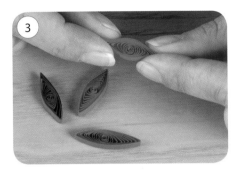

2. Place the coil in a circle template about 2cm (¾in) in diameter in the quilling board. Allow the coil to release to the edges of the template, then make sure that the end of the paper is glued in place. Make three more coils in this way from the different shades of paper, graduating from red to orange.

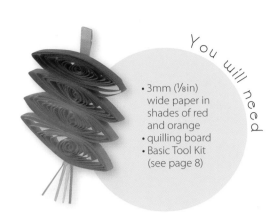

3. Using your fingertips, pinch two opposite sides of each coil to form a teardrop shape (see page 14).

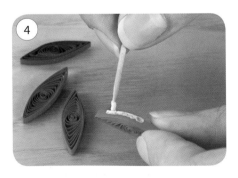

4. Using a cocktail stick (toothpick), apply glue along the edge of one side of the darkest-coloured teardrop shape, but not right to the points, then adhere to the next darkest teardrop shape.

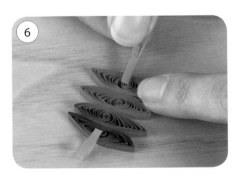

5. Adhere the remaining teardrop shapes in the same way, with the palest coloured at the bottom. Hold the shapes together for a few seconds while the glue dries.

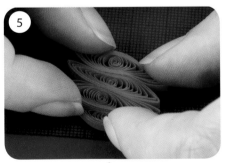

6. Fold a 2cm (¾in) length of pale orange paper over to make a loop and glue to the top of the lantern (the darkest-coloured teardrop shape). Glue a 1.5cm (⅝in) length of pale orange paper, snipped into about four strands, to the bottom of the lantern.

Exotic bamboo

This highly attractive and versatile quilled motif is a great way to start making and using pinched shapes, since in this instance they don't need to be uniform in shape to create the desired natural effect. Some of the leaves are layered on top of each other to add extra dimensional interest.

You will need

- 3mm (⅛in) wide papers – green, brown
- Basic Tool Kit (see page 8)

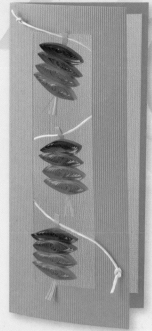

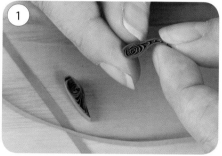

For the leaves, cut several lengths of the green paper, varying between 15cm (6in) and 20cm (8in) long. Make loose closed coils with each length. Pinch one side of each coil very tightly and gently pinch the opposite side to flatten the coil, then pinch inwards to bend the tightly pinched end. Set aside.

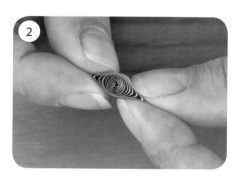

Make a loose closed coil with a 20cm (8in) length of the brown paper. Pinch at two opposing points to form an eye shape (see page 14).

TIP
You can make a larger bamboo stem and leaves by simply doubling the lengths of paper used to make the loose closed coils.

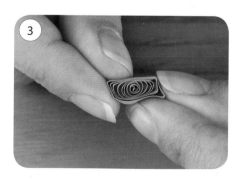

Push the shape inwards at the pinched ends and pinch again to form an irregular rectangular shape. Make several shapes in the same way. Glue some of the shapes end to end to your chosen surface to form a curved stem, leaving a small gap between each shape, adding other shapes here and there as side branches. Glue the leaf shapes around the stem, making a double layer at the top and the ends of the branches.

Lantern window
Strung onto paper cord, this trio of lanterns hangs in an upright aperture cut in a single-fold orange card, with a piece of paler orange card attached to the back panel of the card behind it, thereby allowing the light to shine through the coils. This would be ideal for a Chinese New Year card or an invitation to a special-occasion oriental meal.

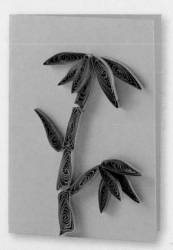

Bamboo breezer
Here, a curved stem of bamboo, as if bending in a breeze, is attached to a vibrant yellow, upright-shaped folded card. This design would delight a gardener with a penchant for tropical plants or those moving or travelling to an exotic location. It would also help to make the message 'remember to water my plants while I'm away' especially memorable!

Beautiful bloom

This elaborate, double-layered flower is made using a special technique in which punched heart-shaped petals are precisely positioned and glued to paper and then coiled and fanned out. The translucent paper for the petals captures that essential delicate oriental quality.

You will need

- orange translucent paper
- clear parchment or translucent paper
- 3mm (⅛in) wide paper – pale cream, deep pink, orange
- heart punch
- pale gold 3-D paint
- Basic Tool Kit (see page 8)

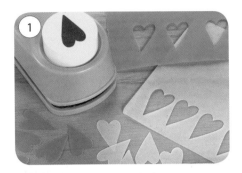

1 Punch six heart shapes from orange translucent paper and eight from clear parchment or translucent paper.

TIP
The spacing of the punched shapes is crucial in creating a successful flower with this technique, so be sure to follow the instructions carefully.

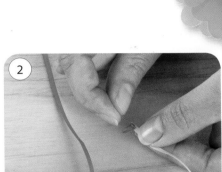

2 Glue a 10cm (4in) length of the pale cream paper to 15cm (6in) of the pink end to end. Then glue the end of the pink paper to a 30cm (12in) length of the 3mm (⅛in) orange paper. Cut four narrow strands of the pink paper 1cm (⅜in) in length and glue to the end of the pale cream paper for stamens.

3 Place the strip of joined papers on scrap paper and glue the six orange hearts where the pale cream joins the pink paper. Allow a 2mm (¹⁄₁₆in) gap between the base of each heart. Glue the tips of the hearts about halfway across the paper strip.

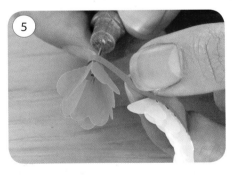

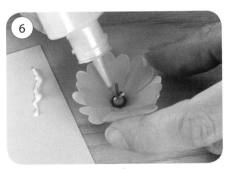

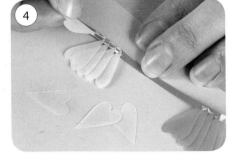

4 Glue the eight parchment or translucent hearts onto the strip 5cm (2in) along from the orange hearts in the same way.

5 Place the end with the stamens into the quilling tool, ensuring that the hearts are facing away from the quilling tool. Make a tight coil and glue the end in place.

6 Use your fingers to fan out the hearts. Add dots of gold 3-D paint onto the ends of the stamens and leave to dry.

Exquisite flower

This is a quicker version of the double flower opposite, using only four petals, punched with a circle punch, and without stamens. Again, translucent paper is used for the petals, and grouped together these blooms make a beautiful display.

You will need

• red translucent paper
• 3mm (⅛in) wide paper – red, pink
• circle punch, 1cm (⅜in) in diameter
• Basic Tool Kit (see page 8)

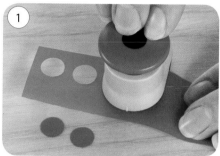

Using the circle punch, punch four circles from the red translucent paper.

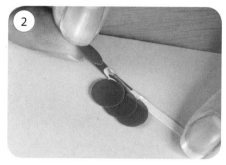

Glue a 5cm (2in) length of the 3mm (⅛in) red paper to 20cm (8in) of the pink end to end, then glue the end of the pink to 15cm (6in) of the 3mm (⅛in) red. Glue the punched shapes at the join of the pink and longer length of red paper. The circles will need to overlap and glue halfway across the paper strip.

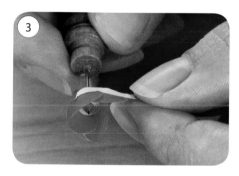

Make a tight coil, starting with the shorter length of red paper, and then glue the end in place; the glue must be dry before coiling, otherwise the circles will fall out.

TIP
If at Step 3 you can tell that the petals are not positioned correctly, don't glue the end but use this as a reference for the next flower.

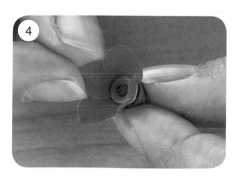

Fan the circles out and then pinch to form petal shapes. Leave some slightly closed and fan out the others more to give them a natural-looking variation.

INSPIRATIONS

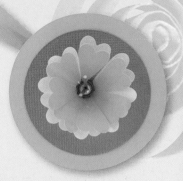

Floating flower tag
To create a sumptuous gift tag, mount the open flower head onto a circle of pinky orange card, then a larger circle of orange card, and add a matching ribbon tie. You could also make this into a stunning brooch, presented on a card for a special summertime gift. Or several flower heads could be mounted onto a wire ring for a celebration cake decoration.

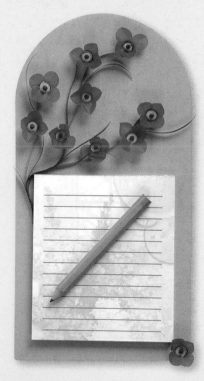

Floral frame
Here, a functional magnetic fridge notepad has been transformed into a glamorous gift, decorated with a sinuous spray of the small, delicate red flowers. These have been glued to either side of three red stems, with strands of paper tapered at one end emanating from the main stem.

Fab Fashion

Fashion is a subject close to many people's hearts and re-creating those defining accessories in quilling will add great entertainment value to your greetings cards and gifts. In the same way that fashion caters for all ages and tastes, here you will find something for everyone, from sophisticated hats for discerning ladies to mini pots of nail varnish for aspirational tweenies.

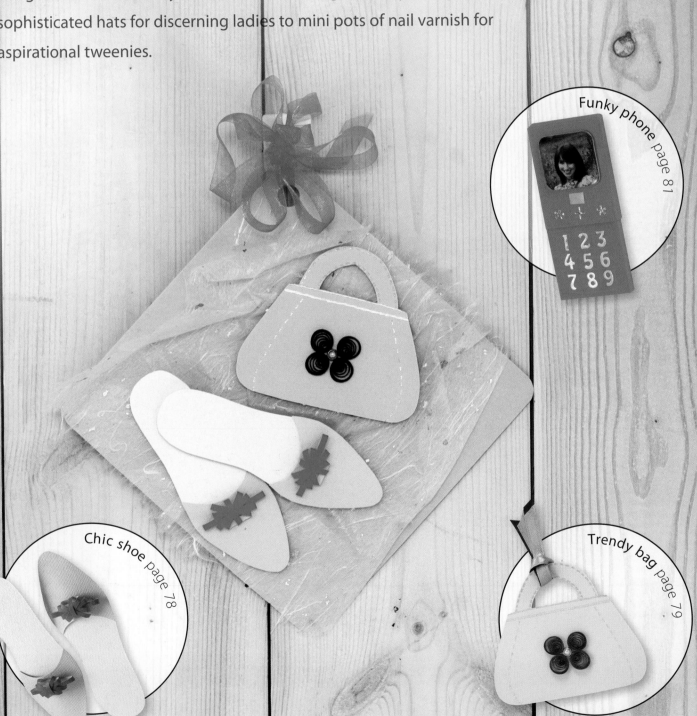

Funky phone page 81

Chic shoe page 78

Trendy bag page 79

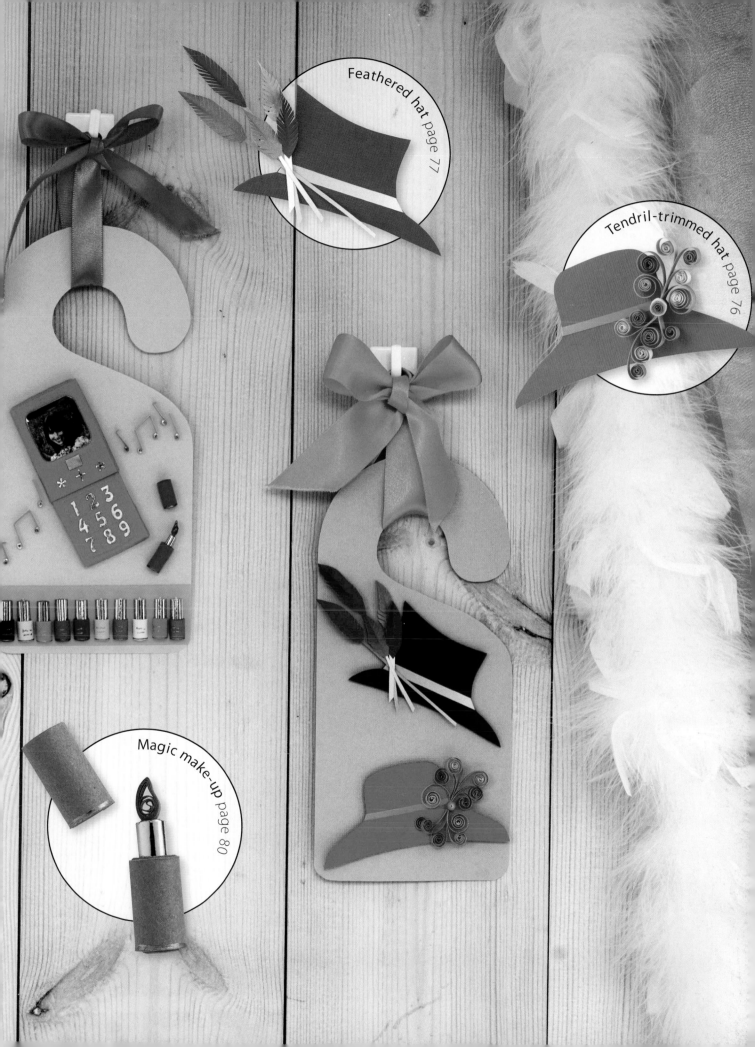

Feathered hat page 77

Tendril-trimmed hat page 76

Magic make-up page 80

Tendril-trimmed hat

This classic Parisian fashion house hat will add a touch of class to any gift card or tag. It is adorned with an opulent trimming of open spiral coils made from two-tone quilling papers (see page 7), which graduate from pale to dark to pale again along the length of each strip, so that the strongest colour is concentrated in the centre.

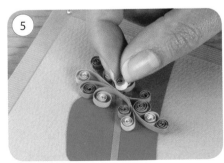

You will need

- 3mm (⅛in) wide pink with dark centre graduated paper
- red card
- Basic Tool Kit (see page 8)

Coil a 14cm (5½in) length of the paper towards the centre of the strip for about 6cm (2⅜in), then release the coil without gluing. Coil the other end towards the centre until you almost meet the other coil and release. Repeat with five more strips. You can make some into 'S'-shaped scrolls (see Step 3, page 52).

Place a small amount of glue on the centre of one coiled strip and glue the centre of another coiled strip to it. Glue another to the other side of the first in the same way. Glue the remaining coiled strips in the same way to either side of the joined coiled strips.

Using the template on page 118, cut out the hat shape from red card. Attach a strip of the pink paper around the base of the hat crown for a hat band, folding the ends around the sides of the hat.

TIP
This hat offers the perfect opportunity to use up those tiny bits of paper left over from other projects to make the open spiral coils.

Place a small dot of glue in the centre of the joined-together coiled strips and attach to the pink hat band to one side of the hat.

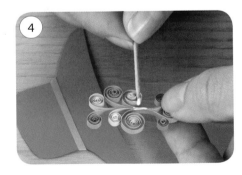

Glue the hat to your chosen card or other surface. Make a tight closed coil from a 10cm (4in) length of the pink paper and glue to the centre of the joined-together coiled strips.

Feathered hat

This ultra-modish hat takes its inspiration from those high-society horserace-goers in their top designer garb, so it is guaranteed to bring a unique sense of style to your cards, gift packages or party invitations. The feathers are fashioned from fringed, graduated-coloured paper strips, where the strongest colour at one end fades to white at the other.

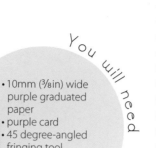

You will need

- 10mm (³⁄₈in) wide purple graduated paper
- purple card
- 45 degree-angled fringing tool
- Basic Tool Kit (see page 8)

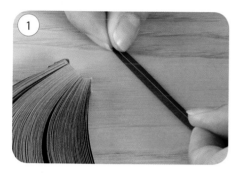

1

Fold a 10cm (4in) length of the purple paper in half along its length.

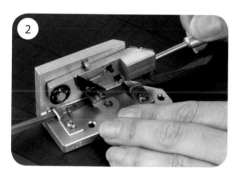

2

Insert it into the fringing tool with the fold at the back, against the vertical part of the tool. Move the handle up and down to fringe the paper. Remove the paper and check that there are no uncut parts.

3

Cut a 2.5cm (1in) piece of the fringed paper, then trim each side to form an oval or feather shape. Repeat to make about five feathers. Cut an unfringed, pale piece of the purple paper lengthways into the same quantity of narrow strips 7cm (2¾in) in length. Using the template on page 118, cut two hat shapes from purple card. Glue a narrow strip of pale purple paper to the base of the crown of one, folding the ends around the sides, then glue the two hats together. Glue the feathers to the strips and attach to the hat, trimming the ends as required.

TIP

If you don't have any graduated paper, use various shades of purple for an equally effective result.

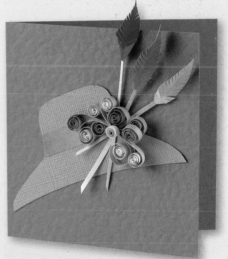

Magnetic attraction

Simply glue a small magnet to the back of this gorgeous accessory to make a fridge magnet for your favourite fashionista – just the thing for keeping those shopping lists of designer goods to hand. Alternatively, use it to decorate a gift box made in the style of a hatbox, for an especially luxurious present.

Crowning glory

Here, a hat shape cut from pale purple card has been mounted onto a square red folded card, then embellished with feathers cut from three different shades of purple paper, trimmed with tumbling pink spirals. This would make an ideal Mother's Day card, mother-of-the-bride thank you card or an upmarket invitation to the races or a shopping trip.

Chic shoe

The flamboyant decoration for this cutting-edge fashion shoe is made using the Spreuer technique (see page 17), as developed by leading quiller Jane Jenkins, taking inspiration from corn dolly maker's in Switzerland who made shapes from flattened straw on a wide-toothed comb. Here instead, paper strips are threaded around and through the widely spaced prongs of an onion holder.

You will need

• 3mm (⅛in) wide two-tone pink paper
• card – cream, pink
• 5mm (³⁄₁₆in) wide pink paper
• onion holder
• adhesive foam pad
• Basic Tool Kit (see page 8)

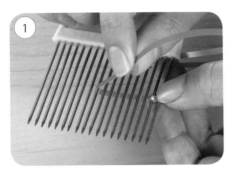

Fold 3mm (⅛in) over one end of a length (44cm/17¼in) of the two-tone paper and loop under the first rung of the onion holder, with the bright pink colour facing up. Place a dot of glue on the folded-over end on the bright pink side. Holding this end in place with your fingers, take the other end up to rung 10 and thread in between rung 10 and rung 11. Pull the paper through and press onto the folded-over end. This is the centre loop.

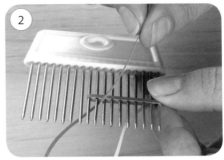

Take the end of the paper up to rung 8, thread between rung 8 and rung 9, then pull through.

TIP
To save having to count up the number of rungs, place a strip of masking tape along the plastic edge of the onion holder and use a pen to number each rung consecutively.

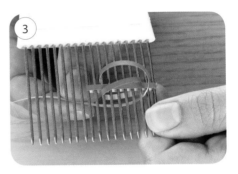

Cross the paper over the centre loop to rung 3 and thread between rung 3 and 4, then pull through. Cross the paper over at the back and take it up to rung 8 on the other side of the centre loop. Thread through and back down over the centre loop to rung 3.

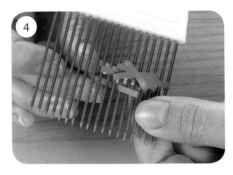

Take the paper up to rung 7, cross over down to rung 4, then cross over at the back up to rung 7 on the other side of the centre loop.

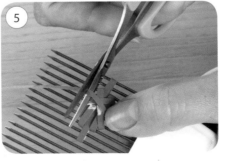

Wrap the end of the paper around the shape in the centre, through the centre rung, and trim. Using the templates on page 118, cut out a shoe sole from cream card and an upper from pink card. Attach an adhesive foam pad to the underside of the upper to raise it slightly, then glue to the sole around the outer edge only.

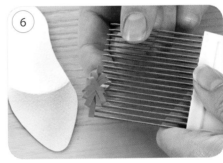

Carefully slide the Spreuer decoration from the onion holder and glue to the shoe upper. To add a heel, make a loose closed coil from a 20cm (8in) length of the 5mm (³⁄₁₆in) wide pink paper and glue to the underside of the sole.

Trendy bag

Even in its simplest form, quilling can add decorative detail to any motif, such as this smart fashion accessory, to give it that special finishing touch. Here, four off-centred, also known as 'eccentric', coils are grouped around a shiny brad for a designer look to rival Chanel or Dior!

You will need

• 2mm (¹⁄₁₆in) wide purple paper
• green card
• silver pen
• silver-edged pearl brad
• quilling board and pins
• Basic Tool Kit (see page 8)

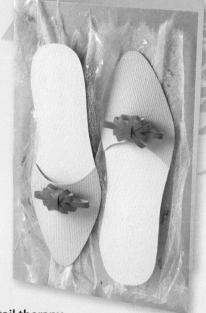

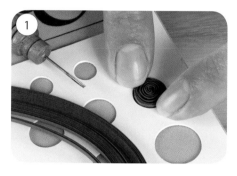

Make a coil with a 20cm (8in) length of the purple paper. Apply glue to the end, then insert the coil into the 1cm (³⁄₈in) diameter template in the quilling board. Let the coil release to fit the circle. Make three more identical coils.

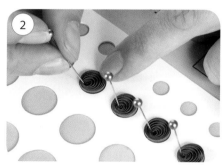

Use a pin to bring the centre of the first coil to the edge where the paper join is. Then press the pin into the board. Repeat for the other coils.

Retail therapy

This card captures that thrill of opening a box of brand-new shoes, nestling alluringly on a bed of tissue paper. An appropriate greeting could be added to the upper sole where the maker's label would be on a real pair of shoes, or add the name of the recipient's favourite fashion designer.

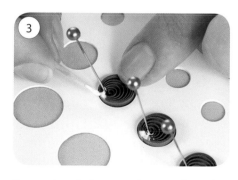

Place a dot of glue near the pin where the centre of the coil has been pulled over in order to hold it in place. Leave the glued coils in the quilling board to dry while cutting the handbag.

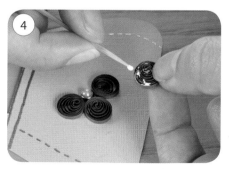

Using the template on page 118, cut a handbag from green card. Using the silver pen, draw rows of stitching around the handle and down each side, and add two parallel lines at the bag top as shown. Insert the brad into the centre of the bag and bend the 'wings' to flatten on the reverse. Glue the four coils around the brad, with the centres nearest to the brad.

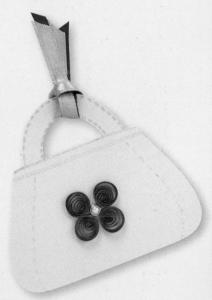

Designer bag tag

Turn the bag into a tag for a fashion trendsetter by knotting two lengths of ribbon in different colours together to the handle; you will need to back the bag with a second piece of card to cover the 'wings' of the brad. It would also make a great motif for a young teenager's birthday card.

Magic make-up

A range of coordinating nail varnish and lipstick colours is a must-have in any self-respecting fashion follower's everyday kit, and these upmarket-looking examples are craftily created entirely from paper. The nail varnish bottles consist of just two tight coils, one in a mauve shade for the base and the other in gold for the top. Since wider paper strips are unwieldy to coil using a quilling tool, the lipstick base is coiled around a cocktail stick (toothpick), with a pinched loose closed coil for the lipstick itself.

1 For the nail varnish, make a tight coil with a 40cm (15¾in) length of one shade of purple paper, then make a tight coil with a 30cm (12in) length of the 10mm (⅜in) gold paper. The gold paper does not glue very easily, so you need to hold for a few more seconds than with other papers.

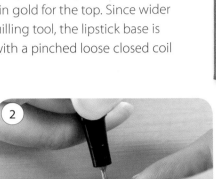

2 Using the gold pen, draw a band around the base of the purple coil. Add suitable words to the side of the coil; I used squiggles to give the impression of text.

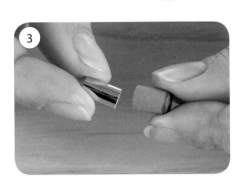

3 Glue the gold coil to the top of the purple coil and hold in place for a few seconds. Make additional bottles of nail varnish using the other purple shades of paper.

TIP
When using different shades of paper, you may find that they are different thicknesses, so even if you use exactly the same lengths of each paper, the coils may vary slightly in size.

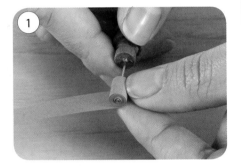

4 For the lipstick bases, place the sheet of purple paper on a cutting mat and use a metal ruler with a cork base to cut several strips 1.3 x 20cm (½ x 8in).

5 Coil one strip around a clean cocktail stick (toothpick). Glue the end in place and remove the stick. Draw a gold band around the base of the coil with the pen. For the lid, make a tight coil with a 40cm (15¾in) length of a matching shade of purple paper and add a gold band.

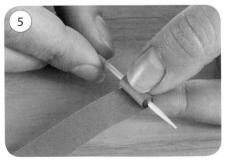

6 Make a tight coil with a 12cm (4¾in) length of the 5mm (³⁄₁₆in) wide gold paper. Glue to the top of the base. Make a loose closed coil with a 7cm (2¾in) length of the red paper. Pinch into a lipstick shape and glue to the gold coil. Make additional lipsticks in the same way with the remaining purple strips.

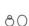

Funky phone

A cutting-edge mobile (cell) phone is the party-goer's essential accessory, for the young or grown-up, so indulge their designer aspirations with this innovative (and inexpensive) paper example. Using pink paper edged with metallic pink adds contemporary-style glitz to the quilled elements.

You will need

- 3mm (1/8in) wide metallic pink-edged pink paper
- pink card
- pink gel pen
- silver stickers – numbers 1–9, 2 stars, cross, square
- clear dome sticker
- photo
- Basic Tool Kit (see page 8)

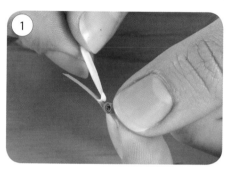

1

To make a single musical note, tightly coil a 5cm (2in) length of the pink paper for 4cm (1½in). Remove the tool and glue the end in place. Leave the tail as it is or bend the top over.

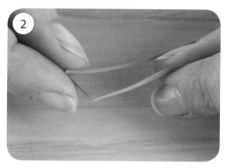

2

For the double notes, take a 10cm (4in) length of the pink paper and make two folds 4.5cm (1¾in) from either end.

TIP
Instead of a photo, you could write a text message.

4

Cut a long rectangular shape from pink card. Using the pink gel pen, draw a grid of nine boxes for the keypad. Add a silver number sticker to each box. Add two stars, a cross and a square sticker above the numbers. Place a clear dome sticker over the area of the photo that you want to use, then trim around the edge. Glue to the top of the phone. Glue the phone to your chosen surface, with the notes arranged either side.

3

Make a tight coil in one end and glue in place. Coil the other end in the same direction and glue in place. Repeat to make a few single and double notes.

INSPIRATIONS

Nailcare novelty tag

Four bottles of different-coloured nail varnish mounted onto a pink card panel make a treat for the eye on this dark purple tag – they look so real, the recipient will be eager to try them out! This would be perfect for presenting a beautycare gift.

Beauty routine

The recess in the front cover of this diary contains a cache of inviting beauty products temptingly revealed through a clear plastic aperture – just the thing for a student following a beauty course or those diehard beauty regime devotees.

Cool phone card

Make your favourite tweeny's day with this state-of-the-art mobile phone card design, with a model that not only plays music but displays a picture of the person who is calling them! The colour scheme could easily be changed for a boy.

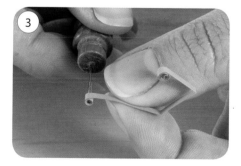

Beach life

The seaside is synonymous with relaxation and pleasure, which makes it a sure-fire success as a subject for your quilled creations. And you only need a key motif to cue all those memories of endless sun-drenched, fun-filled days of leisure. You will also be happily entertained playing with coiled paper shapes to create crazy sea creatures, colourful coral and chic beachwear.

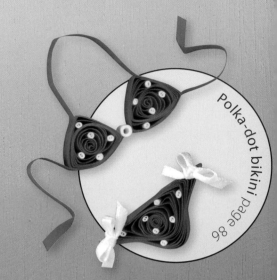

Polka-dot bikini page 86

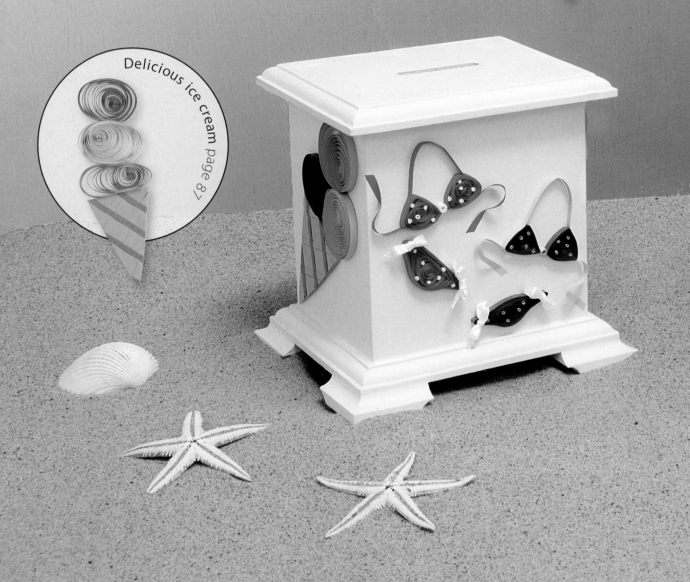

Delicious ice cream page 87

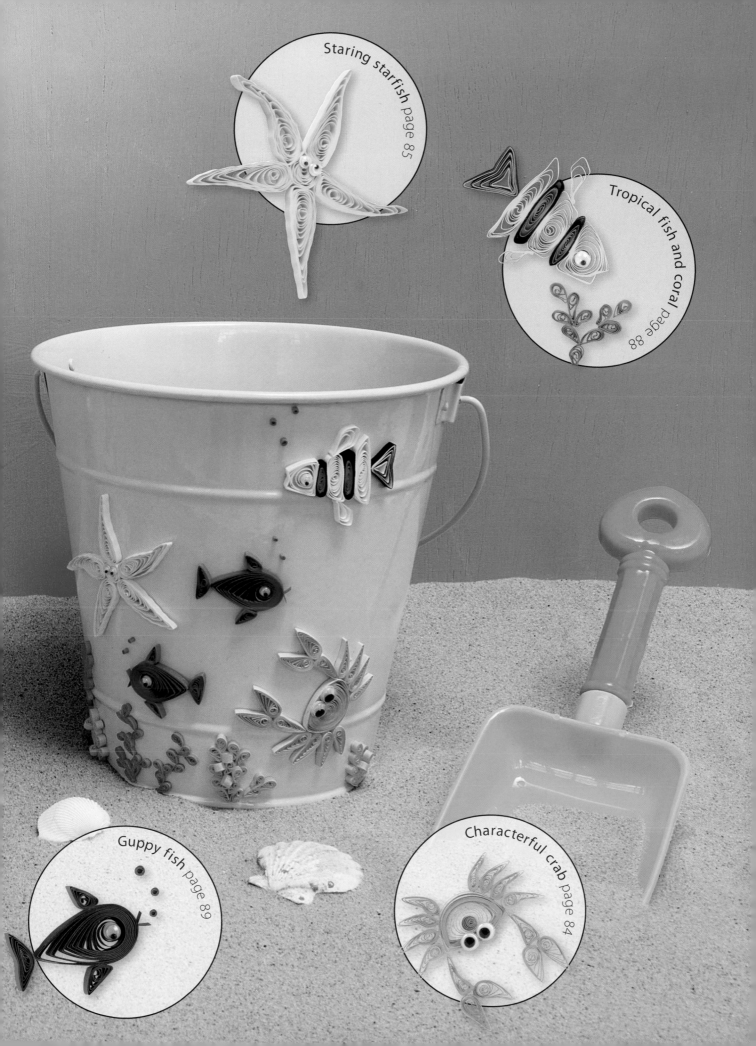

Staring starfish page 85

Tropical fish and coral page 88

Guppy fish page 89

Characterful crab page 84

Characterful crab

This fun quilled crab is made from bold pink paper, giving it instant appeal to children. Beginning with one large loose coil for the body, his attention-grabbing pincers are created by assembling a series of pinched coils, with the legs formed from smaller shaped coils, so that he really looks ready to scuttle away!

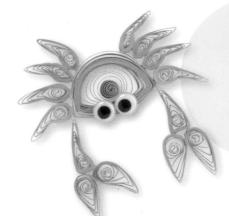

You will need

- 3mm (⅛in) wide pink paper
- 2 wiggly eyes, 6mm (¼in) in diameter
- superglue
- Basic Tool Kit (see page 8)

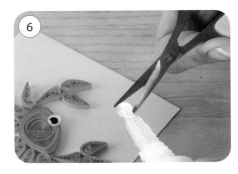

Cut three 45cm (18in) lengths of the pink paper and glue end to end to form a length about 1.35m (53in).

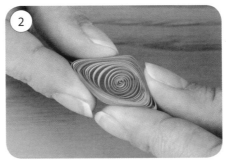

Using your quilling tool, coil the long length of paper into a loose closed coil. Gently squeeze the shape into a crescent with your fingers, trying to avoid pinching the corners, to form the crab's body.

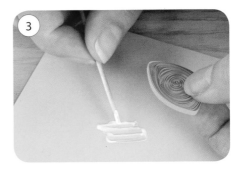

Use a cocktail stick (toothpick) to apply glue to the area on your chosen surface where you want the crab's body to be. Position the crab's body on the glue and hold in place for a few seconds while the glue dries.

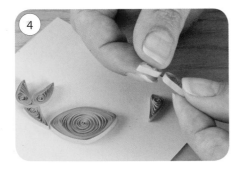

For the pincers, make three loose closed coils from 20cm (8in) lengths of the paper for each pincer. Pinch into teardrop shapes (see page 14) and glue together as shown, then glue onto your chosen surface.

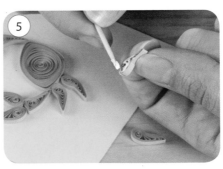

For the legs, make eight loose closed coils from 20cm (8in) lengths of the paper, then pinch into leg shapes and glue in place.

TIP
You can make the crab from brown paper for a more authentic (and less sunburned!) effect.

Holding a pair of scissors in one hand, pick up a wiggly eye between the points of the blades, and with the other hand, place a dot of superglue on the back of the eye. Position the eye on the edge of the crab's body. Repeat with the other eye.

Staring starfish

This cute wiggly-eyed sea creature can be made in any bright colour of your choice. For the starfish's legs, strips of paper are inserted into a ribbler (crimper) to make them wavy before being formed into loose closed coils and pinched into shape, which gives them a slightly rippled appearance as if they are floating in the sea.

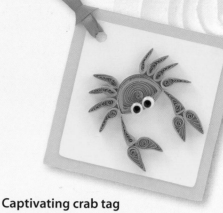

You will need

- 3mm (⅛in) wide yellow paper
- ribbler (crimper)
- 2 wiggly eyes, 2mm (¹⁄₁₆in) in diameter
- superglue
- Basic Tool Kit (see page 8)

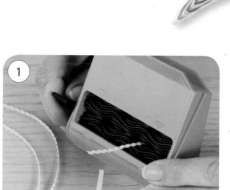

1 Insert a 45cm (18in) length of the paper into the ribbler (crimper) and turn the handle so that the paper is pulled through and ribbled or crimped. Repeat with a further four 45cm (18in) lengths.

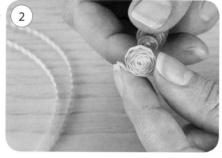

2 Make loose closed coils with the five ribbled lengths of paper; be sure not to hold the paper too tightly while coiling.

TIP
If you don't have wiggly eyes, make two closed coils from white strips of paper, adding a dot of black pen to each centre, then attach with PVA (white) glue.

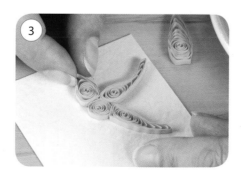

3 Pinch each of the five coils at one end to make long tendril shapes. Make a loose closed coil from a 20cm (8in) length of ribbled paper and glue to your chosen surface. Glue the starfish tendrils around the central coil, holding in place while the glue dries. Glue on the wiggly eyes with superglue (see Step 6 opposite).

INSPIRATIONS

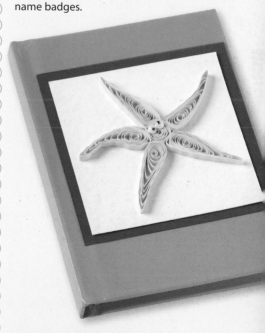

Captivating crab tag
Add a touch of entertainment to a gift package by creating this humorous tag, where this cheeky, 'eye-catching' crab looks like he is about to grab the goodies for himself! The colour scheme can easily be changed to coordinate with the giftwrapping. Alternatively, it could be used to decorate party bags or invitations for a beach or summertime party, or attached to small card shapes to make name badges.

Starfish-struck notebook
Bring novelty value to an ordinary notebook by adding this friendly starfish character to the cover, thereby transforming it into a personalized gift item. It would be perfect for a youngster's holiday journal or scrapbook. Or use it as the focal point for a quirky bon voyage or retirement card.

Polka-dot bikini

The spotted fabric-effect of this classic item of beachwear is convincingly achieved here by inserting small white tight coils into pinched loose closed coil shapes between the inner coils, so that they become integral to them.

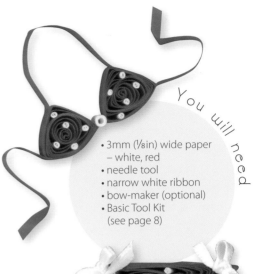

You will need

- 3mm (⅛in) wide paper
 – white, red
- needle tool
- narrow white ribbon
- bow-maker (optional)
- Basic Tool Kit
 (see page 8)

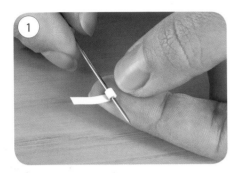

1 Wrap a 5cm (2in) length of the white paper around a needle tool and glue the end in place.

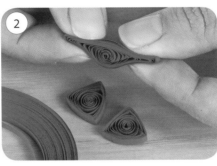

2 For the bikini top, make two loose closed coils with 40cm (15¾in) lengths of the red paper and pinch into triangles (see page 14). Repeat with an 80cm (32in) length for the bikini bottom and pinch into a triangular shape. Glue the two smaller triangles to either side of the white coil.

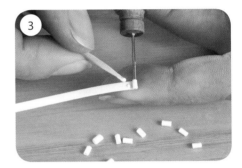

3 Using the quilling tool, make tight closed coils with 1–1.5cm (⅜– ⅝in) lengths of white paper, turning the tool about three times and gluing the end in place before removing the coil from the tool. Five per bikini triangle are needed.

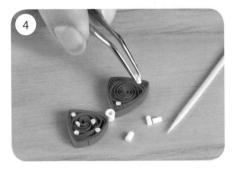

4 Pick up the tiny white coils with tweezers and insert into the bikini. If gluing to card, apply glue to the base, but if you are making a freestanding piece, apply glue to the sides of the coils. You may need to use a cocktail stick (toothpick) to push the inner red coils to one side to insert the white coils.

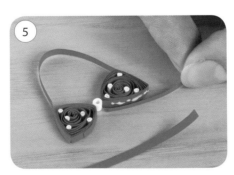

5 For a halter-neck strap, glue an 8cm (3⅛in) length of red paper to the outside edges of the triangles. For the back straps, apply glue along the bottom of each triangle and adhere a 4cm (1½in) length of red paper to each. Trim the ends to a point.

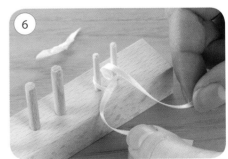

6 Here, mini white bows were made with narrow ribbon and a bow-maker. Alternatively, you can buy ready-made bows or carefully tie your own. Glue a bow to either side of the bikini bottom.

TIP

If you find inserting the white coils too fiddly, you could add very small dots of glitter glue instead.

Delicious ice cream

Weaving with pre-cut strips of paper is another way of adding a further decorative dimension to your quilled designs, and here two different widths and shades of brown paper are woven together to replicate the texture and appearance of a wafer cone, temptingly topped with gently squeezed loose closed coils for scoops of ice cream.

You will need

• 3mm (⅛in) wide brown paper, plus strawberry pink, vanilla cream, pistachio green
• 10mm (⅜in) wide brown paper a shade lighter
• foam block and pins
• double-sided tape
• Basic Tool Kit (see page 8)

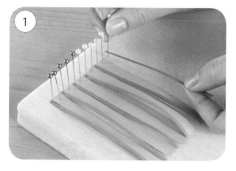

1 Pin strips of brown paper, alternating between the 3mm (⅛in) and 10mm (⅜in) wide, onto a foam block – all the pieces here are 10cm (4in) in length, but it depends on how large you want the ice cream cone to be.

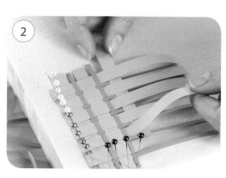

2 Weave a 10mm (⅜in) wide piece of brown paper up and over, then down and under the pinned strips. Pin this at the end to hold it in place. Weave a 3mm (⅛in) wide piece through, starting by going under, then going over. Continue until you have a square of woven paper.

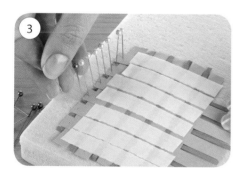

3 Place double-sided tape over the back of all the strips. Leave the backing paper on. Remove the pins and lift the paper from the board.

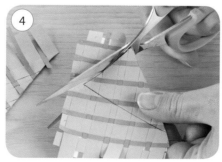

4 Using the template on page 118, cut out a cone from the woven paper. You can then mount the cone onto your chosen card or other surface using the double-sided tape. You will also need to apply glue to the woven ends that are not stuck with tape. For the ice cream, make three loose closed coils from three 40cm (15¾in) lengths glued together end to end of the pink, vanilla and green paper.

TIP
Alternatively, you could make a woven square and cut out a basket shape to fill with quilled flowers (see Flower Power, pages 38–47).

INSPIRATIONS

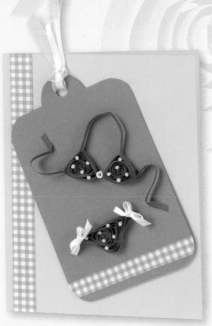

Beach babe
A polka-dot bikini will always be in vogue, and here it adorns a bright, sunny card suitable for a teenager, either on the occasion of their summer birthday or as a post-study vacation send-off. The strips of blue checked paper add a snappy complementary trimming to both the tag and card spine.

A cone of note
Transform a workaday notepad by giving it the seaside treatment with this delectable ice cream cone – a gift that's guaranteed to bring an instant lift to any recipient. You can change the ice cream colours to coordinate with the notepad cover and pen.

Tropical fish and coral

Create this strikingly marked fish for an exotic underwater design by simply alternating contrasting-coloured loose closed coils, pinched into the appropriate shape. The tail is then ingeniously made to match by hand looping different coloured strips together and forming into a triangle.

You will need

- 3mm (⅛in) wide paper – yellow, blue, black, orange
- 2mm (¹⁄₁₆in) wide pink/orange paper
- wiggly eye, 4mm (⅛in) in diameter
- needle tool
- Basic Tool Kit (see page 8)

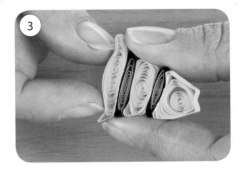

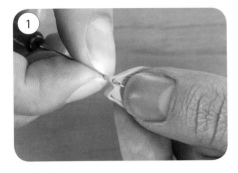

1

For the head, make a loose closed coil from a 30cm (12in) length of the yellow paper. Pinch the coil at two points on one side, then use a needle tool to pull out a section on the opposite side while pinching it with your fingernail to make a fish mouth shape.

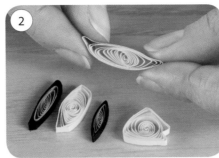

2

The body is comprised of several loose closed coil shapes: 10cm (4in) of blue glued to 10cm (4in) of black, coiled with the black on the outside; 30cm (12in) of yellow; 15cm (6in) of blue glued to 15cm (6in) of black, coiled with the black on outside; 40cm (15¾in) of yellow; all pinched as shown.

3

Apply glue to the sides of the pieces and assemble. While the glue is still drying, hold the fish shape and squeeze it together quite firmly.

TIP

Since tropical fish come in all sorts of bright colours, you can use up leftover paper in whatever colours you happen to have.

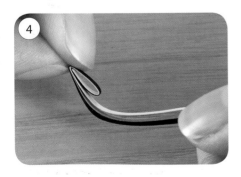

4

For the tail, glue a length of black, yellow and blue papers together at one end, then form a loop 1cm (⅜in) high with all three papers and glue at the base.

5

Loop again and glue and then for a third time. Glue the ends and trim the excess – it is easier to work with longer lengths and trim at the end. Flatten the shape by pushing inwards with your finger to make a triangle. Glue to the fish body.

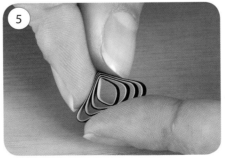

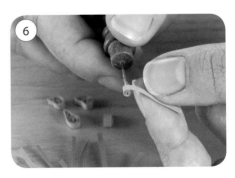

6

For the coral, make loose closed coils with 6cm (2⅜in) lengths of the 2mm (¹⁄₁₆in) pink/orange paper and the 3mm (⅛in) wide orange paper, then pinch into bent teardrops (see page 14). Assemble and glue to your chosen surface to resemble coral (see Gone Fishing opposite).

Guppy fish

More than one strip of paper can be coiled at once, and here three different colours are joined end to end to make this eye-catching rainbow-hued fish. And by trimming the beginning of the joined strip to make it narrower, space is cleverly created to insert a wiggly eye so that it sits flush with the fish.

You will need

- 3mm (⅛in) wide paper – dark green, blue, paler green, turquoise
- wiggly eye, 4mm (⅛in) in diameter
- Basic Tool Kit (see page 8)

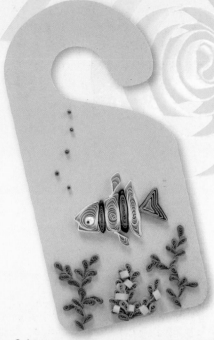

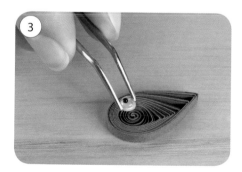

Glue three 40cm (15¾in) lengths of the paper together at one end, one dark green, one blue and one paler green. Cut along the length for 5cm (2in) from the glued end to cut the pieces in half. Trim off one half.

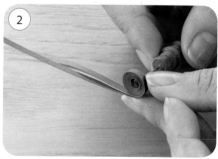

Make a loose closed coil, starting at the narrower end, trimming the excess paper at the ends before gluing, as in Step 2, page 33. Pinch the coil into a teardrop shape (see page 14).

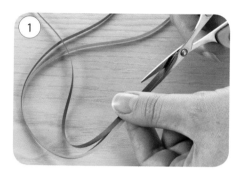

Place a wiggly eye in the centre of the coil; because this was cut narrower, the eye will be inset slightly.

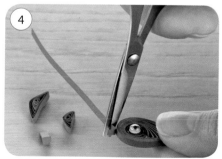

For the fins, make two loose closed coils with 10cm (4in) lengths of the turquoise paper and the tail with a 20cm (8in) length, then pinch into triangular shapes (see page 14). For the mouth, fold a strip of blue paper close to one end, apply glue to the fold and attach to the fish. Leave to dry, then trim the excess paper.

Gone fishing

Here, the tropical fish and coral have been combined to create a convincing underwater scene, complete with tight closed coils for bubbles, glued to a mini door hanger cut from card (template on page 119). You could add a humorous message to the hanger, such as 'I'd rather be scuba diving!'

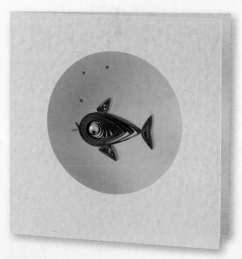

Fish bowl

For this simple yet highly effective card design, a circle was cut in the front panel of a blue square folded card and acetate mounted behind. The guppy fish and bubbles – again, tight closed coils – were then glued to the acetate to enhance the watery effect, for all those who can't have enough of the sea.

Nicely nautical

Sail boats page 95

It can be difficult to find themes that are suitable for males, but these seafaring designs are sure to find favour with many lads and dads, especially when made in traditional nautical colours, which also adds an appealing authenticity. The functional ship's compass will attract the most hardened of sailors, while the jolly flotilla of sailing boats is sure to delight any child.

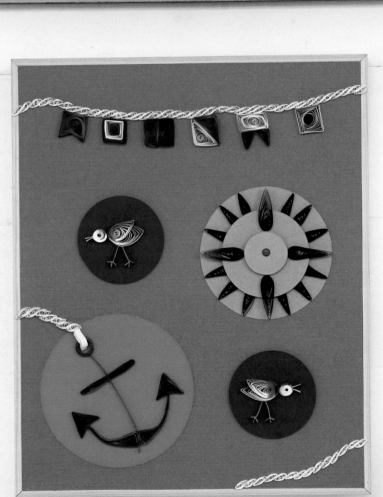

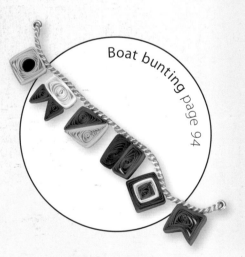

Boat bunting page 94

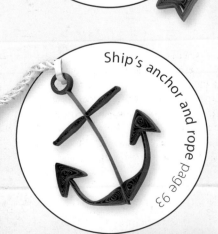

Ship's anchor and rope page 93

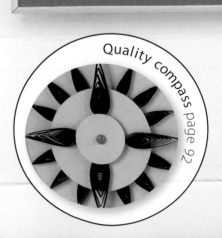

Quality compass page 92

Stalking seagull

This cheering seabird is a staple of nautical life, and can be successfully constructed from a combination of three different pinched coils. To achieve the subtle colouring on the wings and body, grey ink from an inkpad is rubbed onto white coils with a cotton bud, so that you can control where the colour is applied and how much.

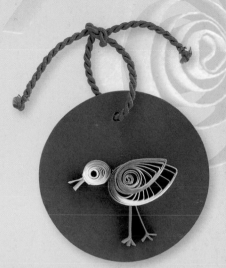

You will need
- 3mm (⅛in) wide paper – white, black, yellow, orange
- grey inkpad
- cotton bud
- Basic Tool Kit (see page 8)

For the body, make a loose closed coil from a 40cm (15¾in) length of the white paper and pinch into a teardrop (see page 14). Repeat for the wing but with a 30cm (12in) length of paper. Press a cotton bud into the inkpad to pick up some grey ink. Rub the cotton bud onto the edge of the body to colour the paper.

TIP

The seagull need not have legs; it could be depicted resting on an anchor – see page 93.

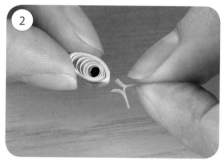

For the head, glue a 1cm (⅜in) length of the black paper to a 25cm (10in) length of white paper. Start coiling tightly from the black paper, and when the white is reached, add a dot of glue, then continue coiling to make a loose closed coil. Pinch very slightly into a head shape. Apply ink as in Step 1. For the beak, fold a length of yellow paper into a 'W' shape and glue inside the fold. Glue to the head.

For the legs and feet, make three mini concertina folds in the centre of a 4cm (1½in) length of the orange paper, each about 2mm (¹⁄₁₆in) wide.

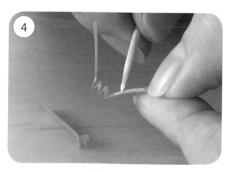

Apply glue inside each fold and along the length and press together. Repeat to make the second leg and foot. Assemble and glue the bird together, with the wing on top of the body.

INSPIRATIONS

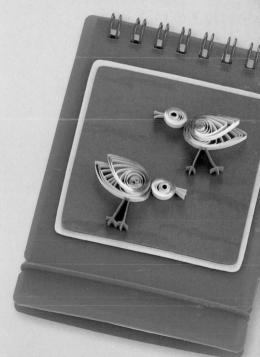

Tagged seagull
A single seagull is glued to a disc of deep blue card punched and threaded with matching blue cord to make a cute tag – perhaps for a going-away gift for someone departing on a birthday or anniversary cruise.

Noteworthy seabird
Two seagulls have been used here to decorate the cover of a small spiral-bound notebook – the ideal gift for a budding birdwatcher. Note how you can vary the stance of the bird by the way in which the head and legs are positioned, for added animation and visual interest.

Quality compass

Every sailor or sea fisherman needs a good compass and here pinched quilled coils applied to concentric circles of card in two layers point the way. This design illustrates yet another use for the versatile pinched teardrop shape.

You will need

• blue card
• 3mm (⅛in) wide black paper
• 2mm (¹⁄₁₆in) wide red paper
• graph paper
• red brad
• circular protractor or compass
• quilling board (optional)
• adhesive foam pads
• Basic Tool Kit (see page 8)

Draw around the circular protractor onto graph paper or use a compass to draw a 10cm (4in) diameter circle. Divide the circle into quarters and each quarter into four equal segments. Then add three inner circles, 7.5cm (3in), 5cm (2in) and 2.5cm (1in) in diameter. Cut three circles from blue card the same diameter as these three circles.

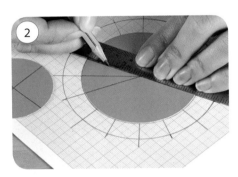

Place the largest card circle on the drawn circle and draw in the dissecting lines, leaving out the North–South (vertical) and East–West (horizontal) axes. Use faint pencil marks – here, darker pencil lines were used in order to show up in the photo. Place the smaller circle in position and draw in the remaining axes.

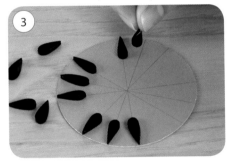

Make 24 loose closed coils with 20cm (8in) lengths of the black paper and pinch into teardrops (see page 14) – you may want to use a quilling board to ensure that they are all the same size. Glue to the largest circle along the marked lines, points outwards and aligned with the edge.

TIP
You could add quilled letters to indicate the compass points – see page 104 for instructions.

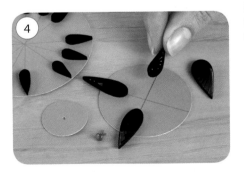

Make four teardrops in the same way with 40cm (15¾in) lengths of the black paper. Glue along the marked lines on the smaller circle, points outwards but overlapping the edge. Insert a brad into the centre of the smallest circle, then mount onto the larger circle with adhesive foam pads.

Ship's anchor and rope

This sturdy-looking anchor is constructed from a combination of simple loose closed coil components, pinched and bent into shape, apart from the top ring, which is formed around a wooden spoon handle or dowel. The challenge here is to match both sides of the anchor as closely as possible.

You will need

- 3mm (⅛in) wide paper – grey, white
- wooden spoon or dowel, 7mm (¼in) in diameter
- Basic Tool Kit (see page 8)

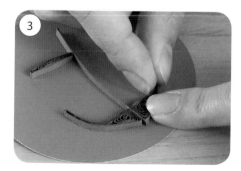

Wrap a 30cm (12in) length of the grey paper around the handle of the wooden spoon or dowel, glue the end in place and remove. Make two loose closed coils from 40cm (15¾in) lengths, pinch each into two corners at one end and press flat at the other. Make two loose closed coils with 30cm (12in) lengths, then pinch into arrow shapes as shown, and two with 20cm (8in) lengths, then squeeze flat for the cross pieces.

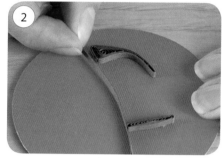

Glue one of the long pinched coils for the bottom of the anchor to your chosen surface, bending the flat end upwards and holding in place while the glue dries. Glue one of the cross pieces in place. For the central piece of the anchor, glue two 6.5cm (2½in) lengths of the grey paper together lengthways, then curve slightly and glue at right angles to the bottom and cross pieces.

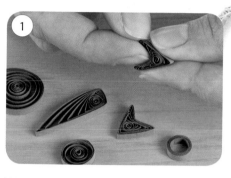

Glue on the second bottom and cross pieces on the other side of the anchor, as in Step 2. Add the round coil to the top.

For the rope, make several loose closed coils with 8cm (3⅛in) lengths of the white paper. Pinch each into an 'S' shape, then glue together as shown for a linked effect.

TIP

The rope could be made with brown or blue paper instead, or for a racing sailor, use bright colours such as green or red.

INSPIRATIONS

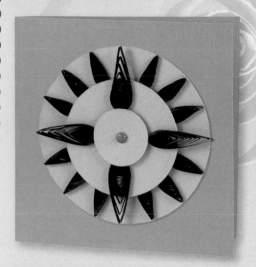

Directional design

The quilled compass simply mounted onto a deep blue square folded card makes a memorable design for a sailor, orienteer, walker or hiker. Alternatively, attach it to the cover of a photo or scrapbook album for capturing those great adventures over land or sea.

Artistically anchored

Transform a plain notebook into a sea captain's logbook with the quilled anchor motif. Simply mount onto a red card circle and attach the rope to the top of the anchor, letting it trail off onto the notebook cover. The same design could be used for a striking bon voyage card.

Boat bunting

These bright and breezy ship's flags, in traditional nautical colours, are quick and easy to make by sticking together pinched coil rectangles and triangles in different combinations, except for a clever trick used for the yellow flag, where the centre of a pinched square is cut out to make way for a black coil.

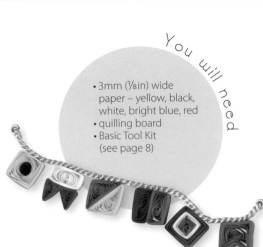

You will need

• 3mm (⅛in) wide paper – yellow, black, white, bright blue, red
• quilling board
• Basic Tool Kit (see page 8)

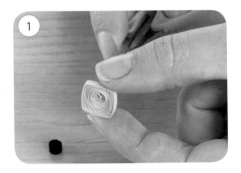

For the yellow flag, make a loose closed coil with a 40cm (15¾in) length of the yellow paper and pinch into a square (see page 14). Using the points of a small pair of scissors, cut out the centre of the coil and discard. Make a loose closed coil from an 8cm (3⅛in) length of the black paper. Insert into the centre of the yellow square.

TIP
Restrict the colours to traditionally nautical ones for an authentic look.

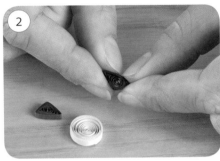

For the blue and white flag, make a loose closed coil from a 40cm (15¾in) length of the white paper and pinch into a rectangle (see page 15). Make two loose closed coils from 20cm (8in) lengths of the blue paper and pinch into right-angled triangles (see page 14). Try to make the paper join on the side that will be glued to the white rectangle. Glue the triangles to the white rectangle.

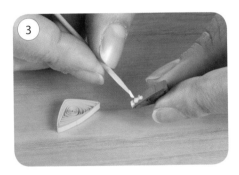

For the red and yellow flag, make a coil with a 40cm (15¾in) length of the red and yellow papers. Apply glue to the end of each, insert into the 1.6mm (1/16in) diameter circle template of a quilling board and release, to make a uniform size. Pinch the loose closed coils into right-angled triangles, with the paper join on the longest side, and glue together.

For the red and blue flag, make a red and blue loose closed coil with 40cm (15¾in) lengths using a quilling board, as in Step 3. Pinch into rectangles, with the paper join on the longest side, and glue together.

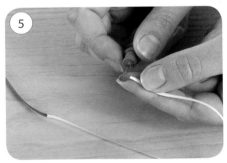

For the red, white and blue flag, glue a 10cm (4in) length of the red paper to a 20cm (8in) length of the white, then glue the white to a 30cm (12in) length of the blue. Start coiling from the red paper and make a loose closed coil, then pinch into a square.

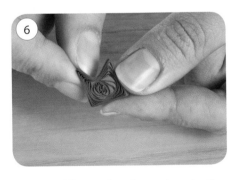

For the red flag, make a loose closed coil from a 60cm (23¾in) length of the red paper and pinch two corners on one side, then pinch into two triangular shapes on the other.

Sail boats

These simple, stylized boats are especially designed to appeal to children, and here the sails can be any mixture of bright colours that will attract and maintain their attention.

You will need

- 3mm (⅛in) wide paper – red, blue, pale blue, dark blue, brown
- 2mm (¹⁄₁₆in) blue paper
- Basic Tool Kit (see page 8)

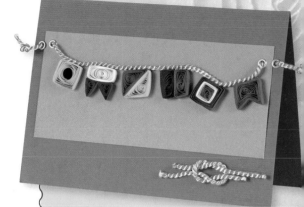

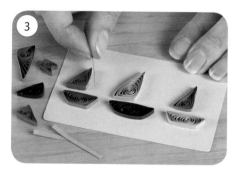

For the three boats, the large and small sails for each (left to right) consist of loose closed coils made with a 30cm (12in) length of red, a 20cm (8in) length of 3mm (⅛in) blue, a 40cm (15¾in) length of pale blue, a 40cm (15¾in) length of dark blue, a 30cm (12in) length of blue and a 20cm (8in) length of red, each pinched into triangles (see page 14).

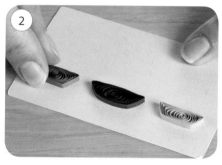

For the boat hulls, make loose closed coils with a 40cm (15¾in) length of the 3mm (⅛in) dark blue paper and 30cm (12in) lengths of the pale blue and blue 3mm (⅛in) papers. Pinch into shape and glue onto your chosen surface, with the larger hull in the centre.

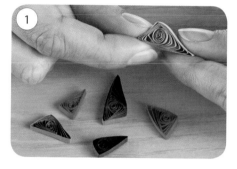

Glue the three larger triangles above each hull. For the masts, glue vertical lengths of the brown paper trimmed to measure 2.5cm (1in) for the smaller boats and 3.5cm (1⅜in) for the larger one. For the red flag, make a loose closed coil with a 20cm (8in) length of the red paper, pinch into shape and glue at the top of the large boat's mast.

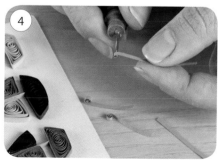

For the waves, cut 2–3cm (¾–1⅛in) lengths of the 2mm (¹⁄₁₆in) blue paper and coil at one end without gluing. Glue beneath the boats.

Flying colours

For this uplifting card design, the six flying flags are glued to a length of cord threaded through a double set of holes that has been punched either side of the folded card and fixed with eyelets. Short lengths of the rope tied into a sailing knot add an extra nautical note. This would be ideal for sending a message of congratulations on passing an important exam or test.

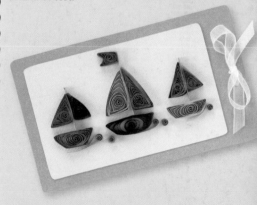

Sailing team tag

The three jolly quilled boats are seen bobbing along on a pale blue card panel mounted onto a darker blue rectangular tag threaded and tied with white sheer ribbon – a lovely design for a baby or young child's gift. It would make an equally effective greetings card for an adult sailing enthusiast.

Cooking capers

Liven up your kitchen – and those of your friends and family – with some cunningly quilled culinary items. Ceramic storage jars, for instance, can be transformed by the addition of delicate herb sprigs, bright red chillies and plump olives, or a metal tin jazzed up with coffee beans. Alternatively, use to create unique greetings cards for aspiring chefs.

Red hot chilli pepper page 98

Aromatic rosemary page 101

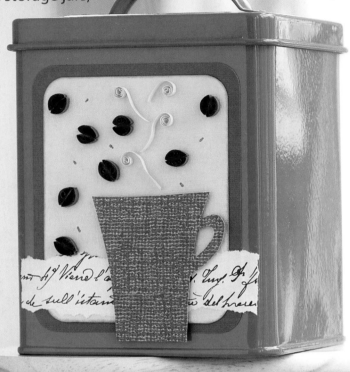

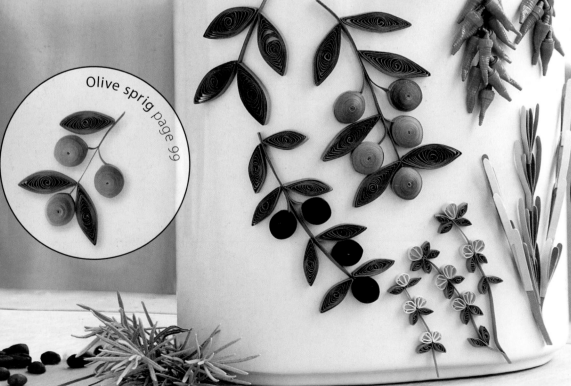

Olive sprig page 99

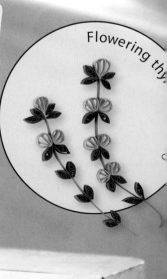

Flowering thy

Real coffee

These coffee beans are proof that just about anything can be made with quilling! They are created with miraculous ease by gluing together two crescent-shaped pinched coils. Any shade of brown paper can be used and the shapes are best when not uniform, so several can be made in a short space of time.

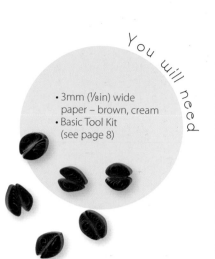

You will need

- 3mm (⅛in) wide paper – brown, cream
- Basic Tool Kit (see page 8)

1

Make loose closed coils with 10cm (4in) lengths of the brown paper. You will need two per coffee bean, so decide how many you need.

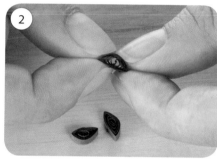

2

Pinch each coil into a crescent shape (see page 14), making sure that the join is at the top, pressing your fingernails inwards on either side.

3

Take two crescent shapes and place glue along the flat edge of one. Press the flat side of the other shape to the glue and hold in place for a few seconds while the glue dries.

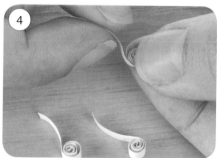

4

To make steam, cut 5cm (2in) lengths of the cream paper and make an open coil in the end of each one. Remove the tool and use your fingers to open the coil a little further. Use a fingernail to curl the other end of the paper.

TIP

Real coffee beans are many shades of brown, so add a few beans made in different brown papers.

INSPIRATIONS

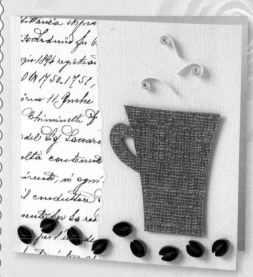

Café sensation

A decorative border of quilled coffee beans is combined here with a coffee mug cut from brown card (template on page 119) and rising coils of steam, mounted onto a pink folded card. A side panel of script-printed paper adds to the sophisticated, café society-style feel of the design. This would be ideal for a 'come round for coffee' or 'let's meet up for a chat' invitation, either for a friend or as a welcome to a newcomer to quilling.

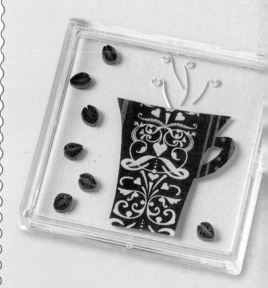

Coffee coaster

This transparent plastic coaster with a built-in recess features a coffee mug (template on page 119) cut from a piece of brown patterned paper with steam curls rising from it, framed by a scattering of coffee beans. This is ideal for resting your reviving beverage on when you are busy quilling!

Red hot chilli pepper

This amazingly realistic red chilli is created from a quilled cone shape, as for the carrots and tool handles in the Gardening gems chapter (see pages 24, 26 and 29), but then deliberately misshapen to create its characteristic twisted, slightly crumpled appearance – you can be quite rough with the cone after the glue inside has dried. The final coating of glue gives it an authentic shiny skin.

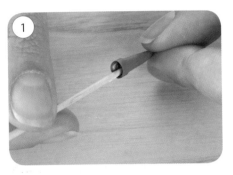

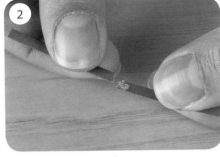

Glue a 4cm (1½in) length of the green paper to a 5cm (2in) length of the red paper end to end.

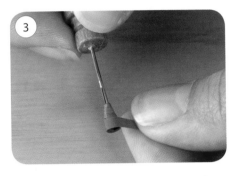

Start coiling from the green paper as if you are making a cone, then when the red paper is reached, stop angling the paper to produce a flat coil. Glue the end in place.

Insert one end of a 20cm (8in) length of the red paper into your quilling tool. Coil tightly for three turns, then continue to turn the tool but angle the paper away from the tool and make sure that the paper overlaps enough to create an elongated cone shape (see Step 3, page 24). Using a cocktail stick (toothpick), apply glue all the way down inside the cone – it is important to leave it to dry thoroughly.

TIP
You can vary the lengths of the papers used to make chillies of different sizes, or use green paper to make green chillies.

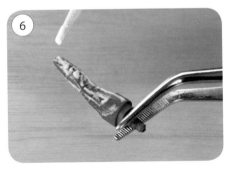

Hold the end with tweezers and apply a good coat of PVA (white) glue all over the chilli. To avoid it sticking, place on acetate to dry. When dry, remove from the acetate and glue to your chosen surface or object.

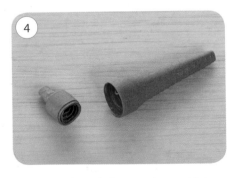

Insert into the red elongated cone. Make several cones and tops and then assemble, as they will all be fractionally different sizes, so if one doesn't fit, you can try another.

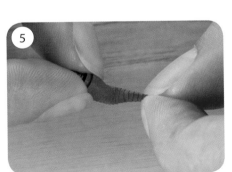

Pinch, press and squeeze the cone to make it look chilli-like, but avoid pulling it, otherwise the cone will unravel, despite being glued inside.

Olive sprig

Real olives come in differing hues of green and black, and also vary in size, so let nature be your guide in making these olive sprigs convincing. The fruits are formed from tightly coiled long lengths of paper, with the inner edge gently pushed out to create a domed shape.

You will need
• 3mm (⅛in) wide paper – olive green and/or black, sea green
• Basic Tool Kit (see page 8)

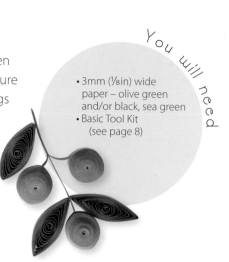

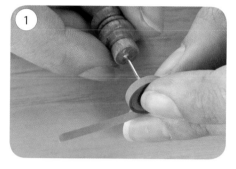

1 Glue three 40cm (15¾in) lengths of the olive green paper together end to end. For black olives, glue two 40cm (15¾in) lengths of the black paper together end to end. Use to make tight closed coils, holding your fingertip over the end to keep the coil flat.

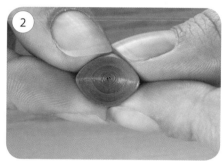

2 Using the nails of both thumbs, push up the inner edge of the coil (see Step 1, page 25); try to avoid pushing up the centre, as this makes the shape too high. Spread glue all over the inside and leave to dry, then pinch the shape into an oval.

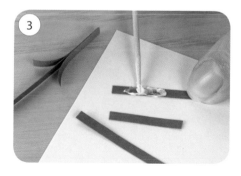

3 For the stalk, cut an 8cm (3⅛in) length of the sea green paper and place on scrap paper. Cut 5cm (2in) lengths of the paper and spread with glue, stopping 1cm (⅜in) from the end. Press the glued lengths onto the longer length. These lengths can vary depending on how long you want the olive sprig.

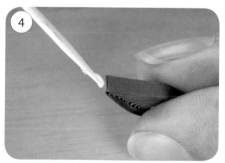

4 For the leaves, make loose closed coils from 40cm (15¾in) of the sea green paper. Pinch both at opposing points to make leaf shapes, ensuring that the join is at one end. Apply glue to the ends and attach to the stalk. Leaves for the black olives are made from 20cm (8in) lengths of the same green paper.

INSPIRATIONS

Turn up the heat

For this eye-catching gift item, a small square of bright green card was placed inside a transparent plastic key ring with a recess, then three red chillies glued vertically in alternating directions to the card and the lid replaced. The chillies were slightly squashed in the process, but this only adds to the effect. This design would also make a great gift tag for a kitchen-related present.

Italian job

Delight even the most discerning food connoisseur with a bottle of top-quality extra virgin olive oil and fashion your own special label, decorated with quilled sprigs of both black and green olives. Alternatively, a sprig or two of olives could be mounted onto a rectangular piece of card, then punched and threaded with raffia and tied around the bottle neck.

Flowering thyme

The petite flowers of this favourite culinary herb are re-created in quilling using the hand-looping method, in a similar way to the leaves on page 46, but in this case on a tiny scale. If you find this technique too fiddly, you can use the husking technique instead (see page 16), inserting pins into a board and wrapping the papers around them, to make slightly larger flowers.

You will need

• 3mm (1/8in) wide paper – pink, dark green, brown
• Basic Tool Kit (see page 8)

For the flowers, bend rather than fold over 5mm (3/16in) at one end of a 15cm (6in) length of the pink paper.

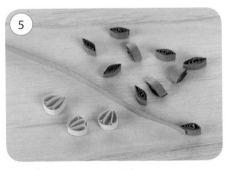

Take the paper strip round and up the other side of the end of the paper to form a loop.

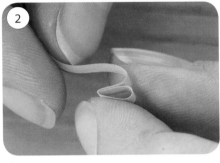

Take the paper back round the other side to make a loop on the other side of the first loop.

TIP
As the thyme sprig is very small, you may wish to use a magnifier to make it (see page 10).

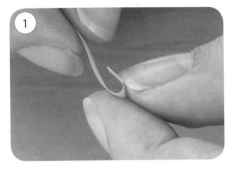

Take the paper right the way round the three loops to encapsulate them and then trim the end and glue in place. Each flower uses a length of paper 5–6cm (2–2⅜in), but it is easier to use a longer piece and trim the end. Make several flowers.

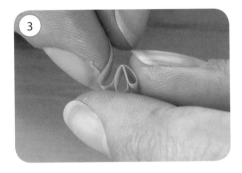

For the herb leaves, make small loose closed coils with 4cm (1½in) lengths of the dark green paper. For the stem, glue two 10cm (4in) lengths of the brown paper together lengthways. Glue a leaf to the end of the stem.

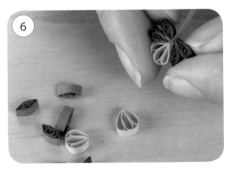

Glue a flower to the leaf and then glue a leaf the other side, then two more leaves either side. Use both hands to hold in place while the glue dries. Glue another flower further down the stem with two leaves. Continue in the same way to complete the sprig.

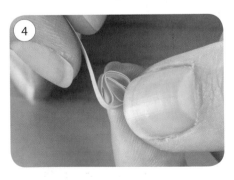

Aromatic rosemary

Quilling papers can be used in a variety of ways, not just for coiling. The needle-like leaves of this highly scented herb are surprisingly easy to replicate by gluing a grey and green strip of paper together lengthways and trimming to round at one end.

You will need

- 3mm (⅛in) wide paper – green, grey, brown
- Basic Tool Kit (see page 8)

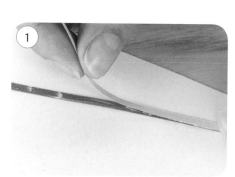

For the leaves, place a 10cm (4in) length of the green paper on scrap paper. Apply glue along the entire length. Top with a 10cm (4in) length of the grey paper.

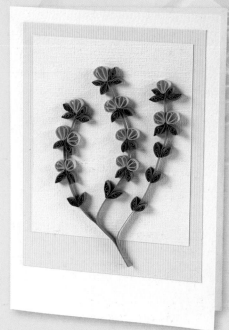

Pick up the glued-together papers and run your fingertips down either side to ensure that the papers are glued down thoroughly and the edges are even.

Cut 3cm (1⅛in) and 2cm (¾in) lengths from the glued-together papers. Round one end of each piece with scissors.

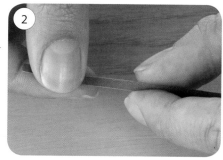

For the stem, cut a 10cm (4in) length of the brown paper. Glue the leaves to the stem in groups of four (two leaves either side), with the smaller leaves on the inside and the grey side facing outwards.

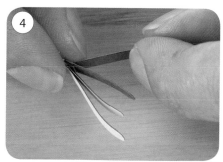

TIP

When gluing the lengths of paper together, your hands will become sticky, so wash them regularly.

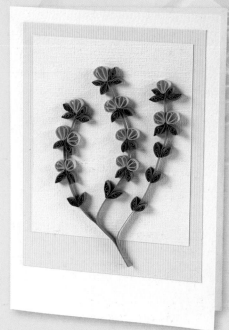

Thyme to celebrate

A delicate sprig of flowering thyme is used here to make a charming greetings card suitable for all kinds of purposes – for a get well or thank you message or to mark the occasion of Mother's Day or a birthday. It would also make a lovely motif for the cover of a cook's diary or recipe cuttings folder.

Herbal helper

Two sprigs of rosemary tied with pretty satin ribbon and glued to a wooden plant label make a welcome gift for someone who loves to grow their own culinary herbs – it could be packaged up with a seed tray and herb seeds. Alternatively, you could glue a magnet to the underside to make a foodie fridge magnet.

Party time

Letters and numbers page 104

Flaming candles page 105

Take the opportunity to introduce a new generation to the wonderful craft of quilling with party bags, place cards and gift tags decorated with quilled designs – that way, it's sure to endure for the next 500 years! Here are easily made, brightly coloured balloons and 3-D tactile candles, together with letters and numbers to create personalized items of party ware.

Floating balloon

Balloons are a perennial party favourite and are quick to quill, being formed from two loose closed coils, one large and slightly pinched for the main shape and the other small and pinched into a triangle for the base. The former looks most effective when the inner coils are positioned centrally, so are best made in a quilling board and manipulated accordingly.

You will need

- 3mm (⅛in) wide green paper or colour of your choice
- 2mm (1/16in) red paper or contrasting colour of your choice
- quilling board
- Basic Tool Kit (see page 8)

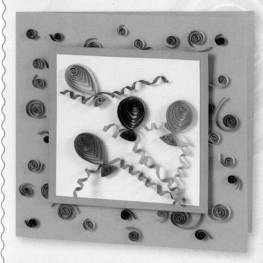

Spiral-bound balloons

Give a birthday celebration a memorable send-off with this balloon bonanza, three tied down and another floating free. The surrounding card is decorated with open coils made with 5cm (2in) and 10cm (4in) lengths of 2mm (1/16in) wide papers in a variety of colours for added pizzazz.

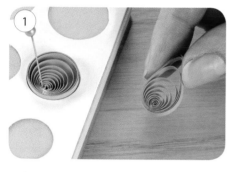

Make a coil with a 40cm (15¾in) length of the 3mm (⅛in) wide paper. Apply glue to the end, then insert the coil into the 2cm (¾in) diameter template in the quilling board. Let the coil release to fit the circle. Use a pin to bring the coil centre to the edge where the paper join is, press the pin into the board and apply a dot of glue to hold in place (see Steps 2–3, page 79). Remove the pin and shape and pinch the coil slightly to make a balloon shape.

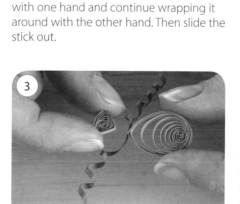

Wrap a 10cm (4in) length of the 2mm (1/16in) wide paper around a clean cocktail stick (toothpick). Hold one end in place with one hand and continue wrapping it around with the other hand. Then slide the stick out.

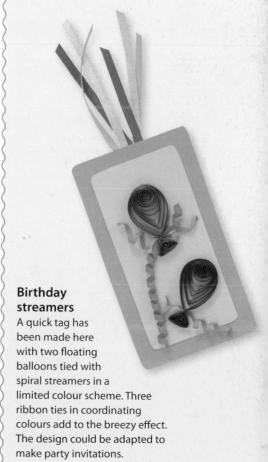

Birthday streamers

A quick tag has been made here with two floating balloons tied with spiral streamers in a limited colour scheme. Three ribbon ties in coordinating colours add to the breezy effect. The design could be adapted to make party invitations.

TIP
You could make a big balloon from a long length of paper formed from several lengths glued end to end and add peel-off sticker numbers for a milestone birthday, such as 40 or 21.

Make a loose closed coil with a 15cm (6in) length of the 3mm (⅛in) paper and pinch into a triangle (see page 14). Glue the spiral to the base of the balloon shape and then glue on the triangle, sandwiching the spiral between the other two shapes.

Letters and numbers

Capital letters look particularly decorative in quilling and are deceptively easy to make. The following instructions show you how to make A, B and C, but by applying the same principles of folding, coiling and gluing the components together, the whole alphabet can be quilled (see page 92 for further examples). Stylish numbers are just as simple to create in the same way.

You will need
- 3mm (⅛in) wide paper in the colour of your choice
- Basic Tool Kit (see page 8)

For the letter A, fold a 15cm (6in) length in half and coil both ends. Make an 'S' scroll (see Step 3, page 52) with a 5cm (2in) length of the same paper and then position this in the centre for the cross bar.

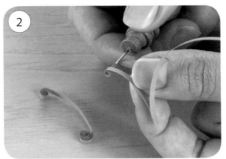

For the letter B, coil either end of a 5cm (2in) length towards each other. Fold a 10cm (4in) length in half and apply a dot of glue to the fold. Coil the ends outwards, then glue to the first length.

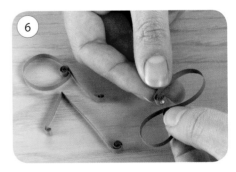

For the letter C, coil either end of a 15cm (6in) length, but use your fingernail to curl the centre portion.

Numbers 1–9 are made in the same way as the letters, as shown. These are the lengths required for each; the measurements can be made larger or smaller so long as the proportions remain the same. Number 1: 7cm (2¾in) and 3cm (1⅛in). Number 2: 15cm (6in). Number 3: 15cm (6in).

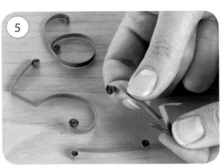

Number 4: two 6cm (2⅜in) and one 9cm (3½in) – fold one of the shorter lengths in half, then fold down each end to create a 'V' shape with horizontal wings; coil one end of the longer length, then glue the closed 'V' over the uncoiled end; coil both ends of the remaining length and glue one end to the left-hand wing to form the short upright. Number 5: 15cm (6in). Number 6: 18cm (7in).

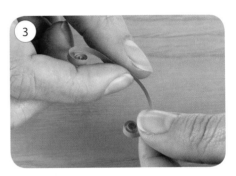

Number 7: 12cm (4¾in). Number 8: 20cm (8in). Number 9: 15cm (6in).

TIP
Both letters and numbers show up best in strong colours.

Flaming candles

Freestanding 3-D quilled candles are sure to attract attention and are simply formed from loose closed coils pinched into upright oblongs. Glue is applied to the reverse side of the shapes and then they are left to dry on easily removable acetate, which makes them rigid and able to hold the weight of the coiled flame.

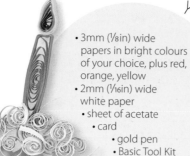

You will need

- 3mm (⅛in) wide papers in bright colours of your choice, plus red, orange, yellow
- 2mm (¹⁄₁₆in) wide white paper
- sheet of acetate
- card
- gold pen
- Basic Tool Kit (see page 8)

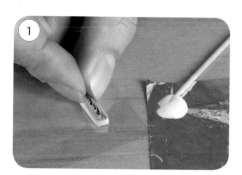

Make a loose closed coil with a 40cm (15¾in) length of a 3mm (⅛in) wide paper, then pinch into a long rectangular shape (see page 15). Apply glue to one side, then place on the sheet of acetate. Hold in position for a few seconds while the glue dries. Make as many candles as you need in different colours, lining them up on the acetate.

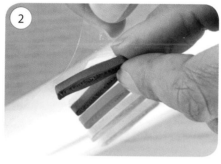

Leave the candles for at least an hour to ensure that all the glue is thoroughly dry. Then remove the acetate from the candles by bending it away from them – don't try to pull the candles off.

TIP
You don't have to use acetate, but you need to use a flexible type of plastic.

For a flame, glue a 5cm (2in) length of the red paper to 5cm (2in) of the orange and then to 10cm (4in) of the yellow end to end and make a loose closed coil, starting from the red end. Pinch the coil into a flame shape. Glue to a candle. Repeat for the remaining candles.

Glue the candle to your chosen card or other surface, in this case by just adding a small amount of glue to the lower part (see Candle Cupcake right) – the candles are strong enough to be freestanding.

INSPIRATIONS

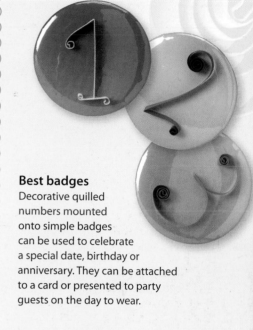

Best badges

Decorative quilled numbers mounted onto simple badges can be used to celebrate a special date, birthday or anniversary. They can be attached to a card or presented to party guests on the day to wear.

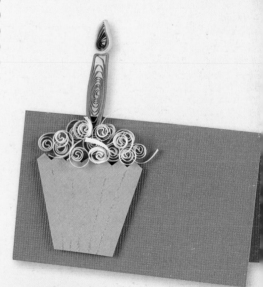

Candle cupcake

A single candle stands upright from a folded place card to make a dynamic design for a party table. The card cake shape (template on page 116) is mounted onto the card with an adhesive foam pad to create enough depth for the decorative topping of open coils made from 2mm (¹⁄₁₆in) wide white paper.

Christmas crackers

The festive season is the ideal time to get quilling and offers the perfect excuse to indulge in luxurious metallic-edged papers for that extra glamour and sparkle. But Christmas quilled decorations need not be glitzy. See, for example, the ornate snowflake made entirely from coiled white paper or the naturalistic beauty of the holly, ivy and mistletoe.

Festive foliage page 112

Curly Christmas tree page 110

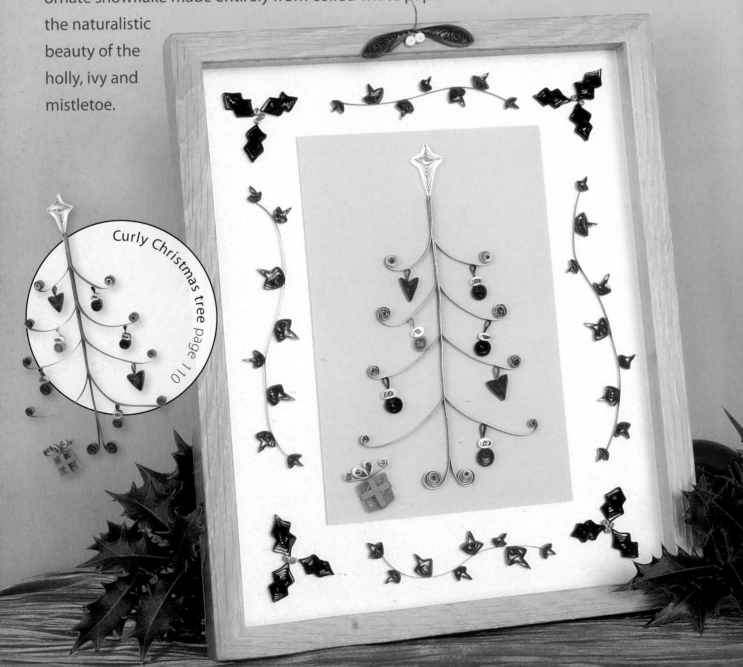

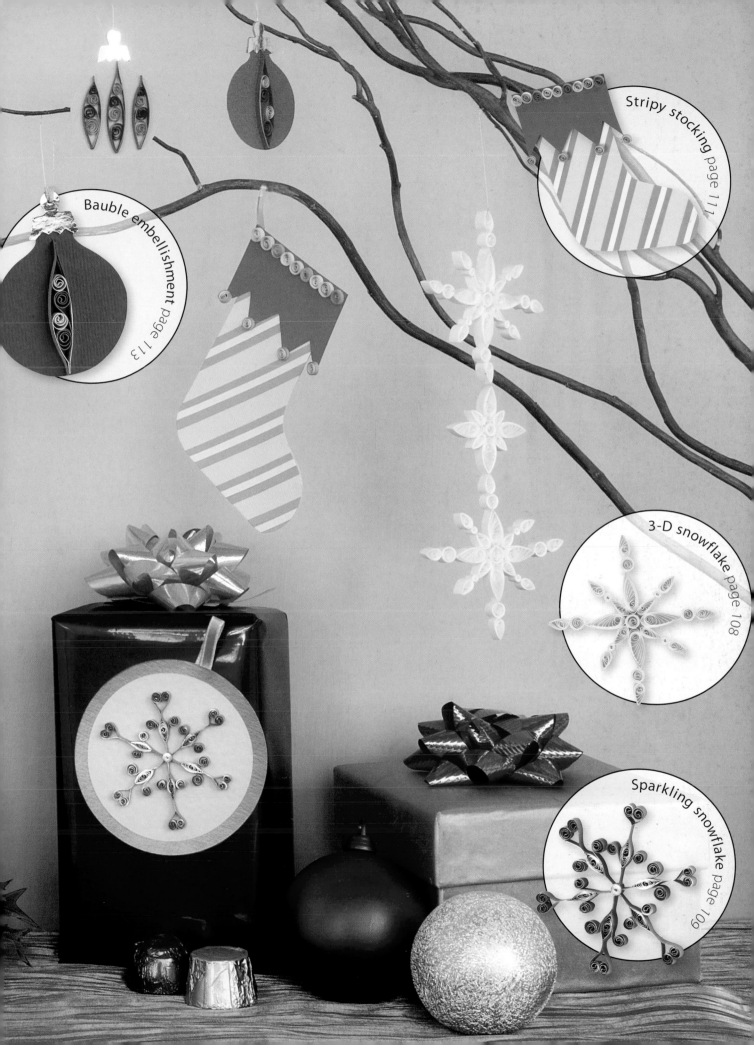

Bauble embellishment page 113

Stripy stocking page 111

3-D snowflake page 108

Sparkling snowflake page 109

3-D snowflake

Pure white shows quilling to its best effect because the focus is on the shapes and the light flowing through the pinched coils, and this elaborately patterned snowflake demonstrates this principle perfectly. As it is a complex design, a foam block and pins are used to help hold the coils and pinched shapes in place. The wider paper makes the decoration more hard-wearing.

You will need

• 5mm (³⁄₁₆in) wide white paper
• graph paper
• parchment (translucent) paper
• blue or clear cotton
• foam block and pins
• Basic Tool Kit (see page 8)

1 Using a pencil and ruler, mark out on graph paper the eight evenly spaced axes for the snowflake. Place parchment paper over the top and pin both to a foam block.

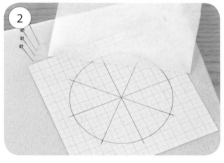

2 Make a loose closed coil with a 10cm (4in) length of the white paper. Position on the centre of the circle and pin in place. Do not apply any glue to the underside.

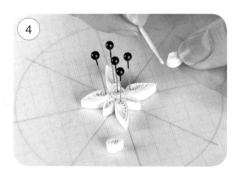

3 Make four loose closed coils with 20cm (8in) lengths of the white paper and pinch into teardrops (see page 14). Glue the rounded ends inwards around the central circle, aligning with the cross axes. Use pins to hold in place while the glue dries.

TIP
The parchment paper not only stops the pencil from spoiling the quilling paper, but it can be used to catch any glue, thereby protecting your template.

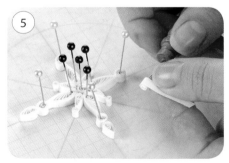

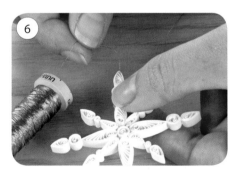

4 Make another four teardrops with 10cm (4in) lengths of the white paper. Glue in between the previous teardrops, aligning with the other four axes.

5 The next shape on the long axes is a loose closed coil made with a 10cm (4in) length of paper, then a teardrop made with a 10cm (4in) length. For the other axes, make a tight closed coil with a 5cm (2in) length and a teardrop with a 10cm (4in) length. Pin all the shapes in place.

6 Leave for about an hour to let the glue dry thoroughly. Remove the pins and then lift the snowflake from the parchment paper. Thread a length of cotton through a top coil and tie in a knot for hanging.

Sparkling snowflake

In this strikingly sophisticated design, open coils are used to encapsulate pinched loose closed coils – a technique known as 'nesting' – to produce a delicate, tracery effect that is still contemporary in style. Other unusual designs can be built up using this approach.

You will need

• 3mm (⅛in) wide silver-edged blue paper
• Basic Tool Kit (see page 8)

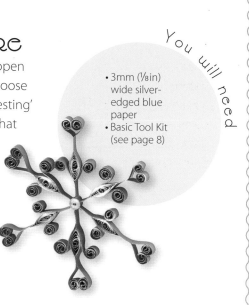

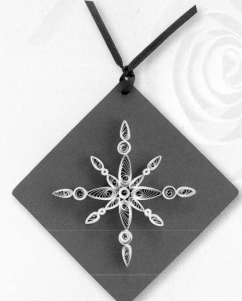

Make a loose closed coil with a 10cm (4in) length of the paper. Pinch at two opposing points. Fold a 10cm (4in) length of the paper in half, then apply glue for 1.3cm (½in) on one side of the fold. Insert the pinched coil into the fold, making sure that the metallic edges are facing the same way. Press the paper to the coil to wrap it.

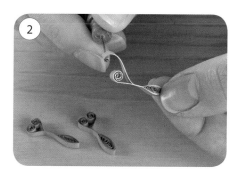

Coil each end of the paper towards each other and remove the tool without gluing.

Quality crystal

The intricate white snowflake makes a bold statement set against a seasonal red card square threaded with green ribbon for a special gift tag. Alternatively, it is dramatic enough to take pride of place at the top of the tree. Be sure to keep well away from naked flames for safety.

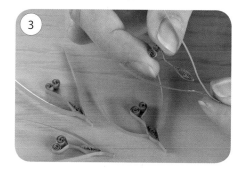

Fold another 10cm (4in) length of the paper in half, apply glue as in Step 1 and press together. Then apply glue as before, insert the teardrop coil and press the paper to the coil. Coil the ends of the paper outwards.

TIP
Snowflakes don't have to be blue or white – be ultra modern and make them pink, red or silver, or to coordinate with your festive theme.

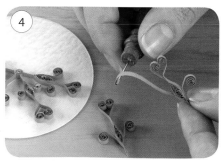

Repeat to make six snowflake pieces in all. Glue around a central tight closed coil made with a 10cm (4in) length of paper.

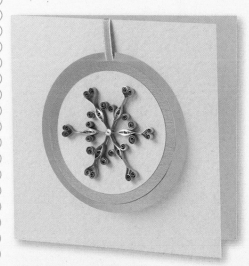

Snowflake centrepiece

This icy blue snowflake is mounted onto a blue card circle and suspended in a circular aperture cut in the folded card front so that it will turn slightly and the silver edging will shimmer in the light. The snowflake circle could be preserved for the following year and hung on the Christmas tree.

Curly Christmas tree

The branches of this elegant festive tree are created by folding paper strips in half, gluing to a central stem by the fold and making open coils in the free ends. It is then hung with a variety of delightful mini decorations, including coiled and pinched hearts, star and gift box, the latter decorated with a bow formed from two tiny teardrops.

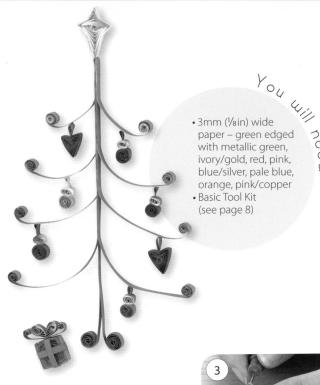

You will need

- 3mm (⅛in) wide paper – green edged with metallic green, ivory/gold, red, pink, blue/silver, pale blue, orange, pink/copper
- Basic Tool Kit (see page 8)

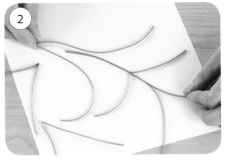

For the stem, fold a 40cm (15¾in) length of the green paper in half. Place on scrap paper. Glue 10cm (4in) along from the fold. Fold the other half of the paper over and press together, leaving the two ends free.

For the side branches, cut 22cm (9in), 26cm (10¼in), 30cm (12in) and 34cm (13½in) lengths of the same paper. Fold each in half and glue at the fold to the central stem, leaving the ends free.

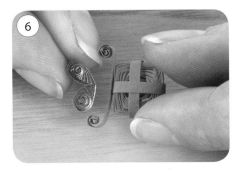

Coil the ends of the branches away from the central stem without gluing the coils.

Make a loose closed coil with a 40cm (15¾in) length of the ivory/gold paper. Pinch into a star (see page 15). Repeat with a 20cm (8in) length of the red paper, but pinch into a heart (see page 15). Make a tiny loop from pink paper. For the baubles, make loose closed coils with 10cm (4in) and 8cm (3⅛in) lengths of the blue/silver and pale blue paper. Pinch the latter into a rectangle (see page 15), glue to the former and add a loop. Repeat with 15cm (6in) and 10cm (4in) lengths of leftover papers.

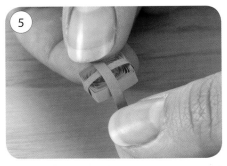

For the gift box, make a loose closed coil with a 40cm (15¾in) length of the orange paper and pinch into a square (see page 14). Wrap two lengths of the pink/copper paper crossways around the present and glue to the underside.

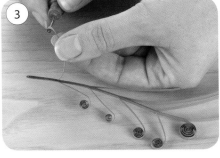

For the bow, make two loose closed coils with 10cm (4in) lengths of the pink/copper paper and pinch into teardrops (see page 14). Glue together at the points. Curl either end of a 5cm (2in) length of the same paper inwards. Glue to the top of the present and attach the bow.

Stripy stocking

This traditional seasonal motif demonstrates another creative way to use pre-cut strips of paper designed for quilling. The stripy patterned 'fabric' is made by gluing wide and thin strips of pink and cream paper to paler pink card. The plain stocking top is embellished with loose closed coils in coordinating colours.

You will need

- 10mm (⅜in) wide pink paper
- 3mm (⅛in) wide ivory/cream paper
- 2mm (¹⁄₁₆in) wide paper – pink, green, dark pink
- card – pink, 20 x 5cm (8 x 6in), red
- Basic Tool Kit (see page 8)

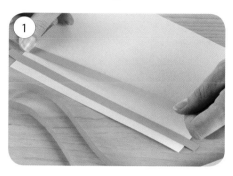

1

Spread glue all the way along a length of the 10mm (⅜in) wide pink paper, then press onto the pink card. Continue to add lengths at evenly spaced intervals in the same way across the card.

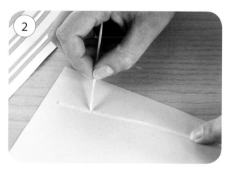

2

Glue lengths of the 3mm (⅛in) wide ivory/cream paper on top of the existing strips, positioning them centrally.

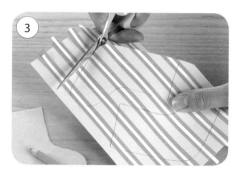

3

Using the template on page 119, cut out a stocking from the stripy card, placing the template at an angle to the strips. If you want to create a freestanding stocking, position the template so that you can cut a second stocking from the card.

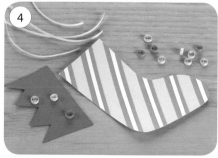

4

Using the template on page 119, cut out a stocking top from red card, or two if freestanding, and glue to the stocking. Make loose closed coils with 10cm (4in) lengths of the 2mm (¹⁄₁₆in) wide pink, green and dark pink paper, then glue to the points of the stocking top and along the top edge. Form a length of paper into a loop and attach to the stocking top at the back. If freestanding, decorate both sides in the same way, then glue together around the edges, sandwiching the loop in between.

TIP
By making your own striped card, you can make it coordinate perfectly with your paper coils.

INSPIRATIONS

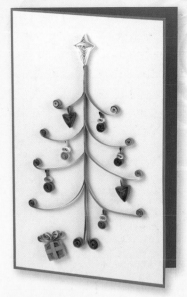

Trendy tree card
Offering a modern twist on the traditional, this minimalist Christmas tree makes a stylish motif for a deluxe festive card. But why stop there? You could change the colour of the tree to white, pink or even black set against a suitably contrasting background for a design with attitude.

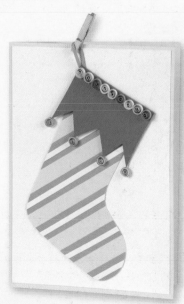

Great expectations
For a characterful Christmas card design, simply mount the stripy stocking onto a pale-coloured card panel for maximum contrast and in turn onto a coordinating pink folded card. Glue a mini clothes peg to the loop so that the stocking really looks like it is hanging up, waiting to be filled with festive treats.

Festive Foliage

Greenery plays a leading role in decorations for the festive season, and is equally appealing in quilled form. So here's how to re-create the classic trio – holly, ivy and mistletoe – from pinched loose closed coils. The pinching technique for the first two requires a little practise to perfect and care should be taken in selecting the appropriate shades of green paper.

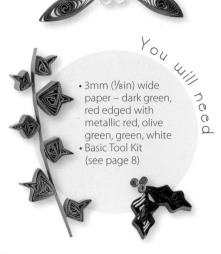

You will need

- 3mm (⅛in) wide paper – dark green, red edged with metallic red, olive green, green, white
- Basic Tool Kit (see page 8)

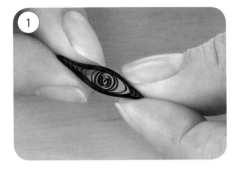

For the holly, make a loose closed coil from a 20cm (8in) length of the dark green paper, then pinch into an eye shape (see page 14).

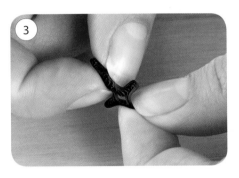

Hold the shape in the centre with the index and thumbnail of one hand and pinch the end of the shape while simultaneously pushing inwards.

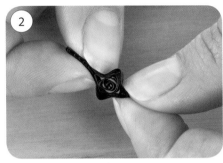

Turn the shape around and repeat with the other end, pinching and pushing inwards, then let the shape go and gently push both ends together to achieve a holly shape. For the berries, make tight closed coils with 2–3cm (¾–1⅛in) lengths of the red paper.

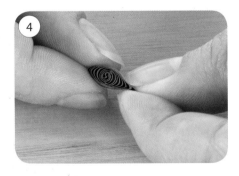

For ivy, make a loose closed coil with a 20cm (8in) length of the olive green paper. Pinch into a teardrop shape with the centre at one end (see page 15). Pinch the other end tight with your fingernails.

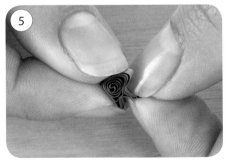

While still holding in this position, push the shape over your fingernail. Release and give the shape a gentle push to achieve the ivy shape. Make smaller ivy leaves with 15cm (6in) and 10cm (4in) lengths.

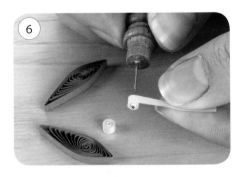

For mistletoe, make two loose closed coils with 40cm (15¾in) lengths of the green paper. Pinch into eye shapes with the centre towards one end. For the berries, make two tight closed coils with 10cm (4in) lengths of the white paper. Assemble with a small 2cm (¾in) length of green paper for the stem.

Bauble embellishment

The 'nesting' technique, featured in the snowflake on page 109, is again used here to create this ornate, Eastern-inspired decoration for a festive bauble. This time, however, the coils that are encased are all open coils.

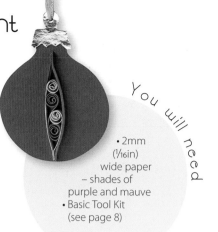

You will need
• 2mm (1/16in) wide paper – shades of purple and mauve
• Basic Tool Kit (see page 8)

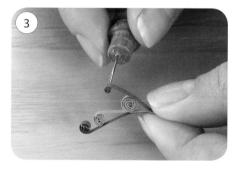

Fold two 10cm (4in) lengths of paper in two different shades of purple in half, then glue together only at the very fold.

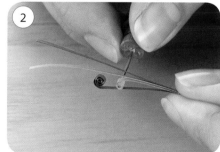

Coil each length down to the fold so the coils are staggered and the colours alternate.

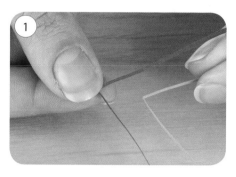

Coil the alternating coloured lengths in varying directions and leave open.

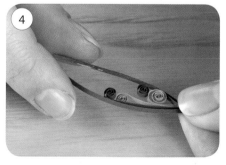

Fold a 10cm (4in) length of dark purple paper in half, then glue the coiled piece to the fold. Glue the ends of the dark purple paper together, encapsulating the coils, then trim the excess.

TIP

If you find using 2mm (1/16in) wide paper too fiddly, you can use wider paper; it will just make the final bauble more bulky.

INSPIRATIONS

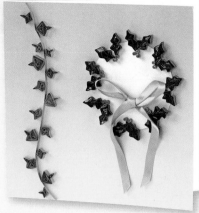

The holly and the ivy
This luxury card offers a feast of festive foliage for those who relish a new take on traditional seasonal decorations. A wreath is created from holly attached in pairs with red berries around a green card circle topped with a gold bow, while the garland consists of ivy leaves glued either side of a length of the olive green paper.

Under the mistletoe
Make your gift stand out from the crowd with this quick and easy tag featuring a sprig of mistletoe mounted onto layered card circles in classic Christmas green and red. The outside circle could be cut with fancy-edged scissors and the decoration hung from the tree.

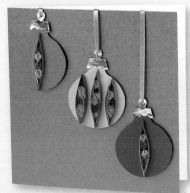

Hanging treasure
For this opulent card design, the bauble shapes were die-cut from coloured card, then a second set die-cut from silver card and the tops trimmed off. These tops were glued to the quilling-embellished baubles and threaded with gold ribbon.

Decorated gift boxes and bags

While gift boxes and bags are easy to make, you may want to save the time involved and buy ready-made ones so that you can concentrate your efforts on making quilled embellishments for them instead. Boxes are available in a variety of shapes and sizes, as are gift bags, which often come with a printed pattern that can be incorporated into your quilling design. If you have made a quilled card, you can then decorate a gift box or bag and tag to tie in with the theme.

Colour karma

This CD box has been tied with orange ribbon around two corners and tied in a bow. A large oriental-style quilled flower (see page 72) was glued to the centre, with six smaller flowers either side (see page 73) – all unconnected by stems to create a 'Zen' feel. This would make an ideal package for a Mother's Day, birthday or thank you gift.

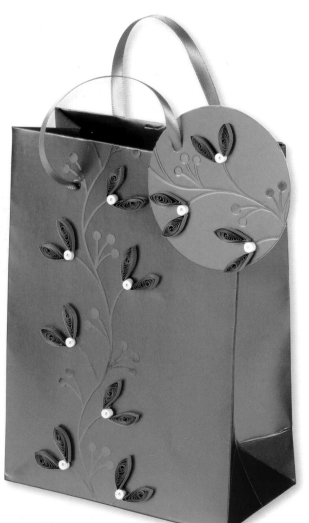

Seasonal leaves

The red metallic bag came with a pre-printed/embossed mistletoe design, which has been embellished with quilled mistletoe leaves and berries (see page 112), positioned directly over the existing motifs. A classic design for a Christmas gift for someone special.

Garlanded with love

This burgundy octagonal-shaped gift box has been decorated with trails of quilled ivy (see page 112) coming up from the base as though it is creeping over it, with a gold circle on the lid, again with an ivy embellishment. The tag features a scrolled heart made from ivory paper (see page 51). Use for a festive gift for a loved one or for a couple getting married at Christmas.

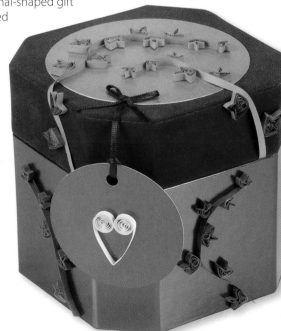

Alpha baby

Ready-made bright blue cardboard letters have been glued in a diagonal line to the centre of this bought baby's keepsake box. Two sets of quilled baby feet (see page 55) in a matching colour have then been added on the other diagonal as a simple yet effective decorative device.

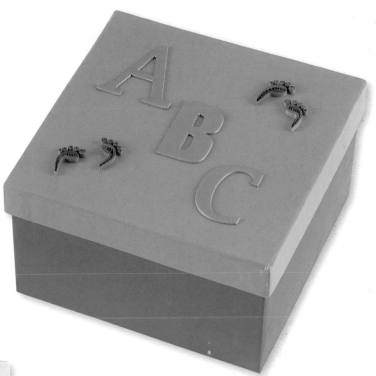

Age spotting

This spotted gift bag has been quickly and easily enhanced by gluing open coils to some of the printed motifs. A simple circle tag has then been decorated with a quilled number 4 (see page 104). Several of these would make great party bags for a children's birthday; the number can be changed according to the birthday boy or girl's age.

Frilled to thrill

A gold bag with a printed leaf design is decorated with three frilly flowers (see page 44) made from paper graduating in colour across its width, so that the fringed tips stand out in white. This gorgeous gift packaging would be suitable for a variety of occasions, from Easter to an anniversary.

Templates

Box (page 19)

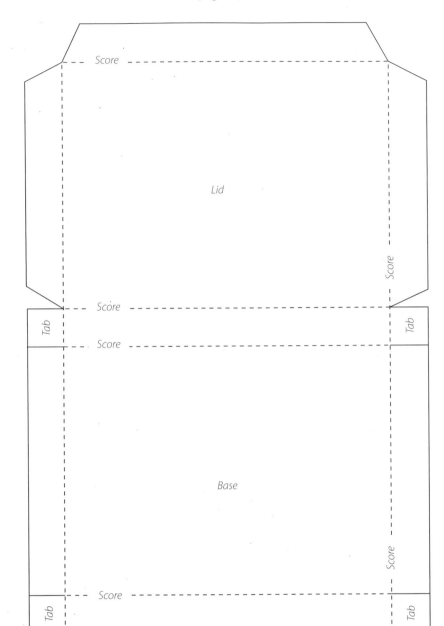

Score

Lid

Score

Tab

Score

Score

Tab

Base

Score

Tab

Score

Tab

Sweet peas (page 25)

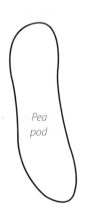

Pea pod

Carrot cupcake (page 25)
and Candle cupcake (page 105)

Cupcake

Trusty trowel and fork (page 26)

Trowel blade *Fork blade*

Timeless topiary (page 28)

Plant pots

Handy secateurs (page 29)

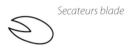

Secateurs blade

Shear delight (page 29)

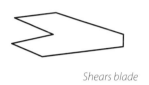

Shears blade

Insect jar (page 33)

Leaf

Hovering dragonfly (page 36)

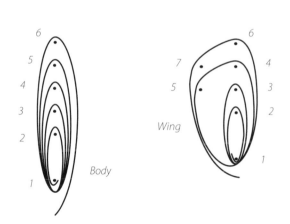

6
5
4
3
2
1

Body

7
5

6
4
3
2
1

Wing

Spotty buggy (page 56)

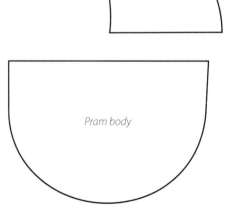

Pram hood

Pram body

Fairy queen (page 60)

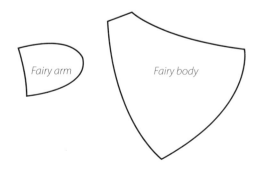

Fairy arm

Fairy body

Ornamental fan (page 69)

Fan

Handle

Tendril-trimmed hat (page 76)

Feathered hat (page 77)

Trendy bag (page 79)

Handbag

Sole

Upper

Chic shoe (page 78)

Delicious ice cream (page 87)

Cone

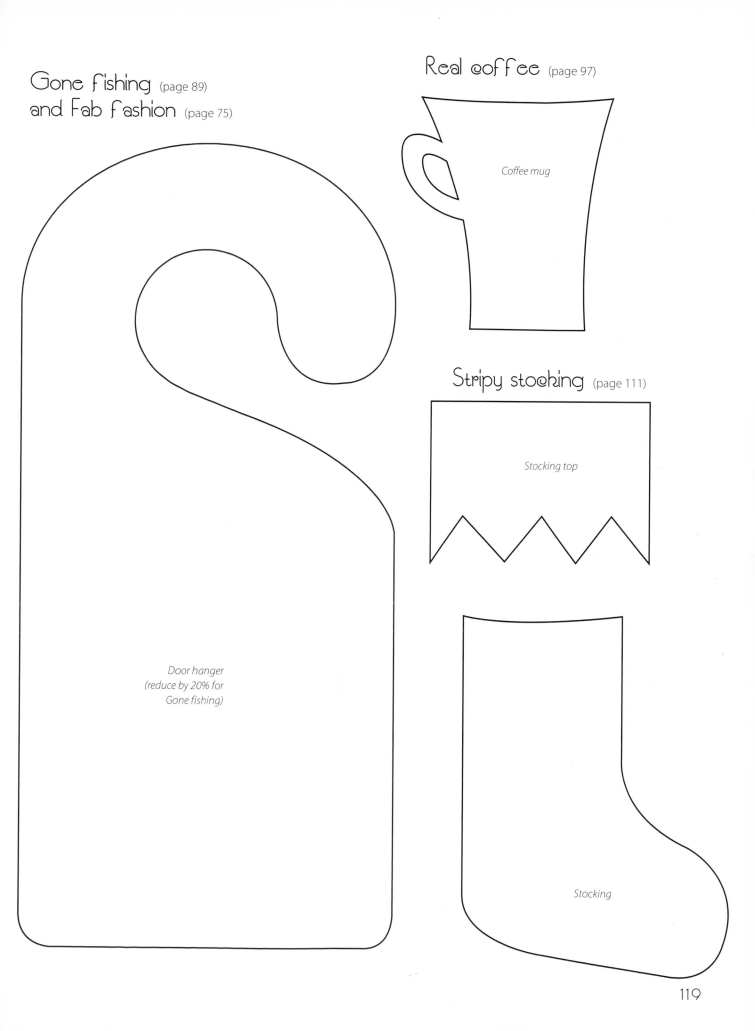

Gone fishing (page 89)
and Fab fashion (page 75)

Real coffee (page 97)

Coffee mug

Stripy stocking (page 111)

Stocking top

*Door hanger
(reduce by 20% for
Gone fishing)*

Stocking

Suppliers and materials

UK

DoCrafts (trade only)
www.docrafts.co.uk
For suppliers of quilling materials including quilling boards

Evie's Crafts Ltd
79 Dale Street
Milnrow
Rochdale
OL16 3NJ
Tel: 01706 712489
www.eviescraftsltd.co.uk
For quilling papers and supplies

Fred Aldous Ltd
37 Lever Street
Manchester
M1 1LW
Tel: 0161 236 4224
www.fredaldous.co.uk
For quilling kits and supplies

Jane Jenkins Quilling Design
33 Mill Rise
Skidby
Cottingham
HU16 5UA
Tel: 01482 843721
www.jjquilling.co.uk
For all quilling supplies

Lakeland Ltd
Alexandra Buildings
Windermere
Cumbria
LA23 1BQ
Tel: 01539 488100
www.lakeland.co.uk
For quilling boards and materials

Pebeo UK Ltd
PO Box 282
Southampton
SO45 5XD
Tel: 0808 234 2290
www.pebeo.com
For 3-D paint

USA

Crafter's Companion International
5703 Red Bug Lake Road
Winter Springs, FL 32708
Tel: 1800 399 5035
www.crafterscompanion.com
For envelope makers

Lake City Crafts
1209 Eaglecrest Street
P O Box 2009
Nixa, Missouri 65714
Tel: 417 725 8444
www.quilling.com
For fringing tools and supplies

Michaels Stores Inc
Attn: Customer Service
8000 Bent Branch Dr
Irving, TX 75063
Tel: 1 800 642 4235
www.michaels.com
General craft store chain

Quilled Creations
PO Box 492
Penfield, NY 14526
Tel: 585 388 0706
www.quilledcreations.com
For all quilling supplies

Ranger Industries Inc
15 Park Road
Tinton Falls, NJ 07724
Tel: 732 389 3535
www.rangerink.com
For Perfect Pearls™

Australia

Jonathan Mayne
P O Box 345
Mt Martha
Victoria 3934
Tel: (03) 5988 4099
www.jonathanmayne.com.au
For fringing tools and papers

Europe

Kars
P O Box 97
4050 EB Ochten
The Netherlands
Tel: 31 (0) 344 642864
www.kars.nl
For ready-fringed papers

Acknowledgments

Many thanks to Jane Trollope, Emily Rae and Eleanor Stafford at David & Charles and special thanks to Jo Richardson, Karl Adamson, Kim Sayer, Selina Jackson and my friends and family.

For further papercrafting ideas, information about the author and details of her forthcoming workshops see www.elizabethmoad.com.

Index